BY CRAIG MOD

THINGS BECOME OTHER THINGS

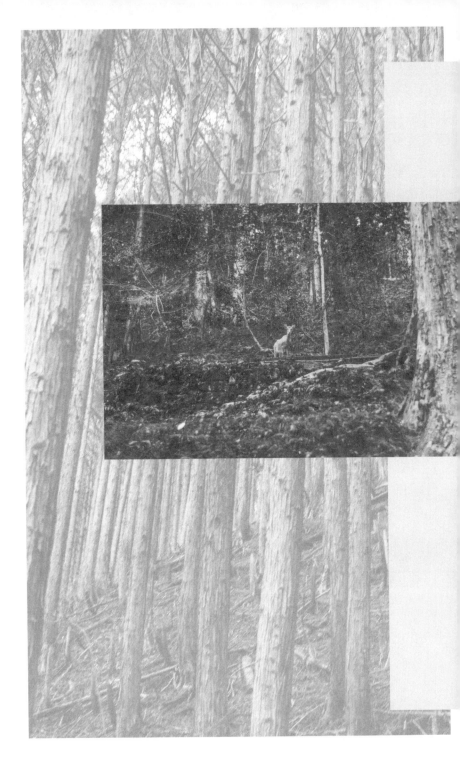

THINGS BECOME OTHER THINGS

...

A Walking Memoir

CRAIG MOD

RANDOM HOUSE

NEW YORK

Published in the United States by Random House, an imprint
and division of Penguin Random House LLC, New York.

Random House and the House colophon are registered trademarks
of Penguin Random House LLC.

The image on page 18 is copyright ©1988 MASH · ROOM/AKIRA
COMMITTEE All Rights Reserved. The photo on page 105 is copyright © 1952
TOHO CO., LTD. The fried bologna sandwich drawing on page 140 is copyright
© Luis Mendo 2023. All other images are courtesy of the author.

Hardback ISBN 978-0-593-73254-0
Ebook ISBN 978-0-593-73256-4

Printed in the United States of America on acid-free paper

randomhousebooks.com

1st Printing

FIRST EDITION

Book design by Barbara M. Bachman

The authorized representative in the EU for product safety and compliance
is Penguin Random House Ireland, Morrison Chambers, 32 Nassau Street,
Dublin D02 YH68, Ireland. https://eu-contact.penguin.ie.

To Mizuki

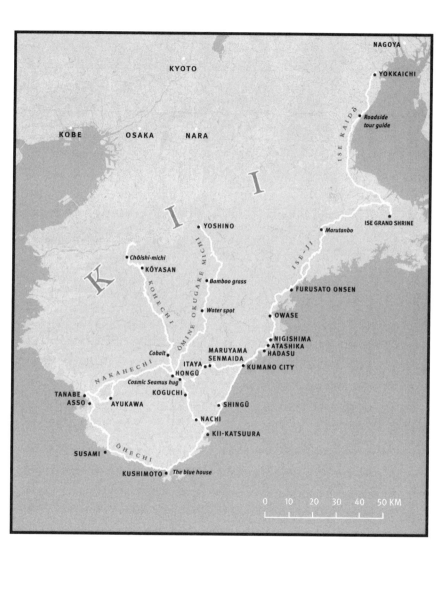

NAGOYA

KYOTO

YOKKAICHI

KOBE OSAKA NARA

*Roadside
tour guide*

ISE GRAND SHRINE

K I I

YOSHINO

Marutanbo

Chōishi-michi
KŌYASAN

Bamboo grass

FURUSATO ONSEN

Water spot

OWASE

Cobalt

NIGISHIMA
ATASHIKA
HADASU

MARUYAMA
SENMAIDA

ITAYA
HONGŪ

KUMANO CITY

Cosmic Seamus hug
KOGUCHI

TANABE
ASSO AYUKAWA

SHINGŪ

NACHI

KII-KATSUURA

SUSAMI

KUSHIMOTO *The blue house*

ŌMINE OKUGAKE MICHI

KOHECHI

ISE-JI

ISE KAIDŌ

NAKAHECHI

ŌHECHI

0 10 20 30 40 50 KM

They say the great typhoon of 1889 filled the air of Kii with a mythic kinda rage. Meiji 22: The black skies cracked, and down it came. Waters rocked. Rivers rose. That towering *torii* of Hongū Grand? Fell hard. The holy land went all mush, they say, earth unstuck, undulated like the ocean. Above— three-legged oily rascals wheeled and cawed and surveyed the slop. For when that divine mayhem of all-penetrating wetness finally pulled back, they say Hongū had been reduced: Mud, mud, and more damn mud. Shrines and homes swept halfway down the Peninsula, shattered, floating off into a dead-still sea.

THINGS BECOME OTHER THINGS

B.—allow me to begin again, just for you.

Why am I drawn back to this place? To this peninsula, the Kii Peninsula? This once-wiped-clean land of lost villages and dusty roads, of fallen-pilgrim graves and boats stuck in the earth? In part, it's because they say the stone here suffers few dickheads, is happy to chuck you off given the slightest vanity. Us—two dickheads without vanity, from a place that never knew vanity: buzzed skulls, stained T-shirts and jeans, sneakers with half-attached soles. Walking these roads and ridges you'd have made it for sure, I know this now. Touching this rock, walking these paths, I've found an unexpected peace in these recondite hinterlands.

I admire the old road and rock, but the people—their stories, their immutable connection to this place—have brought me back again and again. Their language enchants: a delightfully foul mellifluousness, a soiled twang we know well. And it's these people and their words that make me think of you more than anything else.

It's been a lifetime since I've written your name: Bryan. (There it is.) Written with a "y" not an "i." The only "true" way to write it as far as I'm concerned. A name that never left my mind. (How could it?) *Bryan.* But it wasn't until this walk that you returned to me in full. Why now? I don't know. Maybe I'd just seen enough, finally. Was finally brave enough to look back.

Here's what I do know: This world turns and turns and the more I move my feet the more I believe in things we never understood. Life, irrepressible, it billows over the top of the pot, man. Let me be your eyes as best as I can. I'll bear witness to this wonder you never got to see.

HOWDY

Twenty-seven years since we last spoke, a catch-up is in order. Here are the broad facts: I'm now forty-one. I moved to Japan when I was nineteen. I walk a lot, mostly alone, always compulsively, down these old Japanese roads.

I walk twenty, thirty, sometimes forty or more kilometers until my feet feel wonky, hot in spots, minced. Until I'm sure I can't take another step. And then do the same thing again the next day. And then the next. Repeat this for weeks, months. I do this easily, as if my body has been waiting for this my whole life. I photograph those I meet, the things I see, the banalities of life I pass. I dictate my observations and thoughts into a recorder, talking to myself like that bag lady who roamed our suburban sidewalks, who walked past our homes. (Why didn't any of us try to help her?) Each night, I spend three or four or five hours collating the photographs, compiling my notes, doing laundry, chatting with inn owners, creating an archive. Where does it all go? Here, you're holding it. The whole thing, an ascetic practice. I even shave my head like some performative mendicant, one who lives off stories as alms. This is a walk, yes, but also a series of relationships with people and objects: purpose wrought from a slideshow of faces, old tales, new tales, histories, fields, forest climbs, pachinko parlors, and pine trees.

• • •

Down the road I see what might be a *kissa,* an old café. These have become my favorite places of all the places in the world—*kissaten* or kissa for short, Japanese cafés with the air of mid-

century American diners but entirely of their own mirror-world aesthetic. Low Formica tables, low seats. "Sofa seats," they're called. (I love that—*sofa seats*.) Kissas are smoky, creaky community hubs. Sit in the right one for an hour and, if nothing else, you'll understand the town a bit better. The oncoming shop's canvas awnings look like they've been shredded by storms. The place looks abandoned, let me tell you. Like it had been murdered and thrown in a ditch, pulled out, assessed, deemed worthless, dumped back in. But the day is hot and I'm thirsty and the sign says "Howdy."

Inside, the owner is head-down in a newspaper, smoldering cigarette aloft in hand. She doesn't look up.

Ain't got no toast, she says. (They often serve toast.)

You got iced coffee?

Yeah, we got iced coffee. (They *always* serve iced coffee.)

The place is empty. I use the toilet, which is in great shape—old-style ceramic hole in a porcelain-tiled floor. A toilet from a different era, one that requires good balance, haunches like a sumo wrestler's. I once saw a toilet made specifically for the emperor. It was in a small village along another historic route called the Kiso-ji, far from this kissa.

Hundreds of years ago, rumor had it, the emperor was going to pass through. God forbid he need to shit. So they made a beautiful toilet—wooden. (Yes, a wooden toilet.) A hole in the floor, perfectly oblong, lined with aromatic cypress, filled with sand, with a nice little handle poking up at one end to aid with balance. Hitch up your kimono, hold on, that sort of thing. The ceiling was of a delicate woven thatch. Truly, a slyly cultivated place to empty your guts. Why a pit of sand, as if the emperor were a cat? Because his stool needed to be checked. There was an official sifter. A man who analyzed all imperial bowel movements to make sure the godhead was OK. What a job. These things exist, believe it or not. The

stories we tell ourselves, the way we elevate this human over another human—so arbitrary, so bizarre. That toilet in the middle of nowhere never did get used. But the town enshrined it in a way, keeps it on display. You can go visit if you're nearby.

Here in Howdy, the toilet is more or less the same, but with plumbing—not sand—and has clearly been used a few thousand times. Next to it sits a dented-up aluminum ashtray. The place once filled with tobacco smoke, still suffused with the exhaust of a thousand smokers. Over the last decade, laws changed as the Olympics approached. (The Olympics changed Tokyo in 1964 and once again in 2020.) When I first arrived in 2000, everyone seemed to smoke everywhere. You'd have to shower three times to get the smoke out of your hair. But now it's more strict. Hardly anywhere allows smoking anymore. These old kissas are the last holders-on. And they mainly keep it going in reverence to their regulars, who've smoked here every morning for most of their long lives.

I return from the toilet and the iced coffee is already on my table. The owner looks like she hasn't moved, like the coffee had made itself. I take a sip. Wince, cough. It's unexpectedly sweet. Reminds me of coffee you get at Annapurna base camp (one of the first places I ever adventured on my own): instant, loaded with sugar. I arrived at that base camp with my head in the vise of altitude sickness. Above camp was a rocky lip on the edge of the epic moraine. Unable to sleep, I hiked up alone at night, sweet coffee in a small thermos tucked into my jacket, sat on the edge of that vast frozen plain, looked out at the towering peaks of Machapuchare and Hiunchuli and Singu Chuli and Gangapurna and, of course, the 8,000-meter god of Annapurna itself, as the clock ticked over and I turned twenty-eight years old, feeling as small and lost as anyone could feel in a place like that, a place that felt like the moon.

I didn't know it then, but I was coming to the end of a tough decade, and things were finally going to change for the better. In that moment, though, it took everything I had to keep myself from diving off the edge in the face of all that beauty and loneliness.

Clearing my throat I say, Long time, this place, huh? And the owner laughs and says, Howdy? Running this place thirty-five years. Maybe thirty-six. Prolly thirty-five.

Then, cackling some more: Heck, long enough. We could just shut it down right now. Coulda shut it down a long while back.

Time runs differently on the Peninsula. It's difficult to explain, but it's like time had stopped at a very arbitrary moment, forty years ago, and everything left today staggers in circles, precision lost. I feel a softness in this imprecision, a kind of absolution. Kii is as good a place as any to meditate on the past. Folks here cultivate a healthy relationship with decay. The right storm could wipe it all clean overnight. And that's fine, they seem to say, and sometimes outright say it.

I look around at the coffee equipment and stools. Lines of coffee tickets are tacked up on the wall. Buy ten cups, get one free. That sort of thing. Traditionally, kissas hold on to tickets for their regulars. Though whether Howdy's regulars still draw breath is another question. In the corner, a glass table with a joystick at each side and a video-game monitor embedded underneath. The tables we adored as kids. Greasy pizza parlors, a quarter to play *Pac-Man,* summer hours lost like smoke. The screen is off, looks like it had never been on. This broke a while? I ask. Ages, she says.

She doesn't question my presence, doesn't make a deal of the big pack I'm hauling around. This is my first day walking in a while and I don't have much of a plan. But finding Howdy, drinking this distressing iced coffee, thinking about lifeless

moraines and imperial toilets—these all seem like good signs to me. The goal is simply to do my "job," to walk the old roads of the Peninsula for thirty, maybe forty days. We'll see how it goes. I'm in no rush.

The owner's cantankerous sprezzatura is impressive. She is impossibly cool. Gives subzero fucks. Speaks vaguely, in riddles, like we're playing ping-pong with a wet sponge. Could have been talking about so much. Of all things, we chat about government competency or incompetency. Virus this, virus that. The world all goin' sideways, she says, and don't know if it *can* right itself. Who knows where the virus lurks. And, heck, who cares. Says, Can't blame a person for wantin' a drink. Any damn thing could come outta anyone anywhere at this point.

All I can do is laugh and agree.

With that, I finish the sweet liquid and pay and ask if I can photograph the place. She relents with a grunt.

Cloudy day, pale light. A tobacco-stained Southern belle hanging on the wall. This is how the decades sweep by.

Thirty days, maybe forty—this is my plan. The walking plan. I'm not depressed per se, no great emptiness has taken hold, but something is off, has been off a while. I feel restless. Maybe it's COVID—the sweep of the virus across the earth. All that attendant solitude. Maybe I've just reached a breaking point of being home for over a year. The world's ground to a halt, Bryan, and has stayed halted and we don't know when it's going to get unstuck. All the busyness we use to ignore trauma, to pretend like everything's OK, well, that busyness has been erased cold turkey. The collective fear of *any damn thing coming outta anyone* is slathered all over our brains. I don't need a drink, but I need a walk. So I set off on this walk. May 2021. The timing feels right to work things over, things I've been ignoring for nearly a lifetime, and know of no better way to do so than to move my feet.

I'm embarrassed to admit it, but the pandemic has been easy for me. Heck, I've thrived. Because this is my job—the walking alone—I can keep doing it, pretty much without restriction. From the walks I write, I photograph, I make books. This is the life I find myself occupying, often in disbelief.

You may wonder why I feel the pull to walk and walk alone and do so for days and weeks and months at a time. As kids, I think it would have made sense without any explanation: all this walking. Of course we walk. We *explore*. In a way, it's all we had. You seeded that exploration in me, you set markers on my mental horizon and pushed me to the edge of our town when I didn't have the guts to do so on my own.

But later on—on the path into adulthood—many of us seem to lose this simple impulse to traverse dirt, to push on the edges of what's known to us. We grow older and settle in and the world shrinks, and the next time we lift our heads and survey things, it can feel like we've been stuffed into a suitcase.

Well, that never sat well with me. That shrinking. That self-stuffing. You know that. You felt that in me decades back, and I felt the same in you. Both of us carrying an impulse to push, to break things to understand how they worked, and in fixing them perhaps learn to fix others around us. Seeing the edge of our town was a way to see the town itself, although we never did get a good view, did we? And so ten years ago, in my early thirties, I began expanding the circle of my known world by walking the historic routes of Japan.

With that simple impulse to walk, my life was forever changed. I know that sounds hyperbolic, a bit bonkers, but it's true. A walk? Life-changing? Yes. What did I feel on the road that first time? Nothing explicit, nothing I could name in the moment. Just the diffuse scent of purpose out there between the villages and the trees and mountains. By that point, I had lived in Japan for over a decade (that I made it past thirty is still a bit unbelievable, and the fact that I've now crested forty and, heck, fifty seems possible are all facts I'm still wrapping my head around; how differently would we have lived had we believed all this time was splayed out before us?) and was looking for the reason why, exactly, I had stayed so long, and where my place might be in a country that would never see me as more than a visitor. Here it was: to walk, and walk well, and witness the people along the way. But *why*? That's the riddle I'm still figuring out. To believe? To make others believe? You could say my eyes were opened. You could say I had a "conversion event." Whatever you say, I was

CRAIG MOD

13

off walking whenever I could. Months out of the year. Often on this peninsula.

The Kii Peninsula sits as—and I feel like this is the easiest way to explain it to you, though I hesitate, and yet here I go— the chubby dangling penis of Japan. It hangs right down at the central belly of the Honshu landmass. A little lonely, mostly mountains, extremely moist. (I know, I know.) Though it has no explicitly clear physical northern boundary, you can think of its northern edge as marked by the east-west line formed by Kobe, Osaka, Nara City. (Kyoto is farther north.) It contains three prefectures: Mie, Wakayama, and Nara. To the west is Osaka Bay and the island of Shikoku, home to the famous, grueling 88-Temple Pilgrimage. To the east and south is the Pacific Ocean. It's one of the rainiest places in the earth's subtropical region. (More rain, even, than in the Amazon.) Its topography is composed of temperate rainforest and logging forests. It is sliced up by dozens of ancient paths and pilgrimage routes, all with individual names but many lumped together as the famous Kumano Kodō. Many of the routes are just a few dozen kilometers in length, but together, it can take months to walk them, years to fully piece them together, and a lifetime to know them.

On this walk, I'm sticking to the coast as much as possible. (None of this will make sense to you, so I placed a map in the front. Go, go take a peek.) I'm starting with the Ise Kaidō, walking to Ise Grand Shrine. Then heading down the Ise-ji route to Kumano City, where I'll grab the Hongū-do path inland to Hongū Grand Shrine. Then I'll take the tough Nakahechi back down to Nachi Falls, walk the streets to Kii-Katsuura, and finally catch the Ōhechi around the southwestern coast up to Tanabe City. I'll touch dense forests on certain days, but mainly I want to focus on the shrinking towns and villages of fishermen working those salty waters. I want to see and hear people, damnit.

...

The walk began yesterday in the northeastern corner of the Peninsula at Yokkaichi Station, where I disembarked from a local train. A bit south of Nagoya, where the original Tōkaidō—one of the two famous classic routes connecting Kyoto and Tokyo—intersects with the Ise Kaidō. These are old roads, pilgrimage roads, some in use for well over a thousand years. Though today you'd hardly know it. Many of the roads of the Peninsula look like those you'd find anywhere in the countryside: One- or two-lane stretches of asphalt fringed with fields and gutters and mountains, sometimes far off, sometimes close. Not too different from where we began.

The start was not pleasant: I walked past the world's loneliest pine tree. I walked past a pachinko gambling parlor. I walked past two, three, five, seven, a dozen convenience stores—FamilyMarts, Lawsons, 7-Elevens. I walked past a pharmacy the size of a baseball field. Cars and tractor-trailers whizzed by. Ramen shops showed off their noodles in glass cases caked in exhaust. Curry shops spiced the air. A robot screamed at me about deals for used cars. No one else walked. I was alone in the walk. Drivers seemed hesitant to make eye contact.

And then, just like that, the path veered at the Hinaga-no-Oiwake junction, narrowed, went back away from the busy road and then farther away still. Cars vanished. So did the convenience stores. The pharmacies turned into rice paddies, the horizon appeared dotted with mountains.

What I saw: A home with a beautifully manicured tree. A driveway blocked by cones cast in golden morning light. Behind them, fields. This time of the year they glisten like shallow ponds. Seedlings poke up above the water in neat rows. Crows hop between, look for worms, squawk. Kudzu envelops

homes and telephone poles. Kilometers pass. The rural landscape seems to set. You can hear the nightingales sing.

. . .

The road slips by and the working-class tone of the landscape, the farming machinery, the lumber equipment, the quietude stamped atop it all by COVID cause my mind to drift back across the ocean. I think about the town we grew up in—our blue-collar, post-industrial home—and I think about you because the town is nothing to me without you. A town once filled with hardworking folks commuting to the bottling plant or nearby armory or airplane-engine factory. As industry left, problems mounted. We saw that, we felt it. (Though we had nothing to compare it to, knew nothing else but our town.) Decades ago I escaped its complicated gravity. My ability to even think about college was thanks to my mother. She began saving at age twenty, years before she was married or even knew she'd adopt me. I didn't know much, but I knew that I needed to be as far away as possible. I found three Japanese universities that had English websites. Applied on a whim and got into one. Tuition was a fraction of what we were told college should cost.

Arriving in Tokyo at age nineteen, this is what I felt: excitement, terror, disbelief, salvation. How could it be that I was here? A cityscape we knew only post-apocalyptically from a bootleg copy of that now-cult-classic animated film *Akira*. Now I was *in* it, the landscape of that film. Those first steps I took outside the borders of our town felt like kicking myself in the nuts over and over. Each step, another smack. Because in each step I felt so clearly our deficits. Holy smokes, were we running on fumes. Everyone I met in the great city seemed so much better prepared—for life, love, sanity. The city of Tokyo itself, too, its clockwork precision, maintained at an unfathomable scale, broke my mind. Unlike our town, there were no guns, no drugs, few homeless. I felt a peace I never knew was possible amid so much movement. It put the few other cities I had seen to shame. Packed trains crisscrossed above and below, filled with purpose-driven women and men buttoned up with a consistent formality that didn't exist back home. A whole army of resolve on the move, dressed for the part. Entire blocks rose in chunks of concrete and glass again and again and again from the bay to the horizon, their buildings separated by just a hair's breadth. Cars deftly negotiated alleys barely their width. Not a scrap of garbage anywhere. Little kids walked to school in shorts year-round, families bathed together, confusing food lurked around every corner. That first year I fell madly in love—with the promise of the cityscape, alcohol, language. But more than any of that, I fell in love with long walks, of being subtly changed by the lives I heard behind open windows. That very first shot in *Akira*— the one after the boom, the anonymous alley with the blinking rectangular sign—that image was seared into my mind and I spent countless nights looking for it (still looking for it now, a quarter of a century later). I had my heart broken more times than I could count, and drank myself into the pavement

just as often. When all you feel are deficiencies, accepting love from a person or even a place is like trying to fart yourself to the moon. So I kept my feet and body moving. Spent weeks hitchhiking from coast to coast, drinking, waking up on the floors of homes I had no memory of arriving at. Was given rides by lonely folks commuting on their own, with their own myriad deficits. They bought me donuts, they drove me to cafés on the side of the highway, they smoked slowly without saying a thing, they stared at their cigarettes and rolled the ash off in plastic ashtrays. I helped push a tractor-trailer up a snowy road just outside Hiroshima, nearly dying in the process.

And that was just the first six months.

I was very much a fool, flailing, overwhelmed, unable to process even the thinnest sliver of what I saw, but I recognize that even amid the confusion and blackouts, these were my first days truly out in the world exploring. Filling my brain with archetypes of people and social and political structures we never imagined possible.

● ● ●

Since then I've learned that Japan was once a country filled with remarkable pilgrim walkers. Pilgrims who'd regularly clock ten *ri* a day. One ri is about four kilometers. They were marked off by *ichi-ri-zuka* milestones—hulking mounds of dirt alongside the road. There are a few left to be spotted if you know what to look for. When I pass them I like to think of the millions who walked before me over the centuries and yell out to them—both the mounds and the dead— *ICHI-RIIIII,* for no particular reason. It just feels good and dumb and right.

The old walkers wore *waraji* straw sandals, bought for five *sen,* or five hundredths of a yen. A fraction of a penny. Blew

through a few pairs a day, the spent ones recycled as animal feed. They carried their lives on their backs. As my body complains on my own walks, I keep these strong men and women in mind.

Given time, these roads shift. A shed–sized Baptist church appears, a hill is now neatly covered in concrete, a home subsumed by kudzu. Historically, many of these roads have been reconfigured by capricious war machines. Cities reduced to ashen frames. A city that was bombed? You feel its aborted history in architectural blandness. A loss of something bigger than the city itself. But alongside that loss, even today, a connection to the deep past *can* persist. A nearby, previously dilapidated and seemingly abandoned woodland shrine is suddenly, mysteriously, renewed with fresh, glowing timber.

. . .

I've walked these Peninsula roads before, many times. Over and over I've returned to Kii, a place disappearing before your eyes from depopulation, and yet a place with an incredible,

beautiful, inspiring history of syncretic Buddhist and Shinto theology and philosophy. Visiting now—while those who knew parts of the old Peninsula are still alive, while some of the old shops are still around—feels paramount.

I've come to crave the solitude and asceticism of these solo walks. There is no quieter place on earth than the third hour of a good long day of walking. It's alone in this space, this walk-induced hypnosis, that the mind is finally able to receive the strange gifts and charities of the world. If that sounds like woo-woo nonsense, it feels even more woo-woo to experience.

On certain stretches of this battered peninsula, when the quiet and light are just right, in those eerie hours of the walk, I'm reminded of you, Bryan—and how we stalked backyard ravines murky with sewer water, turned whatever scrap we could into treasure, lived as soiled dukes behind our broken town, stinking of crabgrass and skunk cabbage.

Had someone told us back then that the key to it all lay in deliberate repetition, we would have never believed them. Told them to f' off. We knew better, always knew better. (And we *did,* in a way.) But it's true. Damn, it's true: I've come to realize the only true walk is the re-walk. You cannot know a place without returning. And even then, once isn't enough. That's why I'm back. Back on the Peninsula. Walking these roads I've walked before. It's only through time and distance and effort—concerted, present effort, controlled attention, a gentle and steady gaze upon it all—that you begin to understand old connections, old wounds. That the shape of once-dark paths becomes clear.

WATCH SHOP

Up ahead, an old man leads a group of even older women. They're on a local temple tour and stand in front of a roadside altar about the size of a food truck. Come, come, he motions to me.

We place our heads next to one another's—the closest I've been to a stranger in months—to peek through the structure's narrow wooden lattice. He speaks almost as if trying to kiss my neck—hot breath on the ear felt through his mask—launching into a reverie directed toward the dark interior. Points up to the old beams, lays out the history of the statues in broad strokes. These figures, he says, pointing to the buddhas, are for salvation. And these figures—his finger now lingering over the *jizō*—are for lost children and travelers. Women who have had miscarriages pray to them. And walkers, for a thousand years, to the same ones.

Damn, you know, I begin to say as we pull our heads from the darkness, I love this stretch of road, the Ise Kaidō. Just three days or so of walking but it's charming, in a way. His gang of blue-permed ladies listens intently with big smiles from a COVID-safe distance. I've walked a bunch of Japan, and this road is quiet, unexpectedly well preserved, hasn't yet been completely transformed into a string of pachinko parlors or chain ramen shops or big-box pharmacies like some of the other roads.

Yes, he says. Well . . . this wasn't firebombed during the war like the industrial areas up north there around Nagoya. So this road—the Ise Kaidō—is in good shape.

He then asks, What is your country?

I chuckle because I am nervous and embarrassed and to

defuse the tension of what I am about to say, and then say (because it feels like it can't be helped, so why not introduce it all sloppy and naked and true), Unfortunately I'm from the country that did all the firebombing.

He laughs.

It's just . . . unimaginable, I say, standing here now, chatting with you, that any of that happened.

Strange thing, he says, history. The mess of our past, still touching us today. Far back now, far back, can't be helped.

He was being kind, demurring, tempering my clumsiness. But for nearly eighty years, the airplane-engine factory employed most of our town. My grandparents met there. My parents met there. Bryan, I know you had family there, too. Everyone did.

That factory stoked a hundred thousand homes. Gave my grandparents a great life. It was also the factory that made some of the engines that powered the planes that firebombed these towns. The Wasp and Double Wasp, air-cooled radial engines. My grandfather—a man who had the profile of a Shakespearean actor with kind eyes and a large elegant nose, flat-footed, high-school-educated, a guy who joined the cheerleading team to watch football games because he couldn't afford tickets—would have been there, working the floor near my grandmother, on the days the firebombings happened. Both widgets themselves in a system of baffling scale, working one of the only jobs in town. My mom wasn't born until a decade later. Who knows what this tour guide's dad did.

Those firebombings of Japan were lunatic and indiscriminate, incinerated sixty-seven cities. Over half a million dead. That's like everyone in our town killed, ten times over. Kyoto was saved by consequence of a lone man high up in the ranks and his recognition of its cultural import. No city's fate should rest upon the whims of one man half a world away. But it did.

It did rest on the whims of one man. Too much power, too arbitrary. I feel this in my bones on the walk. The walk—its slowness, talking to those who remain, walking through those cities with suspended timelines—shows me this in a way nothing else does, these gradients of past violence, this plain-spun stupidity.

And yet, here today we stand as two men without malice, some eighty years after all that tumult. Then, two countries colliding in the most horrible of possible ways, the worst of timelines. Today, with a benign life-affirming dorkiness, a shared interest in history and old roads. Me, a goof, alone, walking a largely forgotten stretch of road (I've never seen another person walking the entire Ise Kaidō), and this guy leading some retirees on an afternoon jaunt. It was enough to make you believe things might be OK.

I bow to them all and shout, Sorry to have interrupted your tour! And they all titter and—mimicking typing in the air—say, No no no! Have fun on your walk and write about this! Tell people about the Ise Kaidō!

...

Hours later: pouring rain, hiding in a café. They serve cake like we used to eat—angel food cake. Simple and light. The only cake I remember us eating as kids. Did our parents know any other? Made from a box mix, hard to mess up. Here, I'm sure, whipped up from scratch. I order it with an excited chirp. Records line the back wall of the shop. There is a mismatched wooden furniture aesthetic. Behind the counter stand a husband and wife.

High on coffee, I chat with the owners. They look thirty. Turns out they're both about forty-five, opened the shop some sixteen years ago. They'll end up being two of the youngest adults I see on the whole walk.

The husband pulls out a photograph. Take a peek at this,

he says. My grandpa standin' out front. This was his place, he says with no small dollop of pride. A watch shop. Ran for two generations, almost a hundred years. Shut down twenty back, he says. Left all empty and musty. Seemed a shame. So my wife and I cleaned it up, started this café. Zero training, two rookies, he says, chuckling, just dove straight in.

...

Later, I walk the day's last few kilometers headfirst into driving rain and the wind races past my ears and turns the world into a white-noise machine. I think about war and erasure. Of how a single cypress pillar in the center of a home has seen a story spanning centuries. Of how bombs turn that history to smoke. Of how you feel the ahistorical newness of the architecture in a targeted city like Nagoya. How it feels laden with a cultural and memorial poverty. How other cities—cities like Nara, cities untouched by war—contain tapestries of life, history, tradition in their wooden structures, the delightful circuity of streets, their generationally helmed shops. And as I walk I can't stop thinking about what is or isn't left on the road beside me. What did or didn't make it. Cakes, roadside shrines, broken video-game tables, too-sweet iced coffee, still here— but why? Suddenly the landscape seems so fragile, so easy to imagine all of this gone, emptied out. Just wood and memories and dwindling stories. Char the wood and remove the people and those timelines terminate. But on my right is a working rice farm, dirt turned over for a century, and on my left a prewar dry-goods store, still displaying rakes and bamboo brooms. And, behind me now, beyond the fields, a well-loved café run by a grandson and his wife, giving new life to an old watch shop. A shop saved by chance—by dint of a handful of kilometers, a centimeter on a paper map—from bombs, fire, violence, annihilation, the mess of our past.

OBJECTS AND ARCHETYPES

Bryan, what did we want as kids? Oh, we wanted a gun—a Colt M1911. It was in our blood and the air; the Colt factory just down the road. We wanted that gun and we wanted a laser sight for the gun and we wanted dirt bikes. I remember us sitting on the school bus in the winter, vinyl seats covered with smooth lighter burns, fingering basic math on fogged windows, calculating the number of years between then and owning those things, and how crestfallen we were realizing how long we had to wait. Laws, dumb laws. *Come on,* just let us *have* 'em. A gun . . . a laser sight . . . a dirt bike. I can now see that those objects represented power, technology, mobility. Three things we had none of. Neither of our families could afford a computer, but we had a Nintendo and *Zelda.* That got us a good part of the way somewhere. A single golden cartridge containing that greater sense of more—a wider world. An object with an incantation: "Made in Japan." A place farther away than we could ever imagine. It exists, and it makes these objects of delight. That's what the cartridge said. Is that where Japan gained purchase in my mind? Perhaps. It is certainly my first memory of somewhere *else,* made concrete through an escape that was a game. In the end, we never got the guns (though many around us did), or the laser sights, or the dirt bikes. But we played that game, we knew its world as well as we knew our backyard ravine. Both, worlds that couldn't hurt us but we could master—the game and the ravine. We knew them as well as we knew which streets in town to avoid. There, on our small TVs in blocky pixels was a map, and even today I remember where to bomb for the secret caves.

...

I often think back, Bryan. Who surrounded us? Some good folks, yes, but also many stuck folks. My mom's boyfriend lived in a trailer park. Who did I want to shoot so precisely? Not him. He was bearded, a truck driver, usually kind. Someone who skirted but never quite ascended to the role of father figure. He drank. Others drank. Around us: a troupe of alcoholics trapped in tiny, constricting loops, in varying states of struggle and confusion. My father—my adoptive one, the only one I knew, that guy I saw now and then for just a few hours—taught me one thing in the entirety of his life: The floor of the movie theater is the garbage. I must have been five or six. We were seated, waiting for the movie to start, eating Sour Patch Kids and hotdogs. He was hearing-impaired, and so everything was yelled. LOOK, he said as he threw half a hotdog onto the floor, THE FLOOR IS THE GARBAGE. SOMEONE WILL COME AND CLEAN IT UP AT THE END OF THE MOVIE.

He was so proud of the move, considered it a great insight, valuable knowledge: The floor is the garbage. That's it. I've racked my brain as I walk and walk and walk and can't think of anything else. Could it be, a decade of teaching in one sentence? Mostly, I remember anti-patterns. Teaching in what-not-to-dos. Once, at a red light, he rolled down his window and whistled at a road biker in spandex. It turned out it was a guy, gave us the finger. I nearly burst into flames. But my father just hooted: ASS LIKE A WOMAN, FACE OF A MAN! and drummed on the steering wheel. A high school graduate (I think?), obsessed with horse racing, he made terrible sounds from deep inside his throat when Samantha Fox appeared on TV, and farted unrepentantly (often in the movie theater, often sending people around us gasping, running). This was

not a man who made laws to govern our world, not a man who could fix things. He hadn't the slightest idea of how garbage worked, let alone life itself, let alone how to unlock its mysteries, to be delighted, to be metacognizant, to present anything to us kids other than those anti-patterns. Soon after the wedding, he announced to my mother, IN THIS HOUSE WOMAN I AM JESUS CHRIST. Thankfully, my mom had the support of her parents and good sense—their legal arrangement lasted just a scant few years.

I want to go back and shake that skinny, flatulent man (so many irrepressible farts—I mean, you simply cannot imagine the fartage) and say, Dude, the floor is not the garbage. Say, Hold on to that shit and throw it out properly. Impart a little pride or valor on the guy. Clearly no one else ever had. He remains in my memory a constellation of deficits. But the more I walk, the less I can blame him for his deficits, his extreme defects of personality. This father of mine had no positive archetypes. Bereft of love, he was born into a scarcity all his own. Born into the curse of the town. His own father also hardly educated, alcoholic (and then his stepfather, the same, almost a clone). Contributed mainly violence to a threadbare childhood. I had none of this blood in me, the blood of these violent, small people. And yet—and yet (and yet (and yet))—goddamn was I worried it was there, somewhere under my skin, the hint of their fuckery, the stink of those farts. Osmosed from the fumes of the town? How could I be sure I was free?

So I walked. I walk. I walk and I walk and I walk and feel the air of our town leave my cells and be replaced by the air and ideas of a different time and place. The more I breathe this Peninsula air, the more I realize that it would have been so easy to have elevated my father as a child. This shocks me, the first time I feel this on the road: the space in

my heart for forgiveness—forgiveness! The moment I felt that was like getting hit in the head with a basketball—a freakish *pang,* a dull ache in the skull. I almost fell into a bush. I was hyperventilating—realizing my heart had expanded in some immeasurable, beyond-physics way that hearts can expand, and in that expansion I had new space. There's a word in Japanese that sums up this feeling better than anything in English: *yoyū.* A word that somehow means: the excess provided when surrounded by a generous abundance. It can be applied to hearts, wallets, Sunday afternoons, and more. When did this happen to me? This extra space, this yoyū, this *abundance.* Space that carried with it patience and—gasp—maybe even . . . love? For a guy who provided almost nothing? These are the shocks of the walk. The walk makes me better than I ever imagined I could be (and in this, too, I see how good you could have been). Better than anyone showed us we could be. (Far better than who I was earlier on.) Stability, a bit of care, is that all it takes? The most basic of resources. But these were resources we didn't have, and guys like my dad never knew. How could my father's parents have felt yoyū when they themselves were pressed against the wall by economic circumstance, by political flops and failures? No one in their circles had seen a child elevated in decades. Enough time passes and you forget how to do that shit.

As I walk the road, more and more clearly, splayed in broad strokes: I see how our traumas and ignorance were carried forward through generations. My heart opens up for all these people of our past, our town. An unwitting meagerness nesting to the core. No notion of yoyū in sight. Somehow, early on, I decided the only way out of our quagmire was to leave. Heck, believed we *could* leave. I remember now, even at age eleven or twelve, making a promise to myself that we would get out. I would get myself out and pull you, too. I'd remove

us from the hexed equation entirely—the equation of the town, the country (for how could a country that let this happen to a town be trusted?). Building on a courage you gave me simply by existing, I began cultivating an independence to set off far away without a map or guidance, praying a mind could be reconfigured. Feeling the tininess of my heart as I hit the road. Feeling constricted by that. Wanting to expand it, to do better. Wanting to show all of them how it could be.

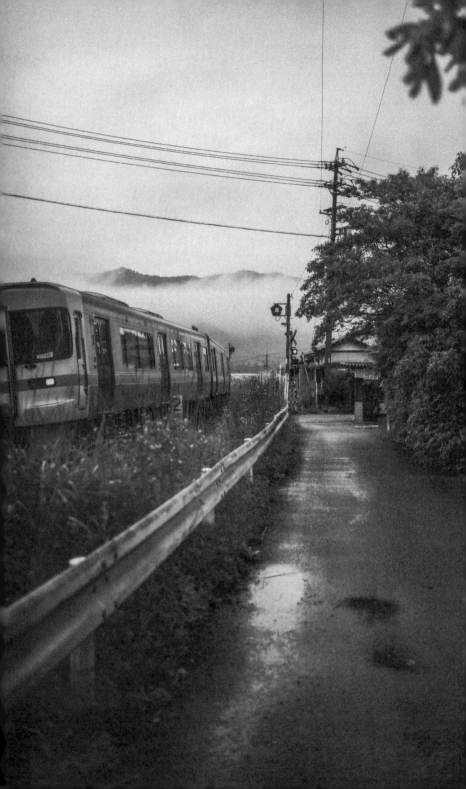

THE OWNER OF AN INN

I walk and my steps take me over the local train tracks. I see the old sign for tonight's inn hanging off an awning—a classic wooden Japanese building with a tiled roof. When I slide open the glass entrance door, the owner comes scampering down the stairs. Wish I had a video of him to show you. He's dressed in pale khakis with a brown leather belt and a tucked-in button-down blue shirt. Up and down the stairs he goes in stocking feet. He uses all four limbs. He bends in yogic ways. He's in his seventies and blurts out to me when I arrive, Well *shiiiiiiit,* on the phone I thought you were Japa-*nese.*

Everyone else canceled. The perks of pandemics. I've got the place to myself. Built in 1865, or maybe earlier—he's vague about the founding year—and still going. Far enough away from Hongū to have avoided the river floods, far enough away from the ocean to have avoided the tsunamis, and far enough away from Nagoya to have escaped the bombs. A Goldilocks position. Nothing to make it a target, no soldiers billeted here during the war.

Each time I return to the Peninsula I try to add more inns, more stops, try to touch it all but know I'll never be able to. I had never stayed at this inn before so I didn't know what to expect. Called yesterday to confirm and the owner answered like a mechanic punting an oil change. Said, Hey boy, you know, I don't really feel like cooking dinner tomorrow, you mind working that out on your own?

I laughed and said, Sure. So that's the plan, later—to "work it out." I got cup noodles. He's got boiling water. We got it covered. It seems great though, the inn. I've been given a high-

ceilinged, ten-mat *tatami* room on the second floor, looking out over the valley, and the shared toilet is tiled in a colorful mid-century, Shōwa-era kinda way, not unlike Howdy's.

I smoke in my wicker-chair-appointed alcove by the window and watch the express trains blow by. A hundred years ago parts of the inn were moved to make way for those tracks. They cut right through what used to be an impressive garden. Some buildings were lifted whole hog and shifted a bit. Paid for by the rail company. Why they didn't shimmy it all a bit more is a mystery because, holy smokes, do the trains cut close. Close enough to swirl the air in your room—*CH-CHUN-CH-CHUN-CH-CHUN*. Earplugs a must. Wake-up call five thirty on the dot.

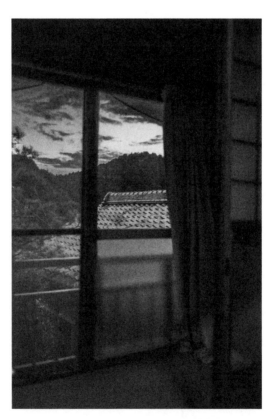

But trains be damned, the loose-limbed owner is grand. Just wants to gab and gab.

Over drinks at night—me, sparkling water; him, whiskey—we talk. I find radical honesty about my past to be the quickest way to build intimacy. To lower a maybe not-so-emotional guy's defenses. These inn owners are often adoptees, pulled from outside the immediate family tree to keep the name going, the line "unbroken." So I tell the owner how I, too, was adopted right after birth. Popped out and into the hands of a mother and father who couldn't conceive.

As a trade, he tells me that his beautiful wife is dead. He misses her *tonkatsu* pork chops. He uses her shampoo on his head of thick curls. Still whispers goodnight to her as he shuts the inn up for the day. The more he speaks, the more he drinks. He sidles up, thigh-against-thigh, holds forth at length. Outside, the rain comes down in sheets. Fills the room with storm energy. You got a real shit sandwich for weather, he says with a savage grin, pouring himself another drink.

. . .

How does it feel to be adopted? It feels like floating off. Like floating off in your own little bubble apart from everyone else. A bit lonely. A bit distant. A bit mythic—yes, there's a mythic quality to adoption. That ever-looming mystery of origin. But as with the protagonists of many myths, loneliness is part and parcel. The generous people who took you as a swaddled baby love you, sure, but there was and always will be a handoff (for whatever reasons, reasons often unknown). You didn't come from us, aren't made from us, but we still love you—your parents say this to you as a child. Does the child understand such a thing? No way. That information: a slap. Wait, if I'm not from you guys, where am I "*really*" from? It's a question so obvious and elemental that it inhabits the cells of the

body more than the mind. It tingles all over, this fact-induced distance. And it hurts.

And so: You form your bubble, unconsciously, to protect yourself against that pain, and begin to float off, create your own universe, wondering all the while where you "*really*" came from.

In contrast, the history of Japan is filled with great adoptions. Known adoptions, where provenance is never a mystery. Edo-period samurai families often adopted young men for the same reasons as these inns: to keep their family lineage "unbroken." And not just samurai—politicians, entertainers, artists, and more. Hideki Yukawa, Nobel-winning physicist, was so promising that his middle school principal offered to adopt him to ensure his scholarly success. Later, he was formally adopted into his wife's family—her father had no sons—and changed his name.

One day, a kindly-looking old man with an unusually refined flair for fashion sat at the table next to mine in a café. We started chatting. Turned out, he had been the CEO of Mikimoto, the famous pearl company. Had married the daughter of the previous CEO, was adopted by the family, took *her* name. She died before he did, and the family made him legally relinquish the name late in life. His business cards—now for no company in particular—still read "Mikimoto" though. I guess in his heart, that's who he felt he had become.

Adoptions like these expand a family like soft flour added to wet dough. New individuals folded into older, often more powerful households. Change a name, take that oath, expand that circle, carry that tradition, that space, that idea forward. An exchange sometimes worth committing a life and body and name toward.

In these examples, provenance is clear. But for me? Like looking for coins in a murky pond, as a kid I dreamed of who

they might be, those blood people of mine. Others around me sometimes showed what was possible, how that connection might feel. I envied your Christmases, Bryan, which were larger than our four-person affairs. At your house: a mom and dad, sisters, cats, aunts and uncles, all gathered around the table and tree. A real tree (ours: 1970s, plastic, inflammable, stabby), chopped and hauled, pine needles covering your father's hands and then later, in January, the wooden floors. None of these details were lost on me. The whole notion was idyllic. Each year you invited me and each year I begged my mother to let me go. Just to observe. I'd be an adoptee there, too, but one swaddled in a vitality we just didn't have (despite my mom's concerted and genuine efforts), our tiny family, my quiet grandparents. I would have cut off a leg to sit in the corner of your home, soundless, motionless. To bask in whatever shape your lives took on. To try to understand a fullness I had never known, to wear it like a suit, even if just for a moment. These are the simple dreams of the adopted.

But I never did go. (I mean, I'd go later that afternoon, and you'd come over, too. We'd compare gifts and I always hid half of mine under the couch because I know you didn't get as many as I did.) Instead, I pestered my poor mother with complicated questions of provenance. (Some part of me hoped the story would change if asked enough, as if I could will a new history into being.) Again and again, she explained how I came from outside. Often explained in front of that trailer-park boyfriend, who seemed conflicted—bemused by my confusion but also upset that I didn't embrace him unquestioningly as a dad, leaving me riddled with guilt, making these very topics taboo. I wanted to believe that babies spontaneously sprouted like seedlings in bellies on honeymoons. No no no, my mother explained, you've never been to Hawai'i in my belly. I'd never been embryonic inside her. Someone else

carried me. Someone nameless, faceless, someone pregnant at thirteen—thirteen! (The only real detail we had from the adoption agency.) A reality I couldn't imagine and wouldn't be able to empathize with until much later in life. As a kid it was all so abstract—pregnancy itself, the mechanics, the ethics. You cannot ask an adopted child to process all of this. (To make things even more complex: My mother saw the adoption agency call as coming straight from Jesus himself, often told me just so. My questions then not just an affront to the boyfriends, but also to the son of God himself.) And so wrap the facts of adoption in as much sweetness as you want, it's still a slight, one that is confusing, one that—without more discussion than you might think—the adopted child is inspired to push down deep into the gut. Floating off. A bit lonely. A bit distant. Mythic to the max.

. . .

Just before bed, the owner of the inn tells me of the workers who used to stay here. The Peninsula is mostly an unyielding mass of crumpled earth. It's from this complex topography that the Peninsula divines its history. The mountainous inaccessibility allowed Buddhism and Shinto to stay mixed even after nineteenth-century edicts demanded their separation. And it's from this mix—preserved even today—that certain paths and places of worship were granted UNESCO World Heritage status. The only pilgrimage routes in the world to have World Heritage designation are the Kii Peninsula's Kumano Kodō and the Camino de Santiago in northern Spain. If you walk them both, and collect the right stamps, you get a special, dorky, fabulous pin. (Of course, I have the special pin. I mean, come on.)

The owner tells me that few roads bisect this landmass. It's easier to circumscribe, as many of the old routes do, he says.

When the government set about bringing some semblance of modern infrastructure to the Peninsula, they settled on a coastal highway and railway. The workers built and blasted in the 1920s and then fleshed out the bypasses after the war. Even now, the final pieces of the incredible Peninsula bypass are being laid in the south near Shingū. For decades this inn served mainly these men, he says. They stayed for months at a time, a few becoming something like family.

The owner has seen much, moves in unexpected ways, carries someone else's name. His wife is gone. His head smells of flowers. Whiskey on the breath, he laughs loud and hard and has traveled far from who he once was.

JOHN

If I know anything about anything in these pages here, it's because a mentor, a friend twenty years older than me—someone you might have hated at first (that suspicion, deep in both of us, rightly so, toward elders) but would have bonded with soon enough—brilliant but secretly crude, kind and patient, but also a man who takes absolutely no shit, who has crushed competitors in global business and elevated young artists around the world, a man named John McBride, a man who has walked Japan for forty-plus years, speaks with an elegant fluency, charms all those who cross his path, this man, this sort of wizard of walking and history, he showed me how to walk.

We first met when I was twenty-seven. I had just finished a book called *Art Space Tokyo,* about the Tokyo art world: a beautifully produced survey with essays and interviews and illustrations with a refined polish that—even to this day—shocks me. That the editor and I were capable of producing such a thing—pulling all-nighters for weeks and months in my twenty-square-meter Tokyo apartment that overlooked a palm tree and a parking lot, with a budget of nearly nil—is a testament to youthful tenacity and hubris. John was involved with the art world but not the book, and we had never met. A mutual friend introduced us. We sat down for breakfast and didn't stand up until five P.M. My writing of that book unlocked a connection. (Throughout life I'd marvel again and again at the power of writing—and writing books, especially—and how all my most treasured friendships were grounded, somehow, in published words.) Over the many intervening

years, his knowledge and generosity has elevated me like he elevates everyone. This elevation I call "the John Effect."

I first spotted the John Effect on a train to Kōyasan. Our carriage was empty. We were heading to climb the Chōishi-Michi: an old mountain route leading up from Kudoyama to Kōyasan's Daimon gate—our first walk on the Peninsula. A trail with stone markers (the *choishi*) every 109.09 meters.

A few stops in, an old guy hopped on. He sat near us and leaned over and said something to John, perhaps in what he assumed to be our mother tongue. I was sitting opposite and the train was clacking and screeching away. I couldn't make out much, really, so I was only able to *witness* the transformation induced by the John Effect from afar. John spoke. The man's facial muscles softened and softened more. John continued. The man's shoulders rose, his smile grew, he became ebullient and animated. By the time we got off, I thought that he might stand and salute.

The second time was just a few minutes later. The station of our disembarkation was barely more than a shack. The middle-aged attendant—uniformed with a crisp cap—came out and John began asking questions. Now I could hear: simple questions about the station, then the general locale, then the old route itself, the twelve-hundred-year-old path we were bound for up the mountain. With each expansion of scope, the attendant leaned in closer and closer still. A local wandering past, wearing a baker boy, came over, intrigued, listened, leaned in. John's questions became more technical, more historical, academic. Revealing, slowly, his encyclopedic interests. Did so-and-so emperor *really* stop by this rock, four hundred meters up there? Did this *daimyo* pray for years by this tree or that tree? It was pure gibberish to me but mana to these folks.

You must understand: The questions were delivered not

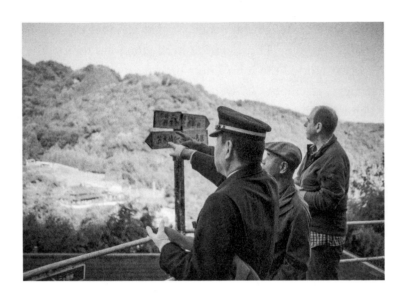

just with total fluency, but also an edge of the imperial. That is: John raised the station of all he spoke with in the *way* he spoke. His language was inflected with forty years of tea ceremony, forty years of running businesses and negotiating tax deals and wiggling out of parking tickets. You can do this in Japanese: Choose to modify the conjugation of verbs, choose upper-register words, make choices sometimes overt and other times sneaky, but choices that convey a deep respect. The power of these choices commingling with his deep historical knowledge was a wild one-two blow to all who crossed our path. Caught so off guard, they'd flip over the swing set of disbelief. Vibing out on the ride John took them on through time and language, blissed and delighted, total converts, absolute allies.

I'd go on to observe this a hundred more times. My own language changed—the very shape of my brain itself felt like it changed—bearing witness to this thing, this undeniable effect. Bryan, you and I grew up with nothing like this in our periphery. The core of the John Effect is deceptively simple.

An archetype of speech and being that we lacked: respect mixed with a fervent curiosity colored by a deep and profound emotional intelligence. A state made possible by boundless yoyū. Just *believe,* John seemed to say through word and action. Believe that through the power of respect you can convert someone to your side. John also *seems* to take nothing personally (though he keeps a secret ledger, of course). Back home, I don't think we ever saw someone rise above personal affront. All the fights in our town, superficial fights. One-dimensional chess. John showed me how to operate on another plane, to not play the game at all. We once got in a countryside cab whose driver seemed wholly against our patronage. Tried to wave us away, crossed his arms, spat some balderdash, squinted with disgust. Had I been alone I probably would have kicked his door and given him the finger. But, no. In a blast of benign elegance that would have made the Dalai Lama swoon, John ignored all that and elevated the poor bastard with beautiful language. By the end of the ride he had given John his card and offered us the fare *gratis.*

I still walk with John. I'll never turn down an offer from him to walk together. Though more and more, I walk alone. As much as I learn from John, I can only "see" the road when I'm alone. When walking with someone, the voices in my head are quieted and I miss the chance to turn inward, which is a primary quality and primary purpose of a solo walk. That inward turn. A little mental pirouette that's tough to pull off in the normal day-to-day. Walking with John feels like attending a class. The best kind of class with the best kind of teacher. Walking alone feels like putting into practice all that John has taught me. So: different acts entirely. I can only walk alone having learned how to walk, how to look at the world with abundant generosity. And even now, as I make my way down the Peninsula, John tracks my GPS coordinates, sees where I

am. Each day he sends me a little note with the day's history. Little facts about what's coming up. I have ten years of these notes. I call them the "Book of John."

I can write all this down and you still won't understand. Had we discovered a "Book of John" when we were kids, would it have changed things? Probably not. The "Book of John" is an extension of the John Effect, and the John Effect is something that will never make complete sense in words. You may get the gist, but it's only by witnessing it, again and again, that you believe it. You really believe it's as simple as: kindness, curiosity, generosity. Yoyū. Just a bit of goddamned yoyū.

IPPON-URA

And so I walk these historic roads, but also many just-off roads. Roads I've nicknamed *"ippon-uras"*—roads behind, roads less traveled, roads a degree beyond. Some pieces of the official routes—parts of the true Ise-ji, Ise Kaidō, Ōhechi, and others—can be stultifying, jammed with trucks, having been turned into highway bypasses, stripped and rebuilt and stripped again. I'm not looking for pure walking romance, but those throughways sometimes tax your sanity. So my love for an ippon-ura often borders on irrational. I'll waddle through a newly tilled field, black earth like quicksand, to get to one. They are, in many instances, the preferable route.

The joy of the ippon-ura lies in bearing witness to lives being lived. This, a core tenet of a good walk: real-time observation of unfiltered life. Without the din and trundle of big-road engines, you hear baths being drawn, children crying, a television relaying the day's news. You poke your head into a barbershop and catch a potbelly flanked by murderous implements, asleep in the chair.

Walk these small back roads, do so for kilometer after kilometer, day after day, look closely and closer still, and you might pick up on the people and patterns of a general area. I wouldn't go so far as to say you'll "know" or "understand" it, but I would say that walking—and walking slowly and deliberately, alone—is probably the first step to familiarizing yourself with a place.

· · ·

Today, Bryan, I found a circuitous ippon-ura that made the whole damn day—a few klicks of elevated footpath between

glistening rice paddies around a strange and sudden hummock. A piece of land you could circle in ten minutes, bristling with bamboo and cedars, no shrines, no homes, just earth left as it was—unleveled, unused, surrounded by fields. An "island" that, had we grown up here, you and I would have most certainly made claim upon—carved out secret hiding spots and called on each other to congregate at dusk. Together, we'd have held unorthodox sermons, passed suspect knowledge back and forth, dissolute wisdoms. We'd have proffered answers to all questions tobacco- and firearm-related, offered illicit trades, administered solemn blood oaths, snickered at stolen pornographic photographs.

Gratitude for these memories knocked loose by the road. By an emptying countryside. Each walking day, a series of ecstatic moments, sad moments, lost moments. My mind bouncing between the crumbling asphalt of our town and the newly poured concrete of this peninsula. Even as the Peninsula's population disappears, the infrastructure is maintained.

The "Book of John" chimes in with a poem about walking these roads, from an 1169 anthology of poetry by abdicated emperor Go-Shirakawa:

Which road to Kumano is shorter
The Ki-ji road or the Ise-ji road
If it is a pilgrimage full of compassion
Then neither road is far

I cut from an ippon-ura back onto the main Ise Kaidō path and pass a knee-high stone marker. At first glance, just a rock. But a rock with deliberate shape. A deliberately shaped rock with chiseled directions. The faint remnants of weather-smoothed logographs, Chinese characters. A centuries-old

signpost for Ise Grand Shrine. The kinds of markers that probably belong in museums but here are left by the road-side where they've always been. They reveal that once, long ago, others also wondered which way was correct, which path might be the better road.

Death is all over the Peninsula. There's rarely a walking day without its visible imprint. This was a place of great pilgrimage walking for over a thousand years. Its inaccessibility made it all the more mysterious, more dangerous, more spiritual. (Danger and spirituality seem to be in constant conversation with each other.) A blithe hunk of earth called Kii on which you had to work to gain entry.

The day's "Book of John" arrives with a language and history lesson: Inside of Kii, in the center of the Peninsula, is an area called Kumano. This is where the Kumano Kodō gets its name. In Chinese characters it is written as 熊野. The original character for *kuma* (熊) is 隈—nook, corner, recess. A recessed space. *No* (野)—undeveloped or virgin, the wilds. The recessed wilds.

John writes that a dude named Alan Grapard describes the

area as a "natural mandala." Says it's a geographic area endowed with "all the qualities of metaphysical space." Says a mandala is a spiritual map symbolizing the Buddhist world, imprinted onto a real place.

Although I'm walking roads, I'm also walking this map representing things beyond what we can see. A layering deeper and weirder than we ever dreamed.

It's easy to imagine how death finds a home here. Millions of walkers over a thousand years. Tough terrain. Poisonous snakes. Angry boars. Bears—those, too. Sometimes walks beside cliffs sheer enough to induce horripilation—views of a death so grim that your hair stands on end.

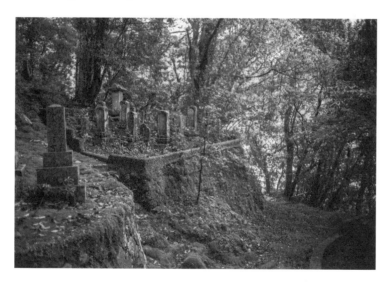

The ashes of so-called fallen pilgrims lie near Owase, a graveyard neatly carved into the mountainside, their markers weathered flat and covered in moss. Stained cliffs mark the high-water lines of past tsunamis near Kushimoto, showing precisely how high the water had gotten (so high, so much higher than you imagine) after tectonic plates deep below swayed a few cosmic inches, sent ripples the size of aircraft

carriers across the ocean. A stone record at Nagashima Shrine reports the precise number of people washed away hundreds of years ago, and then a hundred years before that, too.

On the general matter of death, I'm sad to report that my thirtieth year on this planet was truly bonkers. A vortex of familial expirations. My grandfather passed—the long-retired factory man—and then two months later, my father, that far-off guy whose birthday I had never memorized. And four months after that, my grandmother. The family was small to begin with, and then they all dropped, the ones closest on the tree, near simultaneously. Half a year, just like that—a death chord.

By chance, months before those funerals began was when John invited me to the Peninsula. Not only had I never been, I had never even heard its name: Kii. What a word. A bit sneaky, that extra "i." An English speaker tends to chop it off, staccato the word to death, but in Japanese the double "i" persists, if only subtly. The slightest elongation, a micro-extension indicating fluency and understanding. Details like this make me shudder, the world so damn particular.

That Kii invitation was for me to spend a few days around Kōyasan, the 1,200-year-old Shingon Buddhist temple area smack west of the center of the Peninsula. Founded by the brilliant Buddhist scholar posthumously named Kōbō Daishi, who in *gumonji-hō* meditation (a meditation where you recite a mantra a million times) adopted the name Kūkai: air and sea. This man of air and sea willed into being this place of secluded rock and wood. Secured the funds from cinnabar (mercury sulfide) deposits on the central Peninsula to hire the workers to haul the materials, to build the temples in a time when doing so must have felt as fantastical as living on Mars does today.

Disembarking from the cable car felt like stepping into cra-

dling hands of stone. Mountains surround the inner plateau that is Kōyasan proper. The first organ to freak out was my lungs. This air, they screamed, this cool air in July, this air of life.

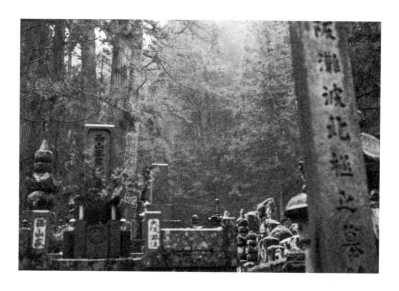

And then my eyes. Because—the fullness. Geez, did it ever astound—those trees! Those centuries-old cedars with gnarly bark. So thick you'd need a starting lineup of footballers holding hands to hug them fully. Reaching ever skyward, those graceful cedars formed a thick canopy up above, flanking the central path through the graveyard, the kilometers-long graveyard at the heart of it all. A graveyard known as Okunoin, surfaced with paving stones worn smooth by the feet of millions, home not only to the ashes of more than 200,000 people, of feudal lords and warring-states daimyo, but also to moss lush enough to lie down on naked and wilt in reverence. Our town was once tobacco and blueberry fields, ground infused with farming and industrial poisons, uncommonly high rates of dementia, violent impulses. Who knows what lurks in our blood? But staying in those temples, surrounded by sumptu-

ous life, I felt my body change in the way that pure nature changes bodies—the fresh inputs of mountain water and mountain vegetables flushing out the garbage I had unwittingly brought forward. I felt lighter. I smelled different; an earthy sourness. Above, a clear blue sky. The spaces between the leaves and needles of the canopy coruscated like daytime stars. Suddenly, birdsong was all around. A series of astonishments. These were feelings I'd carry through those funerals and further still. I didn't think much, but felt it all. In time I'd come to understand: Yep, I get why holy man Kōbō Daishi, ol' Kūkai, picked this spot.

...

When I was nineteen, moving to Japan may have felt temporary, was a somewhat arbitrary choice, but over time it has become an emigration, not an expatriation. Today, I feel nothing like an "expat," that word of extreme privilege applied to Westerners moving east, a word charged with connotations of asymmetric power, of non-permanence, of elevation above and immunity from local laws and customs, of your "home" being better, a place to which you'd *obviously* return. For me, Japan was the place of promise and opportunity built atop sensible legislation and social safety nets and functional governance. A shot across the bow of our narratives spun back across the ocean, the long-since-abased notions of freedom. How can you say that a country "loves" you without providing healthcare? When the schools are criminally underfunded? It took me a while to see this clearly, though. But the more I looked, the more my norms were reconfigured, the clearer it became: Here was a place where people were taken care of by the greater whole. I realize now what luck it was—what great privilege it was—to have access to this new country through a fluke, a quirk of university pricing, a

golden cartridge's impression, and my ability to qualify for an Artist Visa (one renewed for nearly fifteen years after university before converting to a permanent resident). I don't take for granted my being here for one second. I owe my life to this country.

Soon again after those funerals of my thirtieth year, another invitation from John. The Peninsula wouldn't let go. Come, he said, let's do the central walk of Kii, the recently UNESCO World Heritage–designated Kumano Kodō. Had never heard *that* name either. Although by this point I had lived in Japan for over a decade, I was still wholly ignorant of so much. Didn't know the old roads, didn't know Nakahechi from Kohechi from Ise-ji from my boots. But I learned. Suddenly, the months and years were structured around walks, many solo, up and down this peninsula, these very mountains, this very coast.

I had the language skills to communicate with everyone I passed, to hear their stories. I didn't yet know what I'd do with those stories. Over time, my solo walks became tools, platforms for thinking, for drawing the wider world in closer and making the inner world visible. Death, also, was made palpable. That far-off triplet of death I had rushed through (and I *had* rushed through it, much like I had rushed through other deaths in the past)—I began working it over on the road.

The Peninsula and death, stuck together in my mind. Layers of the Peninsula itself, too, now dying before my eyes. Much of its lumber and fishing industries have moved to China. The countryside of Japan is aging out of existence. There are few children to be seen. Peninsula villages wink out in real time. Shops are shuttered, battered by storms, broken windows left broken. Cars rust in ditches. The newest buildings you see are freshly poured concrete tubes looking like Tadao Ando

architectural installations. But they're just government-funded tsunami escape towers.

I think of the people who died making this place habitable. Moiling, chopping through the verdant forest—thick, lush, unyielding—homesteading, carving rice plots out of mountainsides, building all those drystone walls to keep out the boar and deer. Now dead, those people. I pass them each day on the walk. Ashes in cemeteries they themselves hacked into rock.

THINGS BECOME OTHER THINGS

Boy, you . . . drink?

He was seventy. Spoke haltingly like he may have suffered a stroke, though drove confidently down the dark mountainside roads. He was taking me back to his *minshuku* bed-and-breakfast after a wet thirty-kilometer day and a pit stop at the local public bath. Twenty minutes after meeting, we were soaking together in a giant tub with farmers and construction workers. Now the two of us were pleasantly cooked, radiating heat in the cab of his little truck. Dinner was on his mind, and so: Boy, you . . . drink?

Not really, I say.

Oh. Damn, well, that's . . . okay. Got . . . a lotta beer.

And then after a few seconds: Wait, you . . . a . . . a beer man?

Not really, sometimes, I mean, I used to drink tons.

Just then, a deer ran across the road; *Run run, don't you get hit!* I say to the darkness, laughing.

You got . . . good eyes! he says. Most folk . . . today . . . can't spot no deer at . . . night. So you . . . a *sake* drinker, then?

I was getting embarrassed. Considered breaking sobriety to simplify things, but eventually say, No, sir, no sake either.

Then, what . . . you . . . want with dinner?

Maybe some, I dunno, cold barley tea?

And, you'll go . . . cut that with *shōchū*?

Nope. Just boring barley tea. Or even better, water.

Oh, well . . . we got good . . . water.

I think I broke his heart. I think he wanted a drinking buddy.

His wife cooked up enough food for four people. I know this because she says: I cooked for four. I am the only one staying the night, the only one eating. She offers me a spread of some twenty pieces of tempura. A hot pot that could feed a sumo troupe. Tofu. Pickles. Half a kilo of rice. They keep chanting, *Get fat! Get fat!* I laugh as I shovel food into my mouth, imagining them as cannibals. In reality they are old, retired, bored.

A giant cockroach flies into the room. I shriek. The wife's hand snaps out, crushing it with her palm like a leaf.

The water from their well is—I must say—superb.

· · ·

They ask me if I want a Western or Japanese breakfast. Most inns don't offer a choice, most are Japanese-style only. So when I get the chance, I go Western, if only to shake things up. Big mistake. She bakes me five loaves of bread. Can't believe I don't eat them all. The husband keeps gesturing for me to rip them apart and shove them down my gullet.

They stand and watch as I carbo-load. They are unusually touchy, squeeze my arms, check my body mass index. They use a translucent garbage bag to wrap up most of the bread. I tie it to my pack like a hobo.

Just then, a woman who looked in her mid-thirties opens the front door. Strolls in as if she had been waiting for me to finish.

Oh, hey, this is our daughter, the wife says.

Uh, hello, I say, nice to meet you. Your parents are trying to murder me with bread.

She laughs. We chat for a bit, but I have to get walking.

The distance looms large—about twenty-five kilometers with significant elevation to the next inn.

As the husband drives me down off the mountain, back to the Ise-ji path, he breaks our silence by saying, She ain't . . . our daughter.

I am entranced by something out the window: Beyond the fields, past a dirt road, in the forest something burns.

Before I can register what he said, he continues with more fluency: She just appeared seven years back. Wanderin' the country, needin' a job, somehow . . . found us. Not a daughter but like a daughter. Time passes, life moves, and that's what happens: Things become . . . other things.

WHAT TO BELIEVE

It was a day of rain and because of that, soft textures. The world's edges were tempered behind a fine mist that hung in the air. It was a day resplendent with more stone markers, old as can be, glistening, pointing in the direction of Ise Grand Shrine, a sprawling compound containing two primary shrines and 123 auxillary shrines and occupying some twenty-two square kilometers. A place largely dedicated to sun and universe goddess Amaterasu, chief Shinto deity. That's what most walkers on this road would have been aiming for. Stone markers here for hundreds of years. A hundred years from now, might be all that's left.

Bryan, I realize all along I've been writing "temple" and "shrine" to you and maybe the difference isn't obvious. It wasn't to me for the first ten years I lived here. But the distinction is simple: Shrines are Shinto, and temples are Buddhist. People often use the words interchangeably, but Shinto and Buddhism share no common source.

Shinto is Japan's native "religion." A set of animistic beliefs that formed somewhat organically through the veneration of many gods—so-called *kami*. Kami that manifest through rocks ("This one looks like a vagina—it's now a fertility kami!") and gnarled roots and mountains and anything else impressive and beautiful found in nature. You know the director and animator Hayao Miyazaki? *Spirited Away*? That's just cribbing Shinto through and through. That collection of peculiar kami, odd kami, *bathing* kami. That kind of playfulness—that's all over Shinto.

Buddhism, on the other hand, came from abroad, didn't

arrive in Japan until the sixth century—a thousand years after Buddhism was founded. Made its way from India via trade routes, came over on boats to Japan. Something clicked. Shinto and Buddhism became syncretic; that is, they peacefully cohabitated in the mind of Japan. Not just peacefully, but in mutually elevating ways. The kami of Shinto and the gods of Buddhism mixed without detracting from either. The "Book of John" tells me that the Sun Goddess of Japan— the most important deity—became the manifestation of the Dainichi Nyorai Buddha, the Cosmic Buddha. In death, the Shōgun Tokugawa Ieyasu was deified. He ended one hundred years of civil war. Brought about the Edo period, an era of great peace and prosperity. He became Tosho Daigongen, and was considered to be the manifestation of the Yakushi Nyorai, the Medicine Buddha and great healer of the nation.

Because of this tranquil mingling, for much of the last fifteen hundred years, you'd find shrines on the grounds of temples, and temples on the grounds of shrines. This lasted until 1868, when the Meiji government passed the *shinbutsu bunri* law, mandating the severing of the two. This was the start of a complicated era: extreme nationalistic impulses, the winding-up of the war machine, the government using Shinto as "homegrown proof" of the elevation of the Japanese above others in the region. I guess that in the end, even the most beautiful, well-intentioned tool can be used to terrible ends.

But before the split, pilgrims made their way to both shrine and temple without discrimination.

In ancient times, most big walks were pilgrimage walks. You couldn't move freely through the country without a reason, an official stamp in your passport. There were checkpoints everywhere—feudal domains protecting themselves from neighboring invasion (civil war being the primary war of Japan throughout its history). A pilgrimage was the easiest

一、備前岡山より備中国川辺郡川辺村江罷越候節

　　（本文、草書体につき判読困難）

文化七午年二月

　　　　川国備中郡古地村石拝山
　　　　　　　宝憧寺

　　右之通相違無御座候　　川国〱〱㕝〱備

　　　　　　　備前岡山〱〱備中〱〱道郡下原村

TRAVEL PERMIT BASED ON
TEMPLE REGISTRATION

—

ADDRESSED TO ALL DOMAIN BARRIER STATIONS

Bizen Okayama Domain,
County of Bicchu,
District of Shimomichi,
Village of Shimomura

MR CHIKURA MAGOTARO, 56 YEARS OF AGE

I HEREBY ATTEST that Tokubee and his two companions are registered at Horin-ji Temple of the location stated above.

As per the LAWS OF THE SHOGUNATE [a space is then opened up to indicate reverence for the Shogun's laws] I hereby attest that these gentlemen are not Christians, nor are they members of the outlawed Nichiren sub-sect known as Fuju-Fuse nor the Hiden Sect.

On this occasion these gentlemen intend making pilgrimage to the 88 Temples of Shikoku. Your assistance is dutifully requested to provide a night's accommodation to these gentlemen upon night's fall. And, if they fall ill or die on the road, your every assistance is requested according to the customs of your area.

The statement above is the full extent of their travel permit.

SIGNED: Horin-ji Temple

Second Month of the Year of the Horse,
Seventh Year of Bunka, 1810

I attest to the accuracy of the statement above.

Honorable Domain Barrier Stations Please Provide Free Passage to the Travelers Covered by This Travel Permit.

SIGNED: Village Headman Kosai [name unclear]

way to get permission to travel. Who could deny the need for spiritual aid? And why travel? Because it was fun. Sure, you were going to the gods and kami to ask for help, but also the road was a carnival, travelers and food and cheeky carousing aplenty. Very little tight-lipped stoicism. Chaucer in the East.

"Now is the time to visit all the celebrated places in the country and fill our heads with what we have seen, so that when we become old and bald, we shall have something to talk about over our teacups," so begins Thomas Satchell's translation of one of the most famous literary accounts of walking in Japan—*Shank's Mare*. A book from the early nineteenth century. It continues: "Let us join this dissipated Yajirobei and his hanger-on Kitahachi with their money kept warm in the loincloths around their navels; with their light footgear and their many layers of ointment, which will keep their feet from getting sore for thousands of miles; and their cotton robes dappled like the flesh of a clam. Let us go with them through foot-worn Yamato, welcomed by the divine wind that blows from the Grand Shrine of Ise, with the flowers of the capital and the plum blossoms of Naniwa at the end of our journey."

But, of course, not all walkers were as free-flowing as "Yaji" and "Kita," and most villages didn't have enough money to send everyone. So pilgrims were chosen by local lottery. Lucky schmucks, carrying the purse of their village warm in the loincloths around their navels, adopted by all.

Carry us forward in spirit, said the villagefolk. Take the idea of us to those shrines. Let the gods know that we, too, got problems worthy of their attention. Bring back some good stories, stories for us to talk about over these old, chipped teacups of ours.

EVERYONE

Of those I pass, most everyone is old, bent over, of an era soon gone. They yell to me, Where ya from, and say stuff like, Wow, these times, tough bugger. They tend their little fields as they've done probably for some fifty years and will continue to do until their children—off in Osaka or Nagoya, big cities, places with futures, industries, factories, ways to make money—finally send them to some assisted-living facility to finish out their days.

I meet an elderly logger who is the last of his kind. A wizened fisherman who doesn't know how much longer he'll be able to fish. Another younger guy who tells me he catches dolphins, and I'm knocked back on my heels so far all I can do is laugh. (Dolphins, Bryan, dolphins.) Back home, walking Main Street, who would be left for us to meet? Men and women who once worked jobs that no longer exist? Once working lines at the airplane-engine factory or assembling firearms? Or maybe even a retired insurance guy? Since that's what everyone in the city over the river was doing—once the insurance capital of the world, now not so much. That, too, commodified, moved south for tax breaks, without anything real to take its place. Something else filled the void—drugs, poverty. But here, no drugs, no poverty like we knew. It's a mystery I try to understand through these walks, these chats. But I'm beginning to think the answer is pretty simple: People care, and are cared for, on a level of abstraction absent from our town.

The "Book of John" tells me that on today's walk many of the natural features along the routes are considered to be

deities. He means the mountains but I take it to mean the people. Each a tiny god.

So I stop and chat. I'll stop and chat with most anyone. I like their faces, their weathered hands, hands dappled like the flesh of clams. They wear flower-print smocks and comically large hats. They drive miniature backhoes plowing miniature fields. They once built miniature stone walls circumscribing their properties. Those walls now crumbling on abandoned plots. One by one, they wave and I wave back.

ISE

Every twenty years the shrines of Ise are rebuilt. Specialist craftsmen—carpenters called *miyadaiku*—descend upon the grounds and get to work. They carry in hand their delightful *sumitsubo*—ink pots with strings to be slapped against boards marking cut-lines. Three generations work in parallel to pass down the knowledge of joinery and proportion. For some thirteen hundred years they've been doing this with ticktock regularity: rebuilding.

These are well-known facts, the facts of Ise. Well-known and oft-cited facts that delight visitors. But—it *is* impressive, the whole fandango, worth reciting again and again, worth marveling at the collective tenacity on display. Consider: The Colosseum of Rome was built once, built of materials to last the ages. To see it today is to see what was. But even now, we don't quite know how they made their concrete. Knowledge lost. Here, at Ise, the wooden structures feel like flames, constructed from a living knowledge. A knowledge having been carried so very far, with so very much care.

The day's small chapter of the "Book of John" arrives at five A.M., before I set off:

> Big day—such an important place in Shinto mythology! An interesting example of Ise pilgrimage in the Middle Ages is the case of the wealthy Fujiwara Saneshige from Kita-Ise. His diary was only discovered in 1951 inside a statue of Buddha in Yokkaichi City, where your walk began a week ago. By 1241 he had

visited Ise more than thirty times. Saneshige donated rice to Ise every New Year. He paid for Buddhist sutras to be read at the shrine. (An example of its long-standing syncretic nature with Buddhism.) It is interesting to note that Saneshige mostly prayed at sub-shrines, not at the main shrines. Like many others at the time, he was more interested in local deities.

The grounds are littered with these smaller shrines, these "local deities." Each shrine has two plots—plots situated side by side. Every twenty years the shrine's positions alternate, but in the years of the rebuild, the old and new stand next to each other. The fresh *hinoki* cedar of the new shrine glows in the sun as if lit from within, suffused with a purity that makes it easy to understand why it's favored for Shinto ceremonies. The old shrine, its hinoki weather-beaten, seems painted with the wisdom and wishes and hopes of a million million pilgrims. To see this old and new side by side is to see time on a cozy scale. The priests keep them like this for a month or two as the deity moves from one to the other. But soon, the old is dismantled, the wood recycled. The adjacent plot left empty until twenty more years pass.

All the while, children cut around and through the grounds on the way to school, run past the great shrines of Ise as if they were any old building in any old place.

I watch the kids and think of you. Us meeting in first grade. I remember the room, its shape (an almost perfect square), the warm morning light, the orientation of desks, but not the name of the teacher. Or any other students. I remember a math test, and doing well. Who else was in that room with us, I couldn't say. But you were there and we quickly fused as children do, intuitively, without much thought, al-

most chemically, and I remember feeling that yes, yes, this kid. You. It's strange how we feel these things, these obvious truths, so young, with so little experience.

You were four months older than me and always a bit bigger. But we had the same dirty-blond hair and well-defined cheekbones and sharp jaws and body shapes that stayed thin and athletic—no matter how much garbage we swallowed—as we grew. Everyone who met us assumed we were brothers, which—I don't know if it delighted you, but it delighted me to no end, gave me so much happiness—inspired us, I imagine, to do the same.

It's been years since the last Ise rebuild, and so only one shrine stands. Today, caramelized by rain and wind and baked by the sun, it no longer glows. It has the patina of time exposed, feels ready to sink into the surrounding forest. I do a quick calculation in my head. The shrine probably looked something like this when we met. Maybe a little more worn, but not dissimilar. We felt a flame in that classroom. Moved on it quickly, figured out our homes were close. Oh, shit, just *there*? Just there. Realizing how if we took roads the route was stupidly long and annoying, but if you cut down and up the ravine, just a minute. Easy. In this way we shared our first secret, constructed a path all our own, built a space to nurture that energy of friendship. In this moment we were the same.

Two healthy young boys with healthy minds, capable of so much. Our paths ran parallel for so long, until they didn't. But as we now know, you can start at the same place, under shared circumstance, and in the end it means nothing.

The "Book of John" urges me to visit the shrines at twilight. Matsuo Bashō, the famed haiku poet, wrote about visiting Ise in his 1684 travel journal *Nozarashi Kiko*—"The Records of a Weather-Exposed Skeleton." John translates:

I went down to Ise where I spent 10 days with a friend named Fubaku. I visited the outer shrine of Ise one evening just before dark. The first gate of the shrine was standing in the shadow, and the lights were glimmering in the background. As I stood there, lending my ears to the roar of pine trees upon distant mountains, I felt moved deep in the bottom of my heart.

Bashō was so moved, he did the thing he always did, the thing that made Bashō Bashō, the thing that carried his name up through the ages: He composed a haiku.

> *In the utter darkness*
> *Of a moonless night*
> *A powerful wind embraces*

I do just that, walk the shrine's grounds at twilight. They're vast. It feels at times like you're in a national park. It's fantastical to think of these cedars—this entire place, Ise—existing as we cut through backyards. If you had put us on a plane and flown us over, we could have seen it. (Imagine *that*.) But in the moment neither we nor anyone around us could have managed such a thing—financially, intellectually, emotionally. Ise, a place once welcoming the arrival of famed poets and retired emperors, today mostly welcoming everyday pilgrims: balding men in boxy suits, women with dyed brown hair in drab office clothing, younger women in baggy jeans with awkward boyfriends by their side, old women with blue-tinted hair in wheelchairs, tightly curled punch-permed local gangsters in sunglasses clutching their leather man-purses. All of them standing before the shrine.

Outside the shrine, not inside the building. Very important. Inside is for the many kami. Even Bashō was kept out:

"The keeper of the inner shrine prevented me from entering the holy seat of the kami because my appearance was like a Buddhist priest. I am indeed dressed like a priest, but priest I am not, for the dust of the world still clings to me." I feel the dust of our town every day, on every inch of my body. So, like Bashō, I stick to the paths of the grounds on my twilight walk. Regardless, most Shinto prayers happen outside. Unlike, say, a Catholic church, where the prayers happen with a roof over your head, Shinto shrines extend by implication into the surrounding nature. The environs—trees, waterfalls, rocks—as important as the formal shrines themselves. I walk and in directions all around me I hear those everyday pilgrims clang coins into the wooden donation boxes on the steps of shrines. They bow and clap. The procedure is quick—no drawn-out litany of yearnings and anguish are unfurled as you might kneeling in a church pew. A prayer at a Shinto shrine is more "hello" than "help." The help being implied through greeting, from simply letting the kami know you're here, putting your very existence on the radar of these local deities. Inside the shrines themselves—through windows and doorways—you catch glimpses of priests in crisp white robes as they shuffle about in the background, carry branches, objects. Deep within, the shrines hold ancient metal mirrors covering *nagi* bayberry leaves, small meals of rice for those unknowable, unseeable kami.

Acts at a shrine are abstract acts of purification. Attempts to remove stains from lives and minds, the past and the future. Shinto is purity, is life, is birth; a spark of belief cultivated for so many thousand years. Hello.

• • •

I spend the night at an old inn called Asakichi near the shrines. It was saved from bombing, just barely. A few kilometers

north, the inns up there in the old brothel district were bombed. They had housed Japanese troops during the war. But my inn didn't, for whatever reasons. And so was saved. The tatami-mat room I sleep in is a hundred and fifty years old, the owners several generations deep.

When did Ise begin? I ask John and he answers: "It's all myth. Some say fourth century. Some say fifth century. The Nihon Shoki—'The Chronicles of Japan,' an eighth-century book—says Ise began two thousand years back." This is how things start: fuzzy, and then not. At some point Ise had no history, was built for the first time. You and I had no real gods, no Christian god we truly believed in, no alternatives offered up, just our blaze of friendship—a kami of our own making. In that, we believed hard. Down and up the ravine, we carried the flame for years, trying—and failing, always failing, operating without blueprints, not knowing the quagmires within which we were stuck—to build something in our lives that had never before been built.

LANGUAGE

The farther down the Peninsula, the deeper the accents. There is great delight in measuring distance through twang, through how loose a tongue feels in the mouth.

Do Japanese people say "ain't"? They do to my ears. Language grounds abstraction, impulse, conceit. It's the form we give to such shapeless things, to the cascading tides of our mind. So while there might not be an explicit "ain't" in Japanese itself, within the Kii Peninsula there is the vibe of "ain't" and the intention of "ain't" and the chemical swirl of "ain't" in how the folks intone, and I try to bring that to these pages.

...

When I arrived in Japan, to live in Tokyo, I knew but the faintest basics—about both the country and the language. I chose Japan mainly because it seemed so opposite, so far from where we came from. Its language—not just the sounds but the feelings, the impulses contained within those sounds—shared no fundamental etymological history with English. For example: Subjects and verbs were flipped. This seemed good. Important. I wanted to flip it all, all the bits of my life—this, the start of rewiring my brain. That linguistic gap carried a potential for self-renewal. Move your lips like so and a new self could be built from a fresh set of blocks. This was the promise of the language. (The promise of all language.) I felt this intuitively stumbling through those first Japanese classes. Blocks to be learned on my own terms, held close until they became part of the muscles of my face and—I hoped—the way I stood, walked, slept, lived.

The emotional intensity and density of that first year was so extreme that I know exactly where I learned specific phrases or grammatical rules. Like walking the streets of Ochanomizu at nineteen—not imagining I'd be here three years later, never mind twenty-three—looking for a backpack, asking a fellow student how to conjugate verbs to mean "I want." There were so many banal things to want back then, and they all seemed wholly outside my grasp.

The homestay family I had been assigned that first year— a husband, wife, son, and part-time-working Korean boy also on a student visa—would have fit in perfectly with our town, Bryan. The trash-jumbled kitchen. Meals with the TV blaring. The lopsided marriage. But all with an othered asymmetry. Here, the trash was styrofoam containers of fermented soybeans, the wife had all the power, controlled the purse, called the shots. They ran a noodle restaurant. She bossed her husband around, a guy who never learned my name in the nine months I lived there. Hey! she'd yell. *BEER! NOW!* To which he'd sheepishly comply. He came home one day with a pate as smooth as a peeled egg. Apparently he had been using a toupee. *Hage! Hage!* Baldy! Baldy! They laughed and laughed at him. New word. I learned a surprising phrase when out for crab dinner with the family's grandparents ("crab" itself, learned in the back seat of their car—*kani*). The grandfather, a war vet, stroked my leg and laughed and relayed to me some war story involving an unknown phrase. I looked it up on my pocket electronic dictionary: *seibyō,* sexually transmitted disease. Later, I was forced to learn the word for masturbation (*onani*—Japanese has always been an unrepentant borrower of words from English and elsewhere, though somehow they feel utterly changed, remade, reflected through the language's subset of sounds) when the eleven-year-old son kept doing it all over the house. Once under the table, next to me in the living

room as I typed out emails. That was it. I came home from school the next day and gave him advice in my then-pidgin Japanese about the best places to jerk off. I hope it wasn't too traumatic a conversation, but fear I may have forever ruined self-pleasuring. The mysterious Korean boy came to my room each night, kneeling in my doorway, and from that I learned the words of salvation and church and how badly he ached for the safety of my soul. He slept in a closet.

It was almost too much, too weird. To travel from where we were and then to land in this home. There was something comforting about it, certainly, some kind of familiar salty-earth purity to it, but hearing of my classmates' families—young couples who lived in "tower mansions" (what high-rises were called—new word) and took their homestay students on adventures to national parks (more new words, learned in the lobby of my university on a Monday morning)—I once again felt so much of our scarcity. The free-standing post-war wooden home I was in was like living in a cardboard box that had been kicked down a frozen canyon. It had no insulation. Crowded between other buildings, it hadn't been touched by sunlight in decades. It was there that I learned the word for sleeping bag (*nebukuro*) and donned a full-body snowsuit when I went to bed. I learned all the words for every permutation of preparing udon noodles—salad udon, grilled udon, dipping udon, curry udon—in their noodle shop, where I ate daily. And I learned the words for photocopier and vitamins when I came home to find the living room filled variously with those items. They were always trying to make another buck. From time to time, I still think about those mountains of unsold vitamin bottles.

Which is why I probably spent so much time walking the city. The house was a bit nuts. The backstreets and alleys of Tokyo healed me with their relative sanity. I was drawn to

Shinjuku again and again because I felt a kinship. If our kind roamed this city, this is where they'd be. The one place in Tokyo where all social strata brushed shoulders beneath Jumbotrons and blinking neon. I'd watch indie bands perform on the street below Studio Alta's giant screen (*Alta-mae,* as the spot was dubbed). I'd walk Shinjuku's Kabukicho neighborhood—the area filled with touts and prostitutes and companions and "happening" bars (where it was said customers had sex with each other out in the open; my shock at this making me more and more aware of my puritanical moral baselines) and perhaps the highest density of broken humans in all of Tokyo. There's a small park in the middle of the district that's famous for runaways. Hello, friends, I'd think to myself, standing on the edge of that neighborhood or sitting in that park.

It was then I bought my first Nikon from one of the many used camera shops, meager budget, something cheap, but even so: The sharp edges of the metal body and pleasing heft of glass felt enchanting in hand. I wanted to look more closely at the city, but was also shy, uncertain, and felt the camera call to me as a silent partner and witness. Below the neon, holding my new tool, I learned the word *ryōkai*—"yes, sir!"—as a military affirmative, deployed playfully. It appeared in a cellphone text from an older student, a guy I looked up to tremendously back then (still do). He didn't know how to slot my history into a socioeconomic hierarchy, had never before met someone from my station in the world. His gaze was new and in that newness I felt acutely that I could be something other than our past.

...

From John, I've learned so many words, of course. And more generally, I've learned the power of elevated language, lexical elegance, to curry favor, to engender supporters and comrades

on our adventures. With particular fondness, I remember a phrase he used in a tiny village on one of our walks together, a village between mountains in a long, thin valley: *Okotoba ni amaemashite*. Said when the mad keeper of a small shrine invited us to see its stuffed god—a squirrel. Meaning, basically, *I melt upon those sweet words of yours*.

...

Arguably, the most boring place in Japan to listen to the language is Tokyo. Everyone talks like a television announcer or newscaster or dour Catholic priest. Go to Osaka to hear dirty talk; sit on the subway there and you'll likely hear two women openly discussing the filthy cocks of their boyfriends, all slang and twisted grammars. Go way down to Kagoshima—down on the tip of Kyushu, one of the country's southernmost points—and the language itself sounds almost foreign, many words entirely different words, a kind of bayou banter wrested from that side of Japan's complicated history with Korea, of them enslaving tens of thousands of potters and with them, their kiln-and-clay technology, in the 1500s. Kyushu—a land of incredible ceramics and language, much gleaned from ancient elsewheres.

The Kii Peninsula strikes a balance. The accents are thick but not indecipherable. For me, this is one of the great pleasures of the place—the language. It feels familiar, holds a working-class sturdiness in its directness, a pleasing tether to where we came from. I feel we know these people.

In my mind, the conversations of the Peninsula are all tied to a specific pass, stretch of road, corner of a field. Anonymous topographies to everyone else, but particular and singular in my mind. Every conversation here is fused with the spot of earth I stood upon, the abandoned car I flanked when it happened. And so each time I walk these routes, these same

paths, the conversations come back as if from a chorus hidden in the forest.

I walk and think of another phrase, too: "fanny fucker." We heard it in first grade. An older kid, eighties bully—you remember the type: casual homophobia, jean jacket—sat next to me on the bus and lobbed it in my face. FANNYFUCKER-FANNYFUCKERFANNYFUCKERFANNYFUCKER. I was frozen in confusion. Didn't know "fanny," barely knew "fucker." Had no idea of the implication. My mom was waiting for me at the bus stop. I got off and as the yellow bus lumbered away, I gave it the finger and yelled, FANNY FUCKER TO YOU, TOO.

She almost fainted.

· · ·

Tell me, Bryan, if this wasn't true: Nothing was unutterable, and we relished each lexical smack, each taboo, the rotten skeins of which we wove into our lives. We were no saints and had no saintly archetypes. Your father was present in a di-

aphanous kind of way, tobacco always in hand, watching, distant. A man who had fallen from his Harley and had half his butt grafted onto his thighs, who delivered mail for some thirty years, always in shorts even in three feet of winter snow, showing off those scars, who had a trick of placing a lit cigarette in his ear and blowing smoke out his mouth, who left books of truly tasteless jokes lying around, some of the only books we saw, books filled with retards and crackers and faggots and assholes and—callously, violently, unforgivably—things far worse. This was the ambient language of our world, a kind of perverted tea ceremony.

As you know, we never spoke any of these words in my home. Me living with my mom, grandmother, and grandfather. Perhaps it was our half-hearted commitment to Catholicism (church on Sunday, but leaving right after communion, never engaging with the group) that provided the moral propriety? Regardless, it was these conventions of our home, conventions into which my grandfather dug his heels, that created some thin bulwark against the rest of the town, that maybe saved me in the end.

"Fart" itself was considered as bad as anything a local tobacco farmer might yell in anger. I had to prime friends to tone it down. Chill man, chill. My grandfather would have none of it. But the borders of a home extend only so far, and the rest of town was off-limits to his rules. The cursed words were simply there, picked up by us in the way that language is unconsciously absorbed by children, deployed without pomp. Phrases designed to cut a person down, to dehumanize a man—and then more rottenness beyond that. Language as a mechanism of self-binding. Language used when you feel a scarcity—of opportunity and resources. If I can't get out of this mess, no way I'm letting *you* get out, either. That's what these words signify, I see this now. A tribal language of scar-

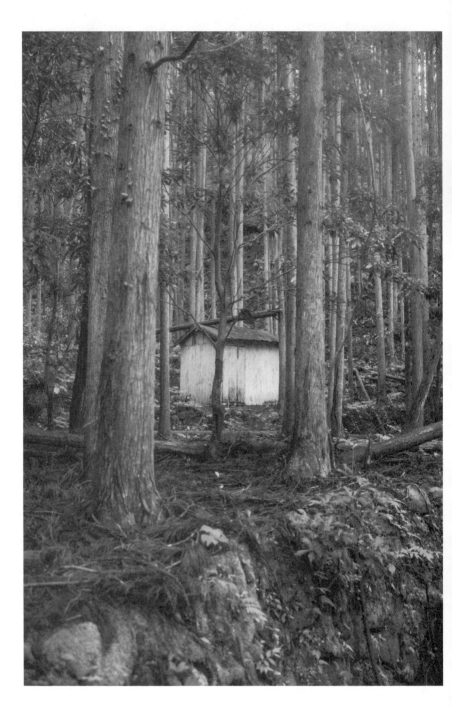

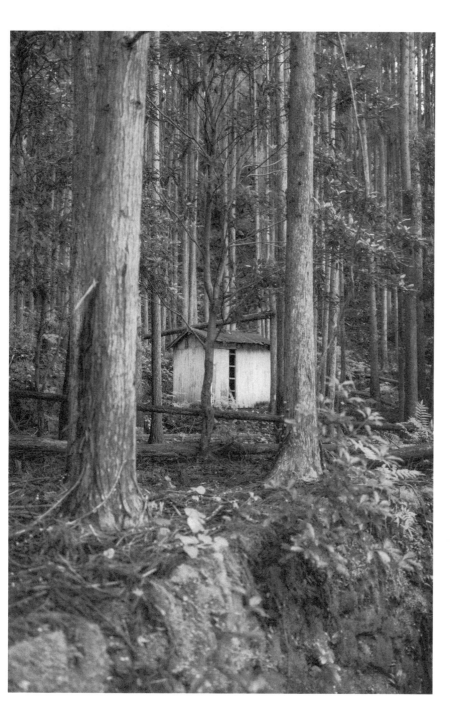

city that when spoken out loud makes the scarcity more and more real. True to their name: curses. We were cursing ourselves a billion times over. Curses ever-present in the hearts and mouths of the kids and adults of town, spread across the entirety of the neighborhood, tethered to no single spot.

So when I yelled that homophobic taunt toward the bus, you can imagine my mother's disbelief. A shocking delta between what the town harbored and what existed behind our closed doors, what my family had hoped for me.

A different kind of disbelief flashes over the faces of the women on the Peninsula as I say hello to them. Not because I greet them with bigotry, but because I greet them at all, on their terms—mimicking their fluent looseness. A looseness that is still polite, crafty in reverence and—coming from a face like mine—makes them smile. My greetings on the Peninsula feel like a palinode to the words of that kid on the bus, those dumb books, whatever fears had been elevated back across the ocean. What we learned as kids, I have tried to shed like the skin of a snake, though I know it well still. Know it is embedded in my heart, in the hearts of many of us from that town. In penance, I try to present something else. Something lucid and buoyant. Overcompensating for an unintentionally felonious past. I hold on to the hope that contrition is fixed within the steps of the very walk itself. Each step, an apology. A million apologies. I want to kiss the foreheads of everyone I see.

AROUND HERE

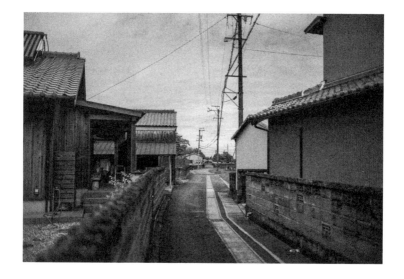

Compact mountain village. I pass the oldest of ladies—nearly horizontal, pale blouse, wide-brimmed straw hat—between cinder-block walls down a back lane. Hello! I yell and smile wide with my eyes, though hers don't rise to meet them. A few seconds later, to herself: Well, I reckon that boy weren't from around here.

MARUTANBO

Oh, honey, this your first time? The waitress is in her seventies, didn't flinch when I entered. Opened thirty-four years ago, Marutanbo operates out of a log cabin on Route 42 just a bit south of the sleepy village of Misedani. The original owner had recently passed. She is described as a vivacious and hilarious woman, named to me only as "Mama." In the corner is a small shrine for her with a kind-looking portrait. My waitress was her elementary-school classmate.

The night before I had stayed in a nonsensically opulent Marriott, nestled between day-worker digs. It was part of a revitalization effort between the local government and Marriott—they got tax incentives to build a handful of them along the coast of the Peninsula. Was it working? Who knew. But it was funny to stay there because of how different it felt. I was the only one staying last night. And yet the employees— having been shipped in from other parts of the country to work this Marriott for a little while before running off elsewhere—never really "opened up," didn't chat. The chasm between the general kindness of this Marutanbo woman (and the inn owners and other folks along the road) before me and the studied, city formality of that Marriott—no vernacular to be enjoyed in their Tokyo-no-accent language, never going off script—was jarring. When I asked locals about the new Marriott they all said, I hear that place ain't got a bath. Who'd wanna stay at such a thing for such a price. (I gotta say, the shower was pretty great, though.)

My masked-up waitress makes approving eye contact each time she passes by and doesn't seem fazed that I'm an out-of-

towner or that there probably hasn't been an out-of-towner in here for some time. She explains how the owner's son (in the back, cooking) and daughter-in-law had taken over the restaurant after their mother passed away. How the regulars are legion (but nowhere to be seen today) and well, heck, hon, if this is your first time then you just *have* to try the *uni* sea urchin pasta.

I like uni (sometimes), but not necessarily on my pasta. Instead, I get the fried *aji*—horse mackerel—set lunch. It is crisp and voluminous. I order an iced coffee and it arrives presweetened like at Howdy, in a kind of glass bowl, almost like a cold dessert soup.

Marutanbo is a kissa, but it's also a roadside diner with exposed logs and "folksy" vibes. I haven't been here before but have seen many places like it elsewhere in the world.

. . .

Bryan, you and I wanted a stack of pancakes the height of our faces. Wanted them covered in syrup and for that syrup to be mostly on the table. Wanted to unscrew and mix up the salt and pepper shakers like idiot hooligans.

We could bike to the Greek diner from home without much trouble. Biking to the diner was fine, but not much farther. Routes were cut short by highways and throughways, roads too big and brutal, too full of tractor-trailers, for even us to cross, roads that chopped cities and states into socioeconomic zones. Entirely different potentials for life (and tax bases) literally across the street.

Here, on Kii, too, and in many other parts of Japan, highways have changed lives. Towns that once had through-traffic from backroad drivers were made redundant as bypasses chopped them off. I've walked down tiny Main Streets that were so ghostly you expected tumbleweeds. But you could

also imagine what once was: a collection of local shops, dry-goods stores, beauty salons, a small theater. And two hundred years before that, even more, when the dirt road was pure pilgrimage and purred with foot traffic.

What did the highways do to us? They boxed us in. Kept us riff-raff at bay. Followed the edges of farms. We saw plenty of evidence of the town's agricultural origins near our homes. Only had to bike two minutes and you were at the fields. Everything, once, fields, before other industries took over. The efficiency of capital may push places "forward." But what happens when that capital retreats?

Boxed in by those swaths of concrete, that Greek diner was about as far as we could go. Shorts, dirty knees, buzz-cuts, scabby knuckles, caricatures of ourselves, we'd burst in and the old waitress—probably young, probably just twenty, but feeling old and older still after her endless shifts, and impossibly old to our fresh kiddie eyeballs—would welcome us with a weary smile, knowing the mess that was in store.

Years later—older and alone, while organizing my father's funeral and taking care of his home and sorting polka records—I'd end up back at another diner. Not the one we knew. Ten times the size of anything we saw. It had been eleven years since I had moved to Japan, and in the interim it felt like the whole country had scaled itself up in some grotesque foie gras of life. The lot of the mega-diner teemed with trucks—pickup trucks and SUVs but also homemade trucks, cars that looked like they had been hacked into trucks—roofs removed, back seats turned into flatbeds—trucks painted with fingernail polish and others washed and waxed and shining so bright you were afraid they might light you on fire.

Inside, it was like ascending to the heavenly plane to which all diners aspired. It was so crowded I had to wait twenty min-

utes in a vast Disney-esque shopping purgatory. I saw a man with a gun on his belt who was not a cop. I saw one hundred rocking chairs all in a row. I saw stacks of jam and jelly. I saw cowboy hats. I saw boots and plaid. You could buy antlers. I heard Kenny Rogers, and thought about how we never knew when to hold or fold anything, how it felt as if things were constantly held or folded for us, often in spite of us.

I saw kids—skin white as bleached sheets, revealed just above T-shirt tan lines—jump around, smack into people as if running through soap bubbles. Everyone was white. I was white. We would have slotted in just fine here. Been a couple of the happy little shits flopping about. Having spent the majority of my twenties in Japan, it had been a while since I'd been in a place I didn't know, and yet was so readily accepted as a local. There was no second-guessing how to speak to me, no hiccups with language, no shock at my ability to speak or implicit or explicit questioning of where I was "really" from, no looks as if I were a horse that had wandered into a shop and had begun lecturing about physics. The realization was a shock: Standing there, I was able to slide into someone else's world by dint of simply leaning against a wall. And yet— something had failed us on this side of the ocean and I was still trying to pick it apart. Something systemic, not any one person or thing, but the whole of it all, and no matter how easy it may have felt to slide back, I knew then I could never return.

Around me, the crowd fused into the singular, the blob smiled, picked up jars of fruit. Something in the parking lot caterwauled and not a single eye blinked. You and I were everywhere in this tangle. Astride huge parents, attenuated kids with towhead mops made gun shapes with their fingers and killed one another—BANGBANG.

...

In an empty Marutanbo I put "sauce" on my fried aji and slurp miso soup alone at a corner table.

You and I always asked for more and more butter, more syrup, more chaos at our Greek joint.

In that old country diner I mixed grits with hushpuppies. Slopped some combination of gravy and fried catfish onto my buttered biscuit, tried to take a bite, spilt it atop my over-easy eggs. Created a slurry of food, switched to eating with a spoon.

In Marutanbo, the waitress keeps asking what I need, what she can do for me, if I want more rice, more coffee, more water. Mama woulda loved a handsome boy like you, she says. The ceiling is covered in plastic flowers, like a Danish painting flipped upside down.

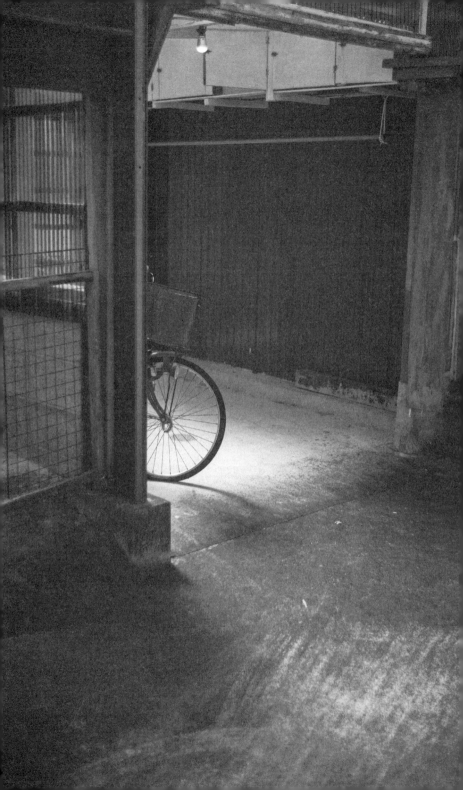

LOGGERS

The route this morning leads me past some loggers. Two men working the cedar forest. I could smell their tobacco a ways off. They were felling trees and a slender cedar crashed down about twenty feet from my skull. I popped out from the brush along the path and they looked at me like I was a leprechaun, like they hadn't almost hit me with a tree. They laughed and laughed. Laughing still, the whole way through my morning route.

YUKATA

Furusato Onsen, nestled between low mountain passes, a sort of micro-Eden, presents itself as groves of *mikan* mandarins picked by elderly women. There is a beach area that maybe sees some tourist action around the Obon holidays in August, but today it was desolate.

I eat dinner alone in a gilded room at an opulent inn. The walls and ceiling are painted gold, and everything placed upon the table takes on an otherworldly lambency. They serve boiled *ise-ebi,* a type of lobster the size of a cat, splayed in half, the brains on display. Bryan, you would have fallen over had you seen the thing. Considered it a monster, said, I will trade you all my damn baseball cards to keep that away from me. Slurp it up, I would have said—now that I was so culinarily refined—just pick up that head bit and tip it into your mouth there. And you would have fake gagged, said, No freakin' way, never never never never.

Truth be told, I still can't eat shit like this.

· · ·

Smack in the middle of the village, between shrubs and fields and farm machinery, is a public bath. I had gone earlier in the day. Despite COVID, the locker room was mayhem. Farmers aplenty. Everyone was wizened, gaunt, but looked strong, like they had been hacked from granite, bodies of bone and muscle and nothing else. Their tan lines were so sharp that their skin looked like burnt toast, like it was painted on. Their elasticated genitalia hung down to their knees. One man bent

over and spread his ass cheeks in my direction. I don't think he meant anything by it. Another palavered as he stretched spread-eagle on a wooden bench I made a mental note to never touch.

Once, on another trip to this bath, as I sat back in the scalding waters looking up at the skylight, a man walked in with testicles the size of grapefruits, colored frostbite-black. They looked almost attached to the bottom of his stomach, seemed to occlude his whole crotch. Did he have a penis? We'll never know. The scene reminded me of a passage from Antonio Tabucchi's *Indian Nocturne,* a book I read soon after arriving in Japan, and which lodged itself in my mind as a near-perfect mystery, a tenderly written travelogue:

> In the first bed was an old man. He was completely naked and very thin. He looked dead, but kept his eyes wide open and looked at us without any trace of expression. He had an enormous penis curled up on his abdomen. . . . "He's a sādhu," said the doctor. "His genital organs are consecrated to God; once he was worshipped by infertile women, but he has never procreated in his life."

The public bath demystifies. Any weirdness we may have felt about our own nakedness could have been so easily and readily erased with a single communal dunk. Think you have weird balls? Think again. Now we know how big balls can get, and how even if they get that big, looking like they've rotted in place, a man can still walk freely, nakedly, showing off his unique testicularity to other farmers with no trace of shame, dipping his sacks of coal into the steaming waters, consecrated to the kami of the bath, letting out a big sigh. Tabucchi would have marveled.

Life is strange and life goes on.

Back in the locker room, a drunken guy—he smelled of sake, trembled, lurched—kept insisting I was putting my *yukata* robe on backwards. No, it's right over *left,* right over *left,* he said, growing more intense, other folks in the locker room now looking at us, laughing. Left over right is how women do it, he said, you ain't a *woman* are you?

Cocks were flopping everywhere. None of us were textbook women. For a second I panicked, thought I might have had it wrong all these years. But, no. A lot of folks get things wrong more often than you'd think. Adults you once thought had it all together were just, in the end, improvising the whole way. This guy, with some robe axe to grind, wasn't trying to get me to do it the "manly" way, but rather the way of death; the dead are wrapped right-atop-left.

I told the farmer, Alright buddy, if you do it, I'll do it, too.

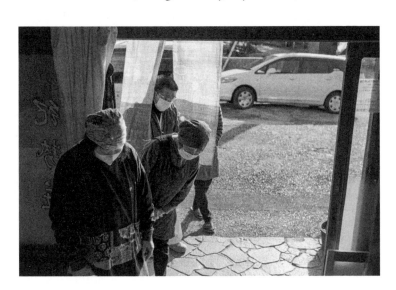

· · ·

Back in my inn at night, alone, thinking of you, I eye those boiled lobster brains in that golden dining room. Later, I slip into my futon and check my nuts—saying a little prayer of gratitude for their appropriate size. And close my eyes, still wrapped like a corpse, as if I am to be laid in the ground come first light.

THE ROPE

Nine in the morning, a weekday. With a belly full of strange sea beasts, I set off. I climb one quick mountain pass and pop out at a working shoreline. Weather-beaten wooden and fiberglass boats are lined up along the beach. Nets, buoys. The sand a mix of brown shells and pebbles, some worn smooth, others jagged. A single boat floats off the coast. Nearby, two savage-looking men—stained overalls, red faces, several days of beard growth—stand in a parking lot. They see me come down from the mountain and start walking toward me, yelling: THIS YOUR ROPE?! THIS YOUR DAMNED ROPE?! They move with unexpected ferocity, and I yell back, No it ain't my damn rope! Jesus! Why would that be my rope?! And they yell, OKAY! THAT'S WHAT WE THOUGHT!

THAT FIGHTING IMPULSE

Morons, I thought. Idiots. Fools. Punk-ass dipshits. A litany of verbal snares lay jacked and ready in my mind. Traps set long ago. Set first by that bully on the bus and then built into a shit-filled kingdom of insults. In our town you were bashed and then you fought back—words, fists, or worse—or the bashing continued. We saw it many times: Without retaliation kids were driven far inside of themselves, had their fires snuffed out before they made it to high school. A bunch of good kids defeated by the age of fourteen.

I learned to bite. Literally. You remember, Bryan, you were there. The older brother of a friend had fucked with me for ages, finally put me in a headlock, so I bit into his fleshy white freckled arm. Salt on the tongue. Cheap move, but it worked and he stayed off. Decades later, I'd hear he tried to kill himself, heartbroken, between shifts of laying floors.

On the bus we ranked on each other hard. I didn't yet understand how to ignore the attacks, didn't have the skill set for defusing abuse. As such, my first formal compositions were all toxins and flare. Discovered a natural talent that was useful within the *Lord of the Flies* hierarchy of the bus. Anyone could be Piggy at any moment. I wasn't bothered by the sight of emotional wounds, was willing to cut to the bone and then some. Laid the others flat, and laid myself flat before anyone else could, too.

Everyone knew I was adopted. You could feel the kids ready to pounce, as kids do, thinking for the first time about what it meant to throw away a human being. You don't know? they'd ask, giggling. You don't know who your *real* parents are?

And to protect myself—to sting myself so hard they couldn't possibly hurt me more than I hurt myself—I'd say my mom was probably a whore, a slut, a drug addict. Hell, pregnant at thirteen, what else could she have been? Raped, probably, by some loser.

The kids froze, backed off. I was drawing inspiration from the painful deficits I felt around us. Pain generational and layered. Pain those kids also knew but perhaps had never fully considered, and certainly never articulated with such barbarity. The same pain that made a kid reach for headlocks instead of acts of generosity.

I'd fill myself with that essence, that foul essence, and look those kids in the eyes and perform this violence on the idea of my birth mother, scare those classmates with a cruelty that also scared me, of which I didn't know I was capable.

Before adoption could be weaponized against me, I sent it up nuclear. And in doing so, instilled the notion that: Shit, Craig wild. Don't fuck with him.

You know that mindset, Bryan. You lived it out more fully than I ever did. Spend youth in our scarcity mindset—a mindset where we have little value, are shown little value, where we don't feel protected, where we feel like it could all slip away with one wrong move—and the voice never really disappears. Somewhere, in a corner of our minds, is a little kid forever ready to go to the mat.

The walk is many things, but it's also a way to say to that kid: Look man, I appreciate you being there back in the day. What you did was tough, brave in a way, but we're good now, you can go. No headlocks, no guns, no violence here.

There's a different tenor of scarcity on the Peninsula. It's strange, as poor as the Peninsula may be, I never feel the dangers we felt back home. I developed a nervous tic in the fourth grade. I blinked so much I was nicknamed "Blinky." Can now

see that I was hyperventilating, having anxiety attacks in response to the stresses of those dangers, instabilities. Something here works on a higher level. You can't fall that far. Maybe it's as stupidly banal as universal healthcare—knowing everyone I pass can get help, and does get help. Or the shared sense of community. Even as the population thins out, not all people are abandoned. (Though of course there are those who do live in crushing isolation and loneliness; less "abandonment" and more the loss of everyone they know.) Whatever it is, I've learned scarcity can exist without *also* being cursed, without self-binding a population into spiritual poverty.

And so, every day on this road becomes a chance for renewal. A chance for me to show that little kid in my mind that the world we're now in is one of abundance, of life, so different from the world we came from, and that you don't need to kill yourself (or the idea of yourself or your birth mother) to save yourself.

With each hello to a Peninsula shop owner, or farmer, or drunken horse bettor, I feel the entirety of my body activate, the heart rise in minor transcendence, and for a second I inhabit some version of who we could have been much sooner, had the right systems been in place.

Like this, the walk becomes an ascetic practice. Creates a space for an aggregate change of the heart and mind. A thousand days and tens of thousands of moments engendering renewal. But every now and then you catch a couple jackasses stealing a rope. It may feel like they want a fight, and that's fine. That scarcity-born kid in the mind stands up, smiles wide, brushes the dirt off his jeans. These motherfuckers ain't nothing, he says. He's ready, always ready, and he knows we can take 'em.

Most of the Peninsula parks are sad, broken, dying, already dead. Some—brand-new though. Some have been rebuilt for children who no longer exist, who may never return. Too lonely even for ghosts. And yet, they are everywhere, up and down the coast. The broader municipalities have park budgets, and those budgets don't necessarily correlate with child head-counts or even population figures. So funds are deployed. Construction crews are put to work. And you have these plots, mostly packed dirt with a scrabble of weeds baked dry by a blazing sun. Mostly silent, like a still from a film. I think often of the closing scene from Akira Kurosawa's *Ikiru*—the story of a dying government employee, working to get a small park made in central Tokyo before he expired. The protagonist sits on a swing set in his newly made snow-dusted

CRAIG MOD

105

park. Sometimes here on the Peninsula, you'll see an old man sitting in the shade, two hands resting on a cane. Sometimes there *are* a few kids running around, and spying them feels as sensational as finding a one-eyed toad.

Anyway—I adore them, these woebegone parks that don't make any sense.

They usually contain a single plaything: a spring-loaded cartoon Doraemon head, a puppy teeter-totter once colorful, now desaturated like a poster of a young beauty left too long in a pharmacy's south-facing window. These open spaces are so raw they bring to mind the nineteenth century, games like stickball. A place to roll an iron barrel hoop? Sure. But also, I think: poo tag. We played poo tag as if life itself depended on it. It seems so fundamental and obvious to the mind of a child—to place shit on the end of a stick and run after one another. It must be done here, too, in these desolate parks. I refuse to believe otherwise.

A lone evergreen flames up toward clouds, like the hair on a character from a fighting game. I see not a tree but a line of quarters on an arcade machine—a borderless afternoon in a windowless mall. You by my side, me lending you coins because I always had more and my games lasted longer. I was always embarrassed by that gap between us. Even though my family didn't have much, you had less. Those games were backgrounded against smudged plaster, the sticky-sweet punch of cinnamon buns baking in the distance. Beside us, teenagers wore red bandannas, blue hats—gang symbols. We quickly learned who to let win. On the Peninsula, the manicured trees are backgrounded against the heavy tile roof of a neighboring house. Sea salt in the air, I've not seen a single teenager anywhere. The colors here, just plain colors.

ANTS

Fact of the day from the "Book of John": The curiously vivid expression "like ants on the Kumano pilgrimage" is first seen in a Portuguese-Japanese dictionary from 1603. Meaning, back then—especially back then—these roads were jam-packed, peaking with walkers centuries ago. In a way, I'm walking a kind of post-apocalyptic version of these paths. Way, way, way beyond their apex, their pinnacle of usage. In the 1600s you would have seen hundreds of thousands of walkers, dirt streets lined with stalls, mountain passes replete with tea shops, extreme levels of revelry and prostitution all about. Very much like ants, that endless stream of long-dead walkers.

Today, I walk atop hard asphalt. I am alone in the walk. The trees are mostly gone, the sun brutally hot, made hotter each year by collective stupidity. I can't help but wonder what will be written about these roads four hundred years from now. Will the walk will be gone entirely? Will it have reverted back to something like before? Perhaps this is more special than I realize, me walking now. Perhaps what I'm doing today will be looked back on in awe and wonder, when such a thing like this was possible.

...

KISSA VEIL

The morning is dismal and wet. Feeling dispirited, I turn a corner, pass an abandoned love hotel, cross some train tracks, and see CAFE HOUSE VEIL, PART TWO.

Part One was a mystery, and remains so.

A sign on Part Two's door reads, DUE TO CURRENT CIRCUM-STANCES WE RESPECTFULLY TEMPORARILY DECLINE OUT-OF-PREFECTURE CUSTOMERS. They mean COVID, viruses. Mie Prefecture has almost no cases. And though most of Japan has very few cases, everyone is being extra-cautious. I suspect this is directed at truck drivers more than folks like me—someone dripping and desperate for coffee. Technically I was an "out-of-prefecture customer," but I've also been in prefecture for weeks by this point. Wary of offense, I stick my nose in; the place is packed. I lift a single finger in the saddest gesture I can muster, and they welcome me with a bit of reluctance.

I dribble all over a corner table. Elderly farmers in groups of two and four read their newspapers in silence. They seem unconcerned. For a couple measly bucks I'm served two neatly sliced pieces of toast, salad, and a hot coffee. Outside the rain comes down like the splash of a parted sea. I could sit here for years.

On the way out, I ask the owners what was up with the COVID sign—I had seen a few shops with similar ones along the way. The owners—a husband and wife so elderly it makes me wonder if there are laws against over-age working—shrug, act almost as if the sign doesn't exist. A customer at the counter sucking on a vape pen lets out a huge puff of watermelon and says, Anyway, ain't like we can *really* tell who's from 'round here or not.

OCEAN

I come out of the mountains and see the ocean and it feels like the end of the world. Like I'm just supposed to keep walking and let it swallow me.

The village before me has a seawall cleaving town from water's edge. From the homes, all you can see is concrete—the ocean replaced by a gray slab intersecting the sky, like a cruel James Turrell installation. This is not uncommon—huge portions of Japan's coast are cordoned off like this. I walk atop the wall, up on its dystopian promenade. To my left, waves rumble like far-off tractor-trailers. To my right, the town is silent. Only an old man stands below in his backyard in the shadow of the barrier, moving rubber hoses around. I smile and wave. I ask him when the seawall was built and he hums up to me a story about the Isewan Typhoon in 1959, and how it did 'em in. That typhoon, sure, but also the tsunamis years earlier. Nature seemed intent on carrying the ocean right into these coastal towns. The old wall was small, he says. But this one—the one I'm walking on, standing on—is huge. Eight meters high. Safe as can be. And as he speaks I can't shake the notion: The ocean, it does not care about your walls and will eat these walls when the day comes.

. . .

Disasters of the last decade are so well documented, it makes you wonder what we'd think about Moses splitting the Red Sea, had the Israelites been carrying smartphones. Today, no matter the horror, hours of footage are just a tap away. After the triple disaster in 2011—the quake, the tsunami, the

nuclear-plant meltdown in northern Japan—I watched, you bet I watched. And this is what I saw:

When the shaking stops and the sirens wail you'll have about ten minutes to climb high. Close to the ocean, it's hard to imagine the waters rising, having never seen the waters rise before. It's like trying to imagine a mountain in the distance doing jumping-jacks, or a hundred-year-old cedar breaking into a sprint. An ocean rising at the level of tsunami seems simply beyond our reality, veering into the realm of supernatural. It's made all the more pernicious because—the tsunami comes not as a grand, violent, singular attack, but rather as devious waves, kilometers in length growing by centimeters in height, sneaky bastards, amplified by the narrowing of bays, like the floor of the ocean itself is rising on a horrible escalator to the stars. One moment the water is below the low seawalls. Seconds pass and now it's slipping over, spilling into the streets like the ocean is in a cup and someone bumped it. You can't imagine more, and yet it comes. The volume is celestial. The water turning blacker and blacker, like oil, carrying more of the dregs of the ocean. The sirens wail. The announcements implore. Mere moments to get higher, that's all you got. You climb the steps of a nearby shrine. Your sense of physics is off. Surely the water can't get this high. It flows without sentiment into the streets of the village, enters homes through their first-floor windows and doors, begins to push back cars, vending machines, dumpsters. Styrofoam boxes spill and bob, all manner of fishing and farming tools float off. The gate of the shrine is nearly covered. You climb higher. Now the sounds of water pressure doing its thing: the creaking of crushed metal, of splitting wood, of ceramic roof tiles sliding, of cars compressing, of glass windows exploding. One car is pushed onto the horn of another and it blares continuously. A sound designed for traffic, to signal a minor annoyance, now scream-

ing uselessly at the sea. All the homes are submerged. You climb higher again and the water follows. Surrounded by the folks of your town, you look on in disbelief. It's all gone. I carried up my grandfather, someone says, meaning his ashes. It's the only thing they had time to grab. No one howls or moans or cries. Nature, someone says to no one, can't be stopped.

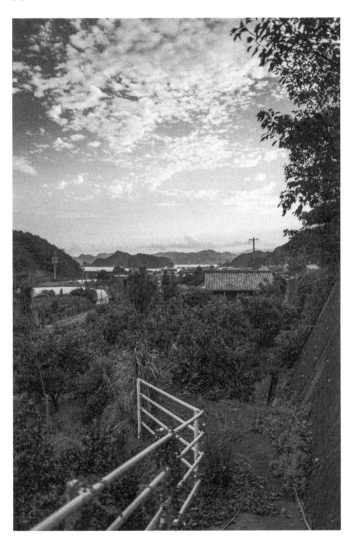

. . .

I walk a different town. The sun is strong and directly over-head. I am sweating through my shirt. Every few blocks lamp-post signs remind me with curious precision of how high I am above sea level: 5 METERS. 8.3 METERS. And instructions: RUN THIS WAY IF YOU FEEL AN EARTHQUAKE LAST MORE THAN A MIN-UTE, reads one. EVERY SECOND. EVERY METER COUNTS, reads an-other. This is life by the ocean. There is no eclipsing wave-wall in this town. The ocean is plainly visible. I love this, this hon-esty. Paradoxically this visibility, this lack of "protection," is what saved people in past tsunamis—being able to see, after a quake, the waters subtly change in anticipation, to know what was coming, the terrible waves. Without the wall there is no trading of beauty for some false hope of deliverance. Here, the water forever scintillates in the corner of my eye. It feels good to be near the water and good to see ships heading out, to feel a town work the water and pull life from the water, ready to accept whatever may come.

SHITHOLES AND NOT SHITHOLES

Where'd you eat lunch, the father of the inn asks me.

I tell him and his wife where I ate lunch and the wife looks confused and says, Where?

And he says, Oh, you know the one, that *shit*hole down the road. We all laugh. It was true. It was kind of a shithole, the restaurant down the road. A married couple having run the place for decades, caring no longer. They served up a sloppy pasta, wet and overcooked.

But this inn? Nothing sloppy, nothing overcooked. The owner is a heavy kitchen drinker, but never fails to deliver class. And the wife cares more than I've ever seen. I've stayed at this inn many times. Their two grandkids run out from the back to greet me. Extremely rare around these parts, this central-Peninsula area in particular—children. The town is disappearing rapidly. The entire elementary school has only fourteen students. Each teacher juggles two grades simultaneously.

And yet, this inn persists. Gourmands from all over the country make pilgrimage. First and second generation keep it going side by side. The son and father shop at the morning market and cook all day. The mother and daughter-in-law manage and organize.

The inn is about a day's walk south of Furusato Onsen. It's almost too much, to stack a Furusato Onsen stay back-to-back with this inn. So much complex, opulent deliciousness in so little time. But I can't help myself.

This inn has only four rooms. Fairly standard size for

inns of this type. Four jewel boxes. The inn is technically a minshuku. Which is considered a lower rank than *ryokan*, your classic fancy-pants countryside hot-spring inn.

But I've never seen a minshuku like this (hell, never seen a ryokan like this). The entire space overflows with elevated details, nearly perfect in my opinion—elegant, considered woodwork along the walls, fresh flowers blooming in classic vases, spacious rooms with fresh tatami mats, fragrant tea and mikans served upon arrival, hanging brush scrollwork, a communal seating area on the second floor with a view of the ocean. That may sound like many inns around Japan, but there is a soulful purity to this place, the fact that the family running it is so involved, so present—so persistently and wholly present—that it feels like visiting the home of your amazing grandmother and grandfather, who happen to both be Pritzker-award-winning architects, Michelin-starred chefs, *ikebana* geniuses, and hospitality Zen masters.

The family here loves their work so much you feel it infect your own heart. The wife greets me with a warmth you cannot fake. Whatever this inn is in totality, it cannot be faked. To get to it is onerous. Hours and hours of trains from the nearest big city. It's in the thick of the Peninsula. Still, visitors come from all over. I found it by accident. Years ago on my very first walk of this road, I was exhausted, saw the inn along an otherwise desolate strip. Knocked. They greeted me with startling alacrity. Though I hadn't booked they made space for me, showered me in welcomes and that tea and those oranges. I'm still reeling from that first stay. I thought I knew about *omotenashi* selfless service—the kind of service that all the expensive inns aspire to, that Japan is so famous for, that customer-above-all knock-your-socks-off service—but in their kindness I realized everything prior

had been a shadow of this, had hoped to be this, hadn't come close.

A friend, now ninety years old, who has run a gorgeous ryokan on the coast of Kyushu for some sixty years, once told me, hotels are just prepubescent ryokans. "Inns without hair" is the exact quote. And staying here, you feel it wholly—how refined and mature it is compared to your average hotel. The Marriott ain't got nothing on this place. A baby at best. This one—refined, perceptive, warm, welcoming.

The father studied food in Kyoto. Says he serves the best *karasumi* in all of Japan. A kind of Japanese caviar. Something I'd never order on my own but eat here, feeling my palate expand on its bitter saltiness. Even you, Bryan, would dig this, I bet. Like Richie Rich beef jerky. Ocean Slim Jims consumed like the body of Christ—a thin wafer of salt upon the tongue. The dad met his wife at college in Nagoya. True love. She had taken a few years off and worked as an au pair in a wealthy college town abroad. They stayed in touch as she saw famous men in the 1960s give historical speeches about human rights in front of hundreds of thousands gathered around vast plazas. Hippies, school buses, happenings. Somehow went from there back to here. The heart won. They are a comedic duo. She slaps his forehead. Their love is hard-earned and everywhere.

The entire inn is laid out with tatami mats. Something you don't see often. Usually, the hallways and corridors of inns are finished with beautiful hardwood, glossed under the padding of a thousand guests. Normally, you wear slippers on the hardwood and take them off when entering a tatami room. *Never* slippers on the tatami. That's the first thing you learn at an inn. (I once took one slippered step on a tatami mat and John almost vomited all over the hallway, such was his shock

CRAIG MOD

119

at my faux pas.) But this on and off of slippers—it's a drag. Truly, it stinks. Even at expensive inns, the slippers are often stiff and cheap. No fur-lined coziness. They're merely vessels for conveying your stockinged feet from one tatami surface to another. And the slippers never fit. Walking up stairs in them makes you feel like a duck. You have to waddle to keep them on your feet. If you can't tell—I don't like slippers. Most people don't like slippers. This inn realized that. Realized if they just used tatami mats everywhere, they wouldn't need slippers, could be done with the on-again, off-again annoyances, and the messiness of slippers splayed in front of doors to guest rooms, sullying the otherwise perfect lines of their hallways. Thoughtful decisions like these; God, I love this place.

The wife further explains that they put tatami everywhere to give the inn a more homespun feel. Didn't want to get too highfalutin. (She says as her husband croons about his caviar skills.) If you put tatami everywhere, she explains, it'll keep the inn humble, helps us keep the price low (and it *is* pretty low considering the splendor of the food). But let me tell you:

Nothing about it feels low. Each time I stay, their kindness and meals fill me with hope. A strange contrast. In the surrounding homes past which I walk, people die alone. Few children persist. How long can this go on for? It's something we don't discuss. Instead I ask for tips, hints, pointers. Tell me, I say, where the best non-shithole of tomorrow is.

I SPEAK WITH A FARMER

I speak with a farmer—have we talked before? I don't think so, but man I can't shake the feeling that we have. His flattened nose, pockmarked face, dusty overalls—I've seen him many times from a distance, have spoken with him up and down the Peninsula. He is watering his crop. He is drunk at nine A.M. He is covered in beet juice. He is eager to chat and it pains me to break free from the conversation. (But, I gotta walk.)

...

1955 Japan: 42 percent rural, 58 percent urban.

Today? 94 percent urban.

The average age of a Japanese farmer now hovers around sixty-five.

Masashi Kawai, in his bestseller *Chronicle of the Future,* notes the following timeline:

2024: One-third of Japanese are over sixty-five.
2027: There will be a shortage of blood for transfusions.
2033: One in three houses will be vacant.
2039: There will be a shortage of crematoriums.
2040: 50 percent of local government will disappear.
2042: The peak of aged population will be reached.

...

On the ground at an intersection, I find a forgotten sickle. (Probably forgotten. *Feels* forgotten.) I pick it up and walk

thirty yards or so, hook it into the doorway of a rural train shack ("station" is too refined to apply here) to be found with certainty, certain I have done this, too, before. It hangs down. I know my buddy will find it.

<div align="center">• • •</div>

I stop in a kissa for coffee and toast on a rain-soaked Tuesday, and across the room: two women, one young, one older, dressed in black office skirts and white shirts. Have I seen them before? These women? Ready to sit behind a desk. Which desk? Where? This tiny team. Nothing like an office for fifty miles. Déjà vu along the coast.

METH

A decade back, across the ocean: pure winter starlight, eight at night. I'm pulled over by a motorcycle cop for "speeding." Maybe five miles per hour over the limit. In truth I was profiled: single white male, rental car, out-of-state plates. He suspected I was involved with meth. (So he tells me later.) Thought maybe I was cooking, concealing, distributing.

The considerable-sized man had me step out of the car. He poked around. Some white dust now in your *ash*-tray, he said. I thought: Why would I keep cocaine in my ashtray? I had been gone so long the notion of meth as a thing—never mind what it looked like, how it had become seemingly endemic, or if it left a trace—never occurred to me.

What you up to here, he asked now standing extra tall, shining that light directly in my eyes. He meant the rental car, my out-of-townness. There were no street lamps on that stretch of road, felt like nothing but fields and forest in the whole of the universe beyond our pocket of asphalt. Anything could have happened. Look, I said, I'm just here to bury my father. I'm alone. He died a few days ago.

This was my adoptive father. The king of farts. The guy divorced soon after adopting me. He eventually moved far away. Moved with his mother and sister and brother-in-law. They all passed within years—cancers and heart attacks. Everyone sick in their own unsurprising ways. He remained, alone in the woods, and died the same. I spent weeks turning over objects in his alien home. I slept on the floor. I looked at the last marks he made in pencil on scraps of paper, measuring his glucose. He had been ill his whole life with diabetes and more. It was likely he had committed suicide. This is what the nurse had told me. She found him well-dead in the hallway of his home. He had skipped his medicine. I photographed everything. A camera between the eye and the world is a powerful tool, a suit of armor, a microscope and telescope in one. Anyway, I didn't know how else to deal with the situation. I was alone, his entire close family dead, the home—utterly foreign to me. I photographed the used blue bar of soap in his shower, the bristle-smooshed toothbrush, the rag over the faucet in the sink, the tin measuring cup I remembered from when I was a kid, still measuring things decades later, it seemed. I photographed the stack of Meals on Wheels trays in his freezer. The expired milk. His polka records next to his "fancy record player" (the only valuable thing I ever saw him own, the thing I was instructed never to touch or else: belt. I later googled what it would have cost in the 1970s: In truth, a very average turntable). I photographed the smear on the wall where he fell and died—his goo had rubbed off his face on the way down. Many objects had this goo on them. His broken body produced it—it oozed from his pores, creating a sort of heat-mapping of things he touched, building up like stalagmites. I photographed the goo on the phone receiver. The goo on the light switches. Yes, he had lived here. I photographed his white Fruit of the Loom undies in neat

stacks on a chair. His home was a duplex and I peered into the half his mother once inhabited. She had died in her sleep a decade earlier and he hadn't touched the place. I photographed the bed he found her in one morning, after her heart attack. The pictures of my father on her wall, his high school portrait, already then looking twenty years older than he was. I processed this narrative—one of tremendous solitude and sickness and loss and sadness—alone, thirty years old, still unsure about my own place in the world, a few years before I'd start to *really* walk.

Oh, what's his name? asked the cop.

I told him.

Dang, I knew him. Ate tacos with him. He was a good guy, that daddy of yours.

Days later, I'd know the cop to be named Duncan and I'd see him atop his motorcycle, once again flashing his lights, a sobbing rotund lead to our thin cortège, clearing the way to the burial.

. . .

I was thinking about my father and his small town in the forest because I was walking the town of Owase, a town shrinking like many of the towns of this area. Owase, 25,000 people in 1995. Fewer than 15,000 today. I walk its streets and think about those still living here. You simply don't see meth or heroin in Japan—it exists in such minute quantities, under such high penalties, that digging it up is more trouble than the high could possibly be worth. Folks reach for alcohol with gusto, sure, but alcohol doesn't zombify you like the powders or black tars or crystals. Alcohol can be horrific, but the fall from grace isn't usually quite as far or fast. And it's as legal as rice.

Back across the ocean, a town like Owase might terrify the sensible. Likely laden with opioid derivatives. Here, it's inert

and curious. Poke around, see what's behind closed doors. Do so knowing that it's likely safe. Bryan, you and I would have snuck into the long-shuttered public bath with the blue tilework out front were we so inclined. (We most certainly would have been.) No one squats in these abandoned buildings because everyone has a home.

It is not perfect here in Japan, of course. The criminal system can be medieval. Twenty-three days: the length you can be held on almost anything without a lawyer or outside contact. And then, they can come up with something else to extend it another twenty-three days, and another. A 99 percent conviction rate. Cells with just a single tatami mat, a light that's never turned off. That sort of stuff. And yet, that cop back across the ocean and the cops here seem to share almost no common origin.

I carry a fondness for much of Owase. How it has the excellent Kumano Kodō Museum, a museum dedicated to the many UNESCO World Heritage–certified routes of the Peninsula. How it's sandwiched between the two great peaks of the Ise-ji—Magose and Yakiyama. How—after descending the mountains under rains so unrelenting that they turn the path into a river—the young woman working at a convenience store will graciously check your head for leeches. You, hopping around like a maniac thinking you have blood on your hands. But there are no leeches, she assures you. Are you sure? you'll ask, traumatized by previous, grisly leech encounters. Those mountain leeches are crafty, climb trees, drop from above. Turns out you're color-blind and the ink from your leather wallet ran wild in the rains.

· · ·

As kids, we never saw meth or heroin, but cocaine was puzzlingly present in rumors and chance encounters. Weed was

abundant. As were guns. But mostly, the prizes to be had were liquor and smokes and porn. It was said that us kids could pay a surcharge to get them from Dairy Mart. We never had enough cash or guts to find out.

You remember the fights, don't you? How frequent they were, so obviously a byproduct of pain. There was always another shoe about to drop. Our town was racially and culturally diverse—its greatest gift, by far, that unexpected diversity. Still the most diverse place I've ever lived. A town favored by immigrants. God, I loved that—walking down the hallway in high school hearing all those languages. But suffering was everywhere if you knew where to look. And the diversity meant that each family seemed to suffer uniquely.

Poor "Sammy the Jew" was pounded daily for his bar mitzvah cash until he ran out. One Asian friend was nicknamed a common racial slur that he embraced like an incurable disease. Another friend's Vietnamese father was sick, couldn't afford to see a doctor, spent his mornings hacking up enough to atone for the lungs of a dozen smokers. Yet another friend's home's walls were covered in unpatched holes (holes from what? A mystery we never considered), his single Indian mother having given all their money to some religious sect. He'd later try to commit suicide by driving headfirst into an oncoming car carrying a family of four. (Somehow, no one died, or pressed charges.) In the moment, few of us understood our place in the context of the larger world. Some of us kept our heads down and tried to study our way out. But a head in a book doesn't protect you for long. And if you thought the kids causing trouble were off the hook from being picked on, you had only to peek into their homes. Fathers made sure those sons had no self-worth, enforced that notion with their fists. The girls seemed pressured by the ambient violence toward sex, many pregnant by their early teens. We

knew a kid who got a plastic sandwich bag thick with hash for Christmas, carried and unveiled it proudly. I visited his house once. They owned no furniture.

Our town paralleled Owase, the population already on the decline. It peaked in 1970 and would continue to fall for the next thirty years. We lost the factories and the jobs that came with them, much like Owase has. But somehow, the effect has been so very different.

Every now and then, in Japan, you get a guy who stalks a woman and chops her up into pieces in his bathroom, keeps the body parts in buckets of sand on his balcony. But outside of those crimes of a specific psychopathy, most of the crimes of Japan teeter between the banal and the strange. Rampant underwear theft (yanked from clotheslines), cheap-bicycle theft, *onigiri* rice ball theft. Sometimes a *muri-shinju*—double lover suicide. Post-war literary icon Yukio Mishima wrote stories like "Patriotism," fetishizing the double-suicide, romanticizing it, drawing it out in precise detail before then famously committing his own ritual suicide in the center of Tokyo.

It's easier to profile a drug dealer than a double-suicidist. In Tokyo I have been stopped many times, had my bicycle registration confirmed over and over. Have been forced to open my bag and empty my pockets, the cops seeing my face and assuming I might be one of the rare vectors for bringing weed or MDMA into society. But here in Owase I don't know what I'd be profiled for. Lost émigré, confused, buying too many potato chips at the convenience store, sleeping alone in that big tatami room at the business hotel? (Again? Yep, he's here again. *Hey,* I'd say to them—*it's the best room in town!*)

As I walk the coast of Kii and pass towns and villages of general poverty, I feel how social systems keep folks afloat, when elsewhere they'd be swept deep under. An invisible hand is at work and everyone benefits. A single good kissa

holds much sway in the name of sanity and greetings. Yoyū abounds. Folks maintain their lot, experience dignity. There are no inward escape routes on the Peninsula, no illicit chemicals with which to anesthetize the mind. The escapes are outward—toward jobs in the big cities north of here. Of those still around: men and women with calloused palms. Their whole lives they've fished. Once at scale, out deep. Now for themselves, slowly, sitting on docks and beaches.

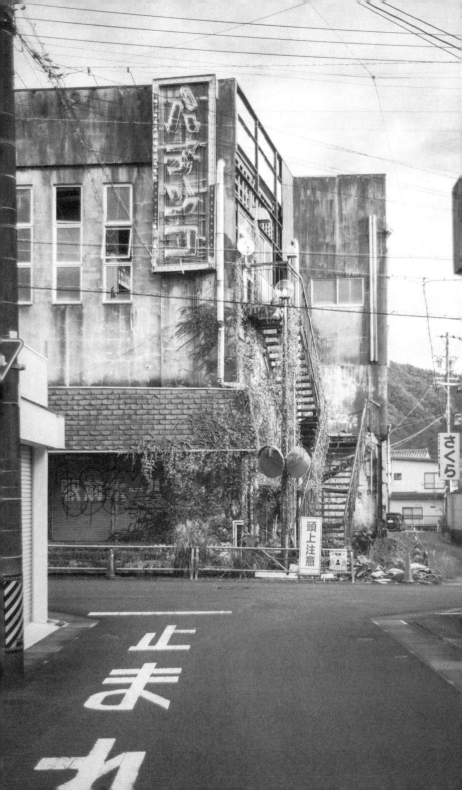

HANKO

Within the smaller towns soon to be gone, barbers and kissas seem often to be the last shops standing. Sometimes though, you get an outlier, a shop you'd never expect. Like a *hanko* seal shop. There are basically no signatures here, only "seals," "chops," "stamps." A small, unique, thin, cylindrical piece of wood or stone or bone with your name etched into one end. Originally from China (like so much here; writing, art, religion, seals—all Chinese in origin), first created some 3,500 years ago. Brought to Japan around 2,000 years ago. Originally just for the emperor and trusted vassals, but eventually spreading out to the ruling classes, samurai, and toward the end of the nineteenth century, society at large. Kind of amazing: a technology fundamentally unchanged for over three millennia.

1784—a farmer's field in Fukuoka. Someone found a golden seal, almost pure gold. Turned out to be the one that the Later Han Dynasty used to name Japan: the "King of Na" seal. "Na" a loanword for "Wa." The kingdom of "Wa." Something of a pejorative character: 倭, meaning "submissive" or "dwarfed." A distant, kinda dinky civilization. A name still used to this day, still "Wa" but with a different character: 和— meaning "harmony" or "peace." This seal is just a tiny thing, weighing 108 grams, one inch by one inch square on the bottom, and not even an inch tall. *And yet:* This petite package from A.D. 57 bestowed Japan with a formal name. So much power in such a small object.

Today, you can buy a hanko for the price of a sandwich or the price of a new BMW. Materials make up the cost differ-

ence. Labor is a rounding error. Almost all official documents still require seals, and folks may need one on the go for any number of strange, bureaucratic, or social reasons. And so a hanko shop may still be here, in the middle of a fishing village, alongside a historic trail.

Enter one of these shops—just a counter and a rack of samples—and the wife of the carver will greet you with a wide-eyed but kind face, will talk you through, in fine detail, the various carving options, the sizes, the style of line, the floral flourishes you can have added around the edges of the less-serious ones. She'll pull out a bill note and show you the red, circular government seal on it. Men, she'll say, are supposed to have seals no smaller than this. (It turns out men and women are recommended different sizes.) You'll choose a wild script—almost illegible, fun, why not—for her husband to render out your name in a "manly" size. A name he has most certainly never carved before. You'll give her the address of the inn you're staying at in a few days' time and pre-pay for shipping and, sure enough, it'll be there, the thin black case wrapped in a soft red cloth, and inside that, a smooth cylinder of bull horn, one end with your name, all squiggles and loops.

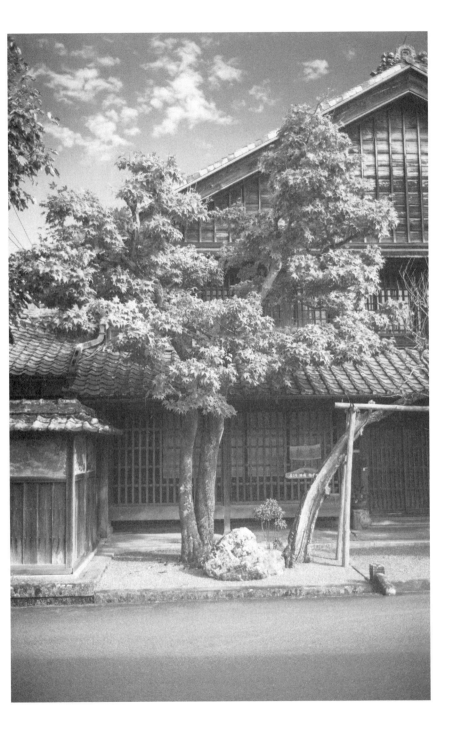

SCALE

I spend the dark and dreary morning at Scale, a kissa run by an old ironworks guy. The top of his gray head barely comes to my shoulder. Seventy-three, turned his garage into a kissa twenty years ago. Use your body when you're young, he barks, and your mouth when you're old! Ha ha! He tells me about the iron he once held and welded, the pungent smell on his hands, in his hair. He points with seared digits. He has built many things.

Today's "Book of John" notes that coffee arrived via the Dutch to Japan sometime in the late 1600s, during Tokugawa Tsunayoshi's rule. (The "Dog Shōgun"; he loved animals, John says.) But it didn't stick! Made its real debut when the country was forced open by Commodore Perry's "black ships," when the coffee tax was set in 1866, and imports began in earnest in 1877.

It was first found in port cities like Yokohama or Hakodate or Kobe—places where the "other" most readily fused with Japan. Made its way to Ginza in Tokyo around 1911. Osaka, 1912. Banned in 1938 as war efforts ramped up. Came back in 1947 with so-called G.I. coffee houses on American occupying bases. And then the real kissa boom took off in the sixties.

Scale wasn't part of that original boom. And yet in the unexpectedly flavorful Colombian beans you could trace flavor notes, bitterness, a caffeine punch back to a dog-loving emperor, some industrious Dutch traders, the opening of a country, the loss of a war, the occupation by coffee drinkers, the intermingling of cultures.

I pair the Colombian with a sliced-cheese pizza toast that sizzles. Pizza toast was the first and only thing I could eat when I arrived in Japan at nineteen. Me, with a palate forged on SpaghettiOs and Snickers, on Friendly's chicken strips and Wendy's milkshakes. That palate has walked thousands of kilometers around this country, snacking mainly on pizza toast.

On the rare days I'd spend with my adoptive father, we ate only fast food. He never learned to cook more than a salted pan-fried steak. One night, I finished off six Whoppers. I must have been ten. Who knows of the gastronomic witch-craft at play on that chilly December eve. But I did it—I ate 'em. Down they went. A Christmas miracle. After the second one his eyes grew wide, by the fourth he sat in disbelief, and by the sixth he was drumming the table, hollering to customers, showing me off like I was the shop's official crown prince—the Burger King's heir. So you can imagine, when I hit the ground in Japan, sushi was out of the question—sacs of cod semen, no way.

Pizza toast soothes. Bryan, you'd have dug it. It's just as it sounds: thick-cut bread slathered with tomato sauce and slices of processed cheese. Kind of a bizarre cousin of the fried bologna sandwiches you and I would cook up. Bologna sometimes Oscar Mayer–thick, but often Polish-deli–thin. Fleshy punches of mystery meat? Yes, please. Butter in a frying pan on the electric stove like my grandmother taught us, watch those flanks bubble (because they did bubble, right? in their weird bologna bubbly way) up to crisp umami-ance. Bread so white and soft and cool we'd place it against a cheek in summer. A few of our beloved banana peppers, yellow mustard, that same sliced pizza-toast cheese, flop it together and coo in ecstasy on a stoop facing a grassless yard of dirt.

I had a friend memorialize our sandwich in a drawing:

Outside Scale, the rain is so heavy I decide to take the day off. Not worth the risk to clamber over Edo-period stones in this stuff. (Mossy, they get slick as ice when wet.) End up sitting in Scale for hours. Follow up the pizza toast with cinnamon toast topped with whipped cream that sits in the mouth as light as cotton candy. As I write and organize notes, regulars come in and gab and gibber. It's as heartening a thing to witness as you can imagine. I wish we could have fried up some

bologna for them all. They would have loved it, would have been blown away.

Inside the shop, metal beams, high ceilings, clean welds. Outside, the concrete bank of a river, rain coming down with a vengeance, battering a series of potted plants teetering on the lip of a crumbling old wall.

...

Hours in, the customers thin out. The owner asks if I want to see something. I do, of course, whatever it might be. We run—he's faster than he looks—outside in the rain, down the road, across a driveway and into a barn. It's dark and damp and he leads me up steep stairs to an attic where murder or miracles lurk. Strands of bulbs encircle the room. He turns on the lights. Before me: a universe of tiny iron frogs. Each just inches tall. He has welded hundreds, maybe thousands. Frogs playing tennis and frogs climbing the Tower of Babel (so he explains). Frogs meditating and frogs performing judo moves. They're all so precise. You immediately know what the frogs are intending to do. Yet he walks me through, one by one, all the frogs. A lifetime of frogwork. Like this, he takes an iron rose off the wall and hands it to me. For you, he says. I try to give him money but he laughs, shakes his head, says he's as rich as he'll ever need to be.

DISPATCH: ANIMALS

Beneath coal-gray skies, three macaque monkeys perch on the roof of a home as I descend from Magose Pass, just hanging out, sagely observing the rain-soaked valley.

Another macaque is urinating in the middle of old Funaki Bridge. He hears me coming, turns around, sticks his tongue out, and hops over the side into the gorge below. It drops hundreds of feet. I run to the edge but he's vanished. Couldn't see the rascal anywhere. Still baffled by where he jumped or if he survived.

· · ·

A few gangly waterbirds—egrets maybe?—taking flight from the misty woods, one of which lets out a white, strangely elegant stream of guano into the sacred river below.

· · ·

Dozens of freshwater mountain crabs emerge from wet forest and river. The "Book of John" informs me they're technically called *Chiromantes haematocheir*. These *Chiromantes haematocheir* scuttle before me as I make my way down a coastal trail. Just after sunrise, as if birthed by the light of day, there they are, red-clawed, itsy-bitsy things, scurrying sideways in their funny way. They move like Claymation, at a skittish frame rate not of this world. But why so worried? What am I going to do to you, poor mountain crab? Nothing, just chuckle. You are hilariously awkward. How have your genes made it so far through history? You scurry like dolts and are oddly shaped. You cannot hide.

You scurry and stop against a rock, looking nothing like a rock. Your inelegance amazes. And why aren't you more terrifying to me? You're spider-shaped and spider-esque, but evoke none of the terror of a giant spider. Your utter hopelessness disarms. You can do no harm, and soon, I imagine, you will be eaten by boars or monkeys as you shuffle nowhere in particular.

. . .

I take a ten-minute break at a pass and it isn't until I set off that I realize a *mamushi* pit viper as long as my leg has been sunning itself just a few feet away. *Hey bud!* I yelp and off it slithers. Snakes, strangely, don't freak me out. Only the prospect of being poisoned on a mountain without cell service freaks me out. Later: a beautiful silver snake sunning itself in the middle of the path. I tap my pole a few times and it takes off into the tall grass.

. . .

If you do get bit, the "Book of John" informs me, don't worry. Just lie down for a few days. (*A few days?!*) Right there, right in the middle of the path. Meditate, stay calm, don't move. The more you move, the faster the poison circulates. Call for help or, if you don't have cell service, just wait for someone to come along.

. . .

The dumbest-looking bird runs straight into a bush.

. . .

Something shaped like a boar or a monkey or a baby bear bolts across the path and up the mountain about fifty feet in front of me.

...

I'm reminded of Norman Maclean. He wrote "bears bolt straight uphill in a landslide—no animal has such pistons for hindquarters" and I wondered how many bears had seen the business end of a tsunami, and how much those hindquarters helped then.

...

I stop to catch my breath just below Mount Tengura. I look up, and a *kamoshika*—the Japanese serow, an antelope-like creature, the creepiest and holiest of forest animals—looks down upon me. Japan has embraced it as a creature unique to its archipelago, and as such calls it "a living national treasure of the forest." It exudes an aura of magic in how fast and sure-footed it is. They appear in the great films of Miyazaki as prescient sages. Like a hefty deer, thick in the middle with meat and muscle thanks to its bovid lineage, a puff of white fluff frames its goat-head and tiny antlers. This one assessing me doesn't blink, doesn't move, sees deep into my rotten core, knows all the bad shit I've done.

...

The monks in Japan seem to embrace severity and looseness in equal parts. The marathon monks of Mount Hiei run a hundred marathons in a row carrying a knife. If for some reason they stop, they must commit suicide on the spot. And yet there is also the famous, handsome priest of Kōyasan, who is a race car driver on the weekends.

The "Book of John" tells me that in the past, euphemisms allowed for vegetarian Buddhist monks of the Kii mountains to partake in certain meals.

In ancient times, wild boar became *botan nabe,* or peony stew.

Deer was rendered as *momiji niku,* or maple-leaf meat.

And horse meat—through some creative act of verbal sorcery—became *sakura:* cherry blossoms.

• • •

Two feisty sisters run the morning's kissa with verve. Its walls are all glass. It overlooks a pond. It's ridiculous and wonderful. A duck flies up onto the balcony and the women go wild—*Oh! It's Octopus! Our beloved, dear Octopus!* They had named the duck Octopus.

HAMLETS

I walk a mountain path I haven't walked before and it turns out to be everything you hope a path to be—circuitous and intimate with villages and with the occasional grand view, fully of my ippon-ura school of backroad walking, soft cedar fronds cushioning each step.

I think about how a walk begins, with balance, in the ear, vestibular, a few feet above the earth. I don't know history, but I know science—was always drawn to and comforted by facts, tested truths uncoupled from the messiness of life. So I write to John: Endolymph, a potassium-heavy fluid, oozes inside the so-called bony and membranous labyrinthine canals of the inner ear. Did you know that? (He did not know that.) It's inside there—those crescent-shaped canals—that gelatinous bulbs called cupula, attached to stereocilia, detect the sloshing of our endolymph. The body moves, the endolymph splashes, heeds the laws of gravity. The stereocilia bend and transmit details of the bend—how far, how quickly, which orientation—to the cerebellum, the brain-nugget secreted at the back of the noggin. The cerebellum decodes the signals, translates, makes a follow-up microsecond game plan. Most often of which, is simply: *Put that next foot down, you fool.* And that's how a body covers hundreds of miles of this peninsula, guided by a finely tuned internal level of bone and flesh and hair.

The system works: the endolymph sloshes, and I stroll upright. As I do, I see the "thousand" terraced rice paddies of Maruyama Senmaida. The visitors are gone and have been gone longer than ever before. Travel gutted by the virus.

Just a few farmers and me, observing this ecosystem of rice carved into a place with no flat land. So much effort for such tiny plots. Onerous positioning on a mountainside, but the mountains are helpful—the upper reaches contain dams holding back water for flooding the fields in late spring. Building these dams, the sluices and canals for irrigation, requires co-operation, a great shared effort. It's hypothesized that this very thing—rice farming versus wheat farming—is at the heart of communal societies going way back. Could it be, such a simple fork? A crop choice based on environment: wet, humid, rainy, therefore: rice. And with that a pervasive care throughout generations, a sense of knowing your happiness and health are intertwingled with those of your neighbor?

Silent morning, abundant sunlight, abundant life. Thinking about this care. Water in the fields rippling in the wind. Mountains of Kii all around, a silent sloshing in my head, keeping the sky up and the ground down.

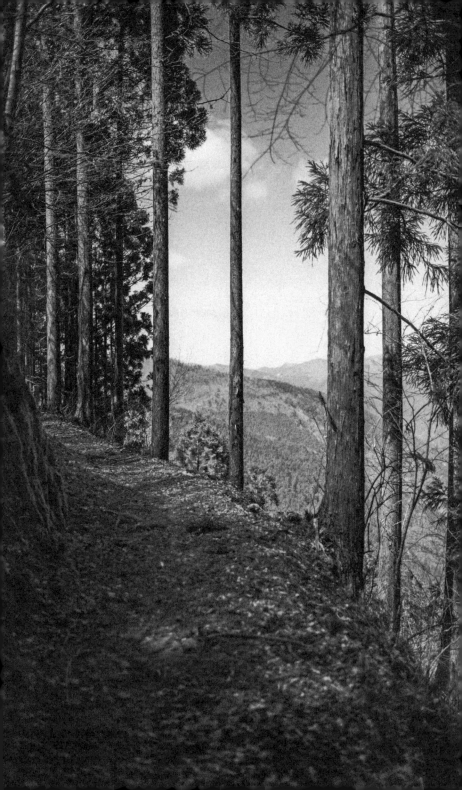

GUNS

From the "Book of John": Look out for the gunshot, today.

John's talking about an old statue, a jizō—one of those bodhisattva protectors of children and travelers. The same type of statue that that tour guide showed us back early in the walk. (There are hundreds of thousands of jizō around Japan, large and small, alongside roads, next to trees, in parks, flanking highways, behind temples.)

In autumn on the Peninsula, sometimes around nightfall you hear gunshots ring out in the distance. Little pops in quick succession. The old men are hunting boar. As you walk the mountain paths you see (if not the beasts themselves) the play of the beasts—where they have dug up roots, or gnawed on trees, searching for food. You find their little mud pits, their wallows, where they slept the night before.

Atop Ōbuki Pass sits John's old stone jizō. Quite big, as far as jizō go. I look closely and find what the "Book of John" was referencing: a bruise on the lower side of the statue. John writes, Years ago a hunter mistook it for a twilight apparition. Shot it instinctively, though I don't know why they felt the need to shoot an apparition. The gun was in hand, loaded, ready. I suppose it's what we do.

TOUGH

From John I learn that in 1201 the poet Fujiwara no Teika wrote, "This route is very rough and difficult; it is impossible to describe precisely how tough it is." In reality, tough, but not indescribably so. It's just steps in the end.

Nearby, on a hard stretch of mountain road leading up to Ōgumotori ("big cloud-touching") Pass, the old route was once lined with inns promising food and a hot bath. They fibbed to the walkers though, said there weren't inns down the valley, although there were. But the pilgrims were so traumatized by the climb that they were happy to believe pretty obvious lies. They weren't lying about having baths, at least.

The inns also laid out cobblestones to aid the trek. And for this, the pilgrims were grateful and expressed that gratitude in a little patronage.

Today, just a few deliberately placed stones trace the foundations of what once stood. Nothing else of the structures endures. The wood reclaimed—by man and forest. A strange vestige of one of the last inns to shut can be seen if you look closely: Alongside an overgrown stone wall sits an impressive mound of sake bottles. Carried up and consumed, but left behind when no one was willing to haul them back down.

FISHING POLES

I pass an old woman dressed in a headscarf and farming smock. She asks if I've been fishing. I'm carrying my walking poles over my shoulder and she thinks they're fishing poles but then catches her mistake. A flash of embarrassment about the face. Then: a story. A story about how when she was in elementary school, second grade, she had to walk over several mountain passes to visit her brother who was sick. He was in the hospital, she said. It was hard, so far, but it was the only way to get there. Up and over one mountain and then another and another. On the other side, eventually, was the hospital and in it, her brother.

These are passes I am to walk soon enough.

I ask what happened to him, her brother. Where is he today? She raises her arms, moves them beside her head as if casting a spell. He became a fisherman, she says, pointing toward the ocean. He's still out there, working even now.

FLATTEN THE MOUNTAIN

Hundreds of years ago, young and old would have climbed these mountains just like that woman, just like me. They did it because there were no real roads to speak of. Nothing like we have today, no highways circumscribing the landmass. Up and over was the only option, using the same routes for centuries. Today, these paths are no longer a means of commerce— just nature paths. But in the 1600s, most mountain passes—not just those especially arduous ones—would have been lined with teahouses and inns. You'd have stopped along the way for a few *dango* rice balls slathered with soy sauce, grilled atop beautiful sticks of charcoal.

And when not walking, these long-ago folks used boats— boats galore. Two hundred years ago, sailing from cove to cove along the Peninsula must have been a heck of a thing, navigating that wild Kuroshio current, seeing the jagged landforms disappear and reappear, feeling that infinitude of ocean ready to suck you out and away toward who-knew-what. From the "Book of John" I learn that a boatless carpenter around Owase fell in love with a girl from Mikisato. He sang: *If I had my way, I would flatten that Mount Yakiyama with a hoe, and allow her to pass.* (Oh, the laziness! Even without the mountain he's asking her to come to him. Girl's lucky the mountain kept him away.) I walked the Yakiyama route just a few days ago. Thought about that girl. It's a hard day's walk. Treacherous in the rain. Back then, even more of an ordeal, an obstacle. Now, a fifteen-minute train ride through the mountain's belly, straight to ill-fated love.

Back then, the waters would have been a panoply of

flat-bottomed wooden boats. Hundreds of people commuting up and down the coast. And then the other, bigger boats. Fishing boats. What they fished for back then, they still fished for recently: ise-ebi spiny lobsters and *mambo* sunfishes and sea urchins and other monsters. The industry peaking in the eighties and nineties. Then, like so many industries, it was offshored. But for a moment there was something like a string connecting what was, once, so very long ago, and contemporary times. A string becoming thinner and thinner in recent years. The oceans are changing. The creatures that live there are changing. Today, people fish for only some of the things that once were. Those walking the mountain routes today do so for exercise, for the pleasure of communing with nature. No need to flatten Yakiyama with a hoe—today we've got a highway, a railway, the miracles of modern mobility. And with that, weaker legs, no lost loves on the other sides of mountains, a little less poetry laid atop this unforgiving landscape.

GEISHA

Finally some sunshine. The visible world is dry. Ground leeches had come out with the rains on previous days and it was nice not to think about them. Not to ask convenience-store clerks to check my head for blood in manic paranoia. I walk fast. I am walking fast. When I catch up to the only other hiker I've seen in weeks, I say hello. She is geared up, looks like a ranger, all beige with a big hat. She both lives in the area and is younger than sixty-five, which is like finding a snow leopard in these parts. Seven years back, she moved to the sleepy village of Atashika. (The characters of the town name mean "new deer" but the "Book of John" chimes in: I love the etymology of place-names. Atashika could mean the "placing of a new fishing net" *or* "new deer." Since it's a coastal town, I prefer the former. Were it in the mountains, "new deer" would be more likely.) Today she works at the post office part-time, and also happens to be a guide for the trails. As we walk, she points out all sorts of foliage varietals, the names of which I wouldn't remember even if you held a gun to my head like I was some forest jizō.

We exit the mountain path and walk the slope down to a different village, equally depopulated—the port town of Nigishima. A crescent of rust and concrete framing the ocean. I've been here many times. We sit at the wooden gazebo, at the table with a view of the bay next to the fish-processing plant. I mention how much I love the jabber of the women who work at the plant. How years ago I ate lunch with them outside, right here, right at this very table, and couldn't understand a word they said. Mouths full of mountain marbles.

The thick of the Peninsula down here. They kept poking me with their fishy fingers and hooting and cackling at whatever I said like I was some cityslick simpleton, which I was (and am).

They remind me of another woman, Bryan, a woman from our town that you never met. She was around later in life. A woman who helped my grandmother when she became incapable of doing anything on her own. This woman had thirteen kids—seven boys, all named Arthur or Arty or Art Jr.—and no teeth, but could gum an apple down to the core. She had a heart the size of a truck, adored my grandmother like her own, cried as hard as anyone at the funeral. Though little about her life made sense (and so little of it had been helped by or looked after by a greater good), I knew she had a special capacity for love.

I tell all of this to the guide. Yes! I know what you mean, she says. The ladies' accents here are so hard to understand, but their words bloom with affection. When I arrived, I couldn't understand half the people who came into the post office. But you pick it up soon enough. And the closer you listen, the more you realize how much kindness suffuses their chatter. They truly care.

She tells me that this area had once been filled with geisha. How this tranquil town we sat in was actually once of some repute for whaling. How in the nineteenth century they hunted the majestic creatures nearby. Some meretricious European came in the early twentieth century and set up shop. Did gangbusters for the whole area. A little coastal boomtown, a blubber-bloom gold rush. For a few decades, total decadence. Hence the geisha. But this was all prewar. Before the whales were driven to near-extinction. Now, perhaps no longer even technically a village, no longer anything in a decade or two. No matter how hard you squint, never in a billion years can you imagine a geisha walking around these

streets. And if you mention the old days to anyone who might remember, they get antsy, she says, don't wanna chat about it.

...

The "Book of John" is glad to "see" me take a break here (him, tracking the walk by GPS). He regales me with tales of the old Nigishima festival that took place right across the very bay we faced. A boat race between Muroko Shrine and Akoshi Shrine. A festival tangentially whaling-related—an excuse for building and maintaining skill sets required to row out to capture the beasts when they would surface in the distance. Men in loincloths, bathing in the ocean, slow dances on hulls followed by furious paddling and furious drinking and fights. (Our well-known trifecta: danger, violence, bonding.) Held for more than three hundred years, the last one was in 2010. They simply ran out of people to participate.

...

Later, on the way out of town, after saying goodbye to my new friend (she had to get back to the post office), alone in the woods, I pass an abandoned stove with delicate inlaid tiling. Look carefully at these mountain paths and you realize: The infrastructure for life is still here. The old infrastructure from when this land was used for small-plot farming, when the plots were protected from wild boar by *shishigaki* stone walls, when these paths were paths both working and worked before the rail line was blasted through the mountains, before the highway was carved alongside the ocean and lifestyles changed and this land returned to nature. Before all that, these mountains purred with human intervention. Not too long ago.

By virtue of the drystone walls, the many plots, the neatly kept paths between them, you can't imagine geisha, Bryan,

but you can imagine folks working, moving earth, growing crops. Life cycling, though that life is now gone. Better jobs elsewhere. No reason to toil a patch of mountain when you can move to the city and make an easy buck. And so it feels archeological. You, the interloper. The whole of the view—the stones, the fallen wood—is covered in moss, electric green, and now trees grow from the middle of some long-abandoned plots and yet mailbox-sized shrines here and there are still maintained, some with fresh hinoki like a renewed Ise, as vigorous as you've ever seen. Who maintains? Someone stooped with wild eyebrows, hands shaped like old fruit.

CANNED COFFEE

On the way into the Peninsula, the roads can be a bit dire. Sometimes you hit patches of what I like to call "Pachinko Road." Stretches of faceless sprawl lined with those pachinko gambling parlors. There is no single Pachinko Road, but many, all part of the greater Pachinko Road that spans the country, the edges of each piece reaching, desiring others, to form an unbroken unit of pachinko blandness, to envelop all of history and humanity and replace it with one amoebic, singular box of jangling, hypnotic, perfectly round metal balls.

The "Book of John" goes deep on pachinko stats for me. The industry peaked in 1980 at $200 billion USD. Even today, it's still around 3 percent of the GDP—3 percent! Pachinko! Some $130 billion USD in revenue. Unbelievable.

It was developed in Nagoya right after the war, he writes, the game and the machines. Plywood, glass, ball bearings—they were in abundance in that industrial town (which is why it was so heavily bombed in the war; a place of critical war-machine industry). Invented by a guy named Masamura Takeichi. He saw potential in those little bearings. The diameter and weight of a pachinko ball—11mm and 5 grams—hasn't changed in seventy years.

I read all of this under a pine tree next to a highway. There is an allure to these roads, to this sprawl. You may think sprawl is as sprawl is, anywhere on this earth of ours, but this is not true. Pass by in a car or on a bike and you'll miss it. A vast plain of poured concrete, chain stores, prefab everything. Dollar General in a different alphabet and currency. But walk slowly, look at the space between the squat, the faceless, pre-

fabricated gray buildings—you will notice a tree. Then another. These leftover pines were planted on a different earth, in a different time. They're older than us. You can't prefab a one-hundred-year-old tree. They are a living question: What did this bright, blighted stretch of road once look like?

Heavenly cool, shaded, *matsu*-pine-lined. Snatches of ocean visible between the gnarled trunks. An Eden of a road. Small wooden-framed shops opening with awnings out onto the street selling snacks and drinks and those common straw sandals. That's what it was once like. Every four kilometers, another ichi-ri-zuka mound, ticking off the distance for pilgrims. Everyone on foot or horse, no carts, no wheels, the exalted carried in palanquins, lives lived at the pace of saplings. Slow-growth days and weeks and months and years.

Today, between national pharmacies and big-box shops, a few pines persist. They cast ancient shade. They are invisible until you see them, and then become remarkable beacons of life. The sun beats down and the hours pass, and I stop for a canned coffee from a vending machine, lean against the rough bark, guzzle that chilled black liquid while staring at a pachinko parlor. I'm grateful for this old patch of cool, a patch most certainly used by other walkers, other pilgrims. I stand and watch the cars pull up, the locals get out, many of whom are addicts. The automatic doors of the building open like jaws: white noise, tobacco smoke, the scream of a billion ball bearings and jackpots. Those people enter and the doors close and, for the briefest of moments: total silence like a silk cloth falls over the landscape.

VENDING

Vending machines are everywhere here. You'll find them in the most remote of locations, on the tops of mountains, down an alley, behind a burnt-out shack: There one is. Never vandalized (I mean, *we* would have gleefully destroyed a few but the kids here don't have that impulse—once again, the power of yoyū?), always on, always ready with sweet goodness.

The greatest vending machine I ever found was in the middle of a rice field decades back. During that first year in Japan, I spent "spring" break (it seemed to land more at the tail end of winter than spring) hitchhiking from Tokyo to Fukuoka. My homestay family didn't even bat an eye when I told them what I was going to do. Good luck! the mom yelled without turning around from the TV.

February, snow in the air, somewhere in Gifu, a stranger picked me up and offered me a place to crash. We ate CoCoICHI curry together. We started with beer. Drunk before even leaving the shop. We did "karate" in the parking lot and drove back to his nearby home. And there we finished a bottle of Jack in his filthy shoebox apartment. I had just turned twenty. I was barely out of our town. It was around this time I felt more acutely the scarcity from which we came, how little we knew about the world or how it worked. The feeling hit me with the full force of the abundance I felt around me in Japan—of such an elevated baseline of wealth and health. Even this guy's shoebox apartment was built on ambient abundance: It worked, it was cheap, it was safe (whether he cleaned it or not was a separate issue). From glimpsing that deficit—between myself and this new world I was starting to

CRAIG MOD

inhabit—a yawning expanse of emptiness was revealed. The sort of emptiness only revealed when you leave the smallness of your hometown, see the greater world, feel your own void amplified in the abundance of others. That emptiness threw me for a loop, scared the shit out of me. Filling it with alcohol came as easy as anything. And damn could I drink. Ten, fifteen shots. No problem. After the third or fourth drink everything changed, some unknown gene activated, the emptiness was gone and all the world existed for one thing only: more drink.

Like this, I drank myself into the ground for nearly a decade because I saw no other way. No guides. No archetypes. More people feel this way than you may think. My empathy for them is boundless. And so at the start of that cursed decade, in some filthy countryside apartment, music was played with a stranger on toy instruments, poison-coated throats, until we passed out, legs under a heated table. Some hours later I woke, terrified, in pain, like my head was about to split. Water. I needed water. Didn't know where I was. Couldn't remember how I had arrived. Didn't think to suckle the tap. Opened the rusted apartment door to a rush of winter-night air and saw stars raining down on the dormant rice fields. That air was bountiful life. I inhaled like I had just surfaced from a shipwreck. The apartment block nothing more than a concrete bunker in the middle of the paddies. It stood alone. From afar, looked like a nuclear spill containment vessel. I stood on the fourth floor. In the distance: a clear glow, like Mars descended, my savior. Transfixed, I walked barefoot across the frosted, tilled earth, to the machine. In my pocket I had the precise amount of change needed to get a sports drink. I nearly wept.

THAT FLOATING FEELING

The body acclimates, grows strong. At a certain point on a long walk, the kind of walk where you clock twenty or thirty or forty kilometers a day, day after day—and you get into that rhythm of waking, walking, working, sleeping—you realize that the body is just a machine. You feed it and it turns that feed into steps. The cerebellum does its thing.

Today I have seven mountain passes to get over and am trying to get to my inn by sunset. So although I didn't intend it to be a race, the day's become a race of necessity.

Up and down the mountains, past abandoned baseball fields. Fields overgrown with wild wheat, old men walking loops around the diamond, making limp the uncut grass. Through fishing villages, past long-since-shuttered cafés and hardware stores. I float with a total and absolute lightness of being, an orangutan ballerina, arboreal and oddly shaped, arms and poles as one, glissading up and down, up and down, yelling, HELLO! and GOOD LUCK! and SORRY FOR GOING SO QUICKLY BUT I'VE GOT TO BEAT THE SUN! to the few locals I pass. They gasp: *Look at him go!*

I feel certain that I could do this forever—this swinging down and pulling myself up mountains. This moving, this gaining ground. There no reason to stop, sunset be damned. The meat machine my consciousness inhabits feels well-oiled, irrepressible, and unyielding to these puny mountains.

Bryan, you and I ran. We ran until our lungs seared, raced each other both formally and informally. You always won, until that one time you didn't (sorry) and I made the team

(gah) and you got cut and your father looked at me like I had accidentally killed your dog. A look seared into the folds of my brain. A shameful branding. He made us run sprints in the yard. All of which I lost, of course. (Pulling back, slowing down, wanting so badly for that look to be reversed but knowing even then it would be with me forever.) He wanted me to know with no uncertainty that you had the physical abilities, not me. I was to stick to the books. I didn't have teenage sisters, both pregnant. I wasn't to take away your few gifts.

Between us, I know we didn't care. You'd shake your head. Forget my dad, man. Not that we didn't love him—we did. He was bearded like Zeus and burly. His scars seemed to shimmer like flesh freshly pressed onto a stovetop. They captivated us, though we only ever dared glance at them from the corners of our eyes. Unmentionable, yet mesmeric. He had survived the Vietnam war, survived his motorcycle crash. Those scars, proof enough of transcendence for us.

And from this cheating of death, he seemed imbued with more height and strength than any other father. He played a monthly softball game with the postal team. Smashed line drives, snatched those pop flies from the air like picking apples off a tree. Drove us there and back to watch—beer and tobacco on his breath—as we sat in the bed of his truck holding our dented and rusted Huffy BMX bikes, hollering to each other beneath that amber summer sky. There seemed to be no rules, certainly no seatbelts. I loved those summer nights with everything I had. My adoptive father was elsewhere, and my mom's boyfriends would come and go, so this brawny mailman was something of a constant and held more sway over me than I think he ever imagined. I never beat you in a race again, did I?

But in the mountains of Kii, sprinting against sunset, against only myself, I can push hard, needn't hold back for

anyone. Some thirty years later I am stronger than ever. Stronger than anyone else on these mountains. Today, I'm as old as your dad was back then, with my own lesser, spotty beard. On days like these, an impulse to go on forever beats inside my chest. It's impossible to grow tired. These legs will never give out. They'll haul this pack over a hundred more passes. To walk like this is the best way I know to show gratitude for the health and privilege authorizing this primitive dance, permitting this day of walking and all other days, too. A tribute to those summer nights we shared.

· · ·

In the distance I hear a train, the Nanki Express. A train I'll ride when the walk is done. An act that feels distant and abstract in the moment, like death. Sure, it'll come, but damned if I believe it. It feels as if all the truth in the whole wide world was here in this forest, just over the next pass, certain to be found on the walk. Everything else beyond the Peninsula is a shadow, a sham, a performance. From the train I knew I'd sneak peeks of the truth of this walk in reverse. A pass that takes an hour by foot flashing by in a blink. Like watching a film spooled up at a thousand frames per second. The slow rhythm of the walk undone, replaced with a rapid clack. The mountains skipped altogether. Compressed air in tunnels. You and I flew through the forest side by side; mid-run nothing mattered and we were gone, out of that town, free from authority, safe, fully inhabiting a world of our own. Scales of observation, two young boys with searing lungs, crudely feeling out our paired truth, moving as fast as those legs of ours would take us.

KII-KATSUURA

In Kii-Katsuura, encouraged by the cool evening breeze, you can touch almost every street on foot given an hour or two. Murals of whales adorn the concrete walls around the docks, raw dolphin is served on common china. Not that I ate it, but I saw it advertised in windows, on menus, the general area having a long and sordid history of slaughtering dolphins. But I was just noticing, passing through without judgment. (Though I know that noticing itself is a form of judgment.)

The "Book of John" informs me that MacArthur revitalized whale consumption post-war. Was the main protein source for elementary-school lunches. Tells me the older generations have a nostalgia for the taste, the texture, the funktified chewiness.

I walk the streets and people who eat things I don't eat say hello with ease and the night's inn has given me a fine room facing the docks. Up early, from my open window, I watch two-person fishing boats slide out into the mirror-still bay at daybreak.

...

COPPER

I know you won't believe it, they said, but hand to heart, Itaya had three movie theaters. Said that's how booming it had been back then. Now, ain't got no theaters. No kids. Once, long ago, they said, we found a fine vein of copper and mined it dry. Sucked it straight out the earth.

Today, no more copper. But that old metal, pulled from the ground by these Peninsula hands, it lives on around the world in many things, the walls of many homes.

. . .

Decades after those theaters opened, the Isewan Typhoon stripped parts of the Peninsula of its trees. Just behind Asuka Shrine, beneath the newly denuded land, the villagers investigated. They unearthed a host of religious objects: more than 190 *kakebotoke*—hanging tablets adorned with symbolic carvings—dating back to 300 B.C. Older than the shrine itself, offerings to kami to protect crops. Objects considered hard proof of certain Peninsula myths.

. . .

Nearby, at Hananoiwa Shrine, a million years ago, Izanami gave birth to her son, Kagutsuchi, the god of fire, dying in the process. Today, a long braided rope connects the shrine's object of worship—a towering rock face with a gaping hole—to the earth. A great pine once stood between the ocean and the gaping hole, around the top of which the rope was wound.

Today, a thin cement tower has replaced the tree. Dressed in his whites, the shrine's priest motions with his hand for me to follow. At the base of the tower is a grate. You can climb in there, he whispers. You can wiggle your little self all the way up to the top.

ONE QUICK WALK

Bryan, here's something I never told you: My grandfather used to invite me on walks around the neighborhood. Come, walk with me, he'd say as he put on his overcoat and hat. I always declined, though in my heart I wanted to join. From my second-floor bedroom window, I'd peek out and watch him stroll with measured elegance down the driveway, turn the corner, disappear. And I'd immediately feel bad about having said no. How simple, I thought, how simple it would be just to walk next to Pop. But I also thought about the other kids. I thought about being seen. I thought about what that might mean, me walking with my grandfather. Stupid, yes. But there it was: this fear, keeping me from doing something so simple, from giving him this kindness.

Nearly twenty years later, I had built a life in Japan, and came back to visit. We went to our local steak place, the place we always went for special occasions (my visiting being a big one), and ate our well-done—forever well-done—leathery steaks. On the car ride home, I sat in the back next to him and held his hand. A hand I should have held much earlier. Later, at home, I heard him tell my mom, Craig held my hand. He was crying. This dumb thing, this holding of an old man's hand. I knew he would soon be gone (and he was).

THE BOAT

The Peninsula begins to eat itself in spring, and by summer is lost within its own terrible fecundity. Without human touch, most old paths would disappear within a few years or become, at least, hidden. Boar and deer would keep their own secret routes fresh, but the others would be lost.

I pass by my favorite boat again. I can't help but smile. Why do I adore this dumb thing so much? It hasn't touched water in decades. An object in the middle of nowhere, now devoid of purpose, along the coast beside a skinny dirt path. It lies close to the village of Hadasu, a village with few inhabitants, embedded in an ocean-facing cliff, stairs connecting small rice plots and homes.

The day I first saw the boat had been long and hot. This was years ago. I turned a corner and ducked below some underwear—gray and worn with stories to tell—drying on a line in someone's backyard. There it lay, like a glitched rendering: the boat. Subsumed by earth, like a half-buried coffin, topmost edge of the wooden hull describing what it used to be, otherwise filled with dirt and grass, like earth itself rose up and half-ingested the thing.

It reminds me of the suicide boats the old priests used to head out on just off this very coast. They called it *fudaraku tokai*—"voyage to the southern Buddhist paradise." The "Book of John" explains it as a simple thing: The priests would enter a little shelter built on a tiny wooden boat and be nailed in. A single sail, no oars, no windows, taken by the current—an extreme form of worship wherein they hoped to arrive at that southern paradise, the home of the Bodhisattva of Compassion.

How many times did this happen? Not many. Maybe twenty or thirty times over a thousand years, but you don't need many suicide boats to be remembered. John thinks it was pragmatic—old priests about to die anyway, why not go out with a bang? Make your temple famous. Increase the alms from parishioners.

This boat, not a suicide boat (you can see an example of one of those down near Nachi Falls), just a boring little boat. But a boat that once pulled life from the water. I've watched it over time, passed it many times. Each time the ground rises a little more and the boat sinks in equal measure, and here it was today, once again.

Beyond suicides, it never fails to bring to mind dust around ankles, dust on the body (our old friend Bashō), volcanic-dusted food stalls in Pompeii. Annie Dillard wrote about dust, once, and I can't help but think of her passage: "Earth sifts over things. If you stay still, earth buries you, ready or not."

What dust covers this boat? The kind of dust drummed up from the ocean, by a coastal breeze. Dust with the skin and bone of those priests, whales, dolphins, pilgrims. Dust as old as the earth itself. It eats the boat: dust. Subsumes it. The boat lies next to the path disturbing an otherwise flat plot, perhaps once a garden or small field, now empty save for a bare tree. To the left, a stone-walled stream, rubber drainage tube. Around it all a thin wire fence keeping us walkers out. The footprint of Kōbō Daishi lies just a few miles south. Twenty more years, no more boat, nothing but grass, all the dust you could want, ready or not.

PARKINSON'S

Hope. The cloudless sky and generous sunlight fills me with hope. I walk one pass and then another and another and another along the Hongū-do—the two-day route connecting Kumano City and Hongū. I eat an egg sandwich in the shade of someone's stoop. I throw chocolate-covered cranberries up into the air and catch them in my mouth. I whistle a made-up 1950s tune at an obnoxious volume and imagine Bing Crosby crooning it in black-and-white. And eventually I amble back down from the mountains to the ocean for a rice pilaf filled with tiny shrimp. My seat faces the sea and the famous "Shishiiwa"—a rock that is said to look like a lion's head.

The kissa owner exhibits signs of early Parkinson's disease. I had watched my grandmother struggle with it during the last twelve years of her life. The tells are often clear once you know what to look for. Like learning a new word, suddenly it is everywhere. Toward the end, the disease curled my grandmother into herself, turned her hands into iron fists so tightly wrapped that her thumbs broke, had to be amputated.

When I was a child, my mother was always nearby, ready to dole out hugs and help me with homework, but also with her head in a book, every free moment spent studying to be an elementary-school teacher. She showed me what diligent focus looks like, but it was my grandmother who ran the home, made the operation sing. Cooking, picking tomatoes from our tiny patch, vacuuming, organizing our bills. Kept the house and our lives in order, force-fed Peppermint Patties to all of my friends (you especially, Bryan). Woke me up with

tears and pleas—PLEASE CRAIGY, PLEASE GET UP—when I refused to rise on certain school-day mornings. Once, on a trip home from college, I went to help her out of her chair, gingerly placed my arm around hers and lifted. Snap. She screwed up her face but wouldn't let on that I had just broken her humerus. Didn't want me to feel bad. Still to this day one of the truest acts of love I've witnessed. She held that pain in for weeks, finally "caught" sometime later when a doctor asked, When the heck did this happen? I knew how these things could end.

The kissa owner fidgets. A cup of coffee quivers on its saucer as she carries it across the room. She repeats gestures as she puts the plate of pilaf on my table: placing and pulling back and placing again, as if to check or double-check the synaptic misfirings that are happening, the disconnects between her intention of positioning one object against another and the sharded reality and tenuousness of her delivery. Internal systems failure. It's crushing, but it also feels nice to be reminded of my grandmother, who made sure we were all okay, served a mean fried bologna, and suffered, I'm sure, in her own many ways, ways I'll never know or understand.

The owner tells me she never intended to own the place. But the guy she married turned out to be a nudnik, couldn't hold a job, and so she entered the kissa game. Took over this shop from someone else thirty years ago. That husband was now long gone, but she keeps at it, loves the work, loves the view. She is buoyant and chatty and her arms and legs have the delicacy of a finely made marionette, shaking as if animated by the beating heart of some puppeteer above.

The shop is supposed to close at five and I notice that it's five fifteen, so I shut my mouth and pay and thank her. I walk back to my inn along the shore under the last of the day's

light. The waves break and break some more, like how a disease overtakes the body, or how a peninsula consumes itself, collapses, starts again. Given enough time, a ceaselessly bashed seaside mountain briefly becomes a lion.

KŌYA FIRE

Do you remember the lighters—cheap, plastic, pocketed at gas stations? How we spread them throughout the landscape of our childhood? Hid them in tree hollows, in metal boxes buried behind that barn? (Are they still there? They must be.) I know now what we didn't know then: that to have fire nearby was to have power. A little spark, a tiny flame with the potential to burn it all down.

As I walk Kii, I feel the pulsing energy of Kōyasan and its many temples nestled in the heart of the Peninsula—as if my skull was full of iron filings and Kōyasan was magnetized true north. It's pretty tough to access, even today. The work to have bushwhacked through the subtropical growth 1,200 years ago, to have climbed these endless peaks, and then to have constructed hundreds of temples can only be defined as mania, a deep-seated piety, a truly committed faith that this spot, this very spot, was the one and only on which to build a site of total worship.

The "Book of John" tells me Kōyasan is an 800-meter-high basin surrounded by eight peaks—a lotus plant in stone. He tells me it is the most sacred Buddhist site in Japan. That 117 temples are still around today, though that's way down from the peak. The graveyard, he tells me, contains the graves of over 60 percent of feudal lords from the fifteenth and six-teenth centuries. The first and second Shōguns—Tokugawa Ieyasu and his son Hidetada—have graves here. That's how much mindshare this place held, a place known and revered throughout the land. A kind of grave Valhalla. Women were banned, John says, from the most holy of its sites, its most

inner areas, until 1872, when a twenty-one-year-old named Ichino Kayano ignored the rules and just up and started living there. Everyone was upset, of course, but she held her ground, and now anyone can go almost anywhere around the site.

Today, the circular path restricting female access to around the perimeter remains: It's called the *Nyonin-michi*. It's a good route if you find yourself up at the top looking for a hike to occupy a few days.

For years I spent New Year's Eve up there, inside the Nyonin-michi, among the temples and the graves. It soothed to be away from the crowds of the cities, the parties, the drinking. Toward the end of my twenties I began to engineer more and more things into my life that deliberately took me away from alcohol. I'd hike up this mountain on December 30th or 31st, sleep in a small tatami-mat room for monks, eat simple meals of soup and rice and those fresh mountain vegetables, observe the fire ceremonies from afar.

As snow would fall on the last day of the year, there before me: a massive torch carried on the shoulders of a dozen men in indigo robes, circular forms on their backs, unlit paths, a few dozen spectators tripping alongside, the odd person falling into one of many ditches, ditches that seemed to be everywhere. All of us supernumerary to the glow. Those cloudy late-December nights dark as heck, starless, no light save that barely controlled burning held by men.

The mountain priests are voluble when poked. A so-called Shinto-Buddhist syncretic ceremony, they'd say, this burning thing. Held on to despite those nineteenth-century Meiji-era edicts demanding tradition be broken, banning ceremonies just like this. Edicts meant to keep Shinto "pure," casting aside any mixing-in of Buddhism. For most of Japan's history, Buddhism and Shinto intermingled with admirable fluency, tem-

THINGS BECOME OTHER THINGS

188

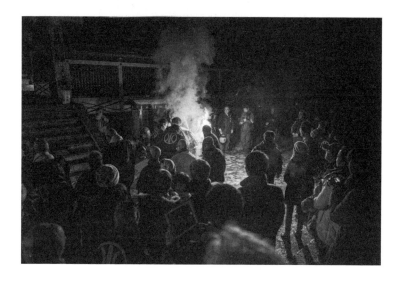

ples and shrines right next to each other, sharing gods and prayers. But once the military government—the Shōgunate—was overthrown by the Imperial Court and Meiji government at the end of the nineteenth century, they needed to hammer home the origin myth of Japan, the purity of its people. Japan was different, special. Anything from the outside wasn't "real" Japan. (A weird notion considering so much in Japan has been borrowed from China and Korea—writing systems, pottery technology, language, DNA—but maybe that's why they were so sensitive: Shinto is one of the few outright native creations.) Buddhism wasn't explicitly banned, but as a holy place you had to choose—shrine or temple, Shinto or Buddhist. You couldn't have both. The Kii Peninsula was far enough away to ignore these federal mandates. In part, that's why this spit of land is today so culturally valuable, why the UNESCO World Heritage listing was granted: Syncretism between two spiritual frameworks is a rarity worth celebrating. And, anyway, the priests told me, it wasn't ever impure, that intermingling, it was always harmonious. Remarkably without compromise

or strife. A ceremony like this is one of grace and clarity and great danger—a forcing function to train one's attention through the use of fire—where the true form of Buddha temporarily becomes a Shinto god. Having the yoyū of mind to allow for another's god in your home—a notion today more important than ever.

If the outdoor fire ceremonies seem nuts (huge flames, dark paths, a profusion of possible injuries), the indoor fire ceremonies are nuts squared. Enacted almost daily in tiny halls—low ceilings, shuttered windows—the priests would perform *goma-taki* morning rituals as they had for centuries. Only recently were sensible laws passed demanding adequate ventilation. I've been to the old ceremonies—covered in smoke, filled with smoke, purified by smoke. Beautiful movements of the hands of the priests as they stoke the flames, wave prayers above them, burn the tablets written with the pains and desires of those in attendance. Movements from another time. But the rate of lung cancer among the priests was too high to ignore.

With all these fire ceremonies, you'd think there'd be uncontrolled fires, destructive fires, and there were. Important structures are often replicated (like, entire backups built nearby) so if anything happens, the prayers can continue uninterrupted.

Even so, out in the cold on New Year's Eve, the huge torch burns. The crowd: mostly men, fathers and sons. Men who look on with suspicion and fear and awe at the great burning thing. Men with glasses cast orange, firelit faces, men with bowed heads, Rembrandt colors. No worries about ventilation beneath the stars. I am with the crowd but watch it alone. Feel apart from it all. (A feeling that comforts.) A single point witnessing the sublime, the old. Flame aloft, the ceremony

creates security and abundance through danger. An impulse you and I understood well.

Nearby, Hōjū-in Temple, a backup for Kongōbu-ji, the most important temple up here. The hint of a torii gate in the shadows. Sparks in the air, snow on the ground.

Snow still falling had been falling all night.

DEET

Before heading out I spray a generous amount of bug re-
pellant up and down myself and suddenly realize that the
entirety of our childhood was a Time of DEET. With the
tangy punch of the chemicals I'm back in the woods, eight
years old, at the trailer park of my mom's boyfriend, that
truck driver who shared a name with a famous cartoon-
ist. We ate canned beans and Fruit Roll-Ups. The air was
filled with the scent of charcoal and burnt wood. You never
came. Maybe I was too embarrassed. Or my mom was. For
whatever reason, this section of my life was cordoned off.
Everyone in the woods in ratty T-shirts and jean shorts. I
played with his kids, kids you never met. For lack of toys
and oversight our games were simple and dangerous, like
breaking rocks. Just hold that down, his two dusty-faced
children said, my hand around a small rock atop the smash-
slab. Don't worry, they said, lifting a rock the size of their
skulls. And then: an explosion of pain lighting up the whole
trailer park. That must have been the same summer I tasted
beer for the first time, the boyfriend giving me a sip as a
joke or maybe in an attempt to shut me up, to quit my
screaming about my finger, and me, spitting it out in shock,
wondering how a person could drink a whole can of that
stuff.

Later, surrounded by old-growth cedars, passing moss-
covered graves of fallen pilgrims, I climb to Ōgumotori Pass
and try to figure out how old my mom and her boyfriend
would have been. Almost a decade younger than me in the

moment. Middle finger, left hand—never been perfectly straight since. The great amusement of that summer was showing it off, the splinted digit. I remember flashing it at your mom, all of us laughing as I said, This one, definitely this one—and gave her the bird.

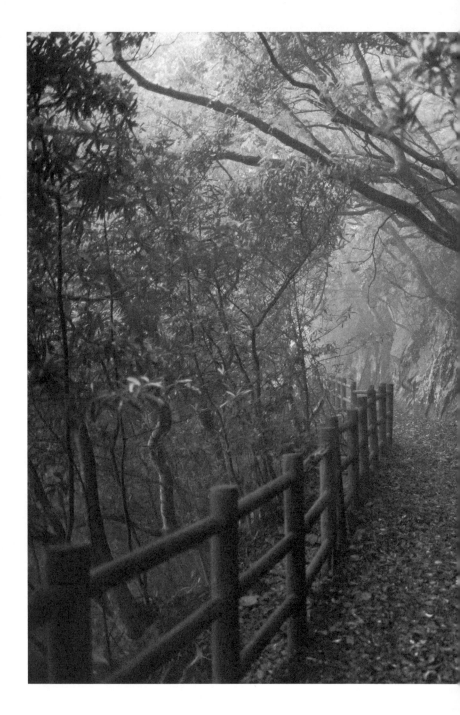

Lying down in Hongū for the night, I open the "Book of John" and it just says: Remember Cobalt.

An evening, years ago. John and I had walked the few hours from Hongū to the tiny lumber village of Totsukawa.

Along the Kohechi route, Totsukawa is a mountain crook of a village with a couple onsens, a few bars, and not much else. A place called Cobalt had been around for decades. A so-called *sunakku* or "snack bar." Basically, a nighttime kissa. Cobalt: great name. I'd seen it a dozen times on a dozen other walks and each time thought about popping in in the same way you might contemplate a shave at a street stall in India—inquisitively, but without the energy or guts to go all the way.

Now, with John, it was easy to go in. We were zonked from a big day of walking, yes, but also curious. Three other customers sat at Cobalt's short counter. John sat next to a shriveled, surly-looking fellow on the end of the bar, and I sat next to John, and the other two customers were next to me, and just like that there was no more counter to sit at.

Behind the bar, the Mama preened with her blue mascara and bouffant perm.

You know, she said—slurring her words a little and making eye contact that would turn the pope red—men are *the* most beautiful creatures. *Vaaaaastly* more beautiful than women.

Nobody moved.

Women must wear makeup. Men—*oh,* if men wore makeup it would be the end of times, their beauty is too great!

The Mama continued in this vein. A Korean soap opera

silently played on the overhead television and the two guys next to me chatted between themselves.

After some time I noticed that John—who is objectively large as humans go, over six feet tall, a hundred kilos give or take, very obviously not Japanese—and the tiny old man at the end of the counter were deep in discussion. The Effect was in play. The little dude, who couldn't have been more than a third the volume of John, was now stroking John's arm, holding it up to the light like a ham, wistful, declaring to the bar, Look at this beautiful hair! Oh, how I wish my arms were hairy like this!

He was a retired logger. Late eighties. Wife had passed a decade back. Born and raised on the Peninsula, just down the road, he had worked his entire life in the mountains, refused to live with any of his many children or grandchildren. Though he lives alone, they keep a close eye on him, and allow this one indulgence: Patronize Cobalt each and every day as long as he's home and calls before nine.

The clock in the corner of the TV ticked over to 20:55. On cue, the old man bolted up and began to hold forth: I have never spoken with a foreigner before tonight. (Truly?! I hear you ask, and yes, probably, truly.) And—he continued, now steadying himself against the bar—I used to think they were ferociously scary, frightening things.

Then, softly, *But . . . now I see—that's not true.*

And with that he leaned over and cradled John's head with his shaking hands and gently placed his lips upon John's cheek.

Goodnight, goodnight, he said as he shuffled off to make his call, to keep his promise, to tell his kids about the lovely ham he got to stroke.

HONGŪ

After spending a night in a guesthouse run by a quiet mountaineer—a volunteer for the local rescue service, a guy who is fastidious in his cleanliness, and mercifully serves coffee and toast and eggs for breakfast—I take a full day off in Hongū. I sit on the grounds of Ōyu-no-hara with an egg sandwich and a bottle of green tea. Sit right where that calamity of 1889 happened, where the Grand Shrine of Hongū once stood and then was washed away. Today it's still considered a sacred space, a power spot, home to eight deities, but kept mostly empty, covered in grass like a park, a holy park, one where you shouldn't play Frisbee or walk your dog. (But an impromptu egg sandwich is fine.)

Through a thin strand of trees I spot the mighty Kumano River. The "Book of John" tells us: Traveling upstream against the current from major shrine to major shrine, from Shingu to Hongū, Heian-period court noble Fujiwara no Munetada notes in his diary: Yelling out in tremendous voices, the boatmen thrust their oars into the dark waters and push with all their might. Their bodies fall nearly level with the hull.

This—Hongū—is where many routes on the Peninsula converge. The beating heart of Kumano and Kii. Hongū. A place wholly venerated: the river for providing water for rice, the mountains for being the source of the river, and the trees and plants for purifying that water en route to hidden aquifers. Even the riverbank is an object of worship. The deities of Kumano descended into an oak tree on this sand-

bar in the form of three moons. So declares the legend connecting back to the founding of Kumano Hongū Grand Shrine in 68 B.C.

Legends, gods, an oak tree! Our backyards—oaks and pines. For as much time as we spent up in the branches of the oaks, picking up the acorns of the oaks (hood-whistles against our lips), I don't think we ever imagined gods descending into them as astral objects. If *these* were the stories we heard on Sunday at mass—would they have made us believe?

Bryan, I've explained the differences between Shinto and Buddhism, but perhaps the "simplest" way to visually differentiate is that shrines have torii gates: markers between the secular and spiritual. And the biggest in the world is right next to me, right at the entrance to Oyu-no-hara. The "Book of John" serves up a heaping plate of facts: 33.9 meters tall and 42 meters wide—biggest in the world. Go smack its side: steel. 172 tons. Six months to make. Six months to assemble. This version is relatively new, reconstructed in the year 2000. (As we've seen at Ise, Japan is at ease with reconstructions.) The oldest form of a torii gate is two wooden posts with straw rope strung between them. Under influence from China they became more complicated. The largest *wooden* torii is at Miyajima Island, near Hiroshima.

To give you a glimpse into the absurdity of my life, of how far I've traveled from our town, I once took Jeff Bezos (he had been knocked down a rung to the world's second-richest human at the time) on a little walk around these parts (don't ask; long story). As we approached the grand torii, I relayed the facts, told him it was the biggest in the world, and he turned to me with the widest eyes I've ever seen and said in his singular Jeff Voice: LET'S BUILD A BIGGER ONE.

It was near this mega torii of Hongū, the one Jeff Bezos

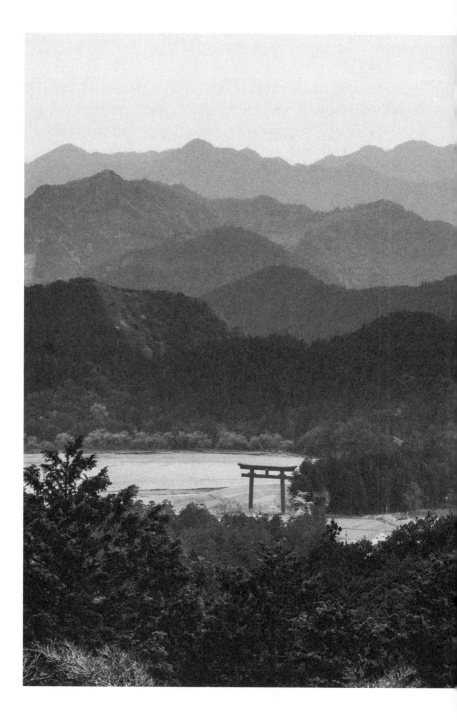

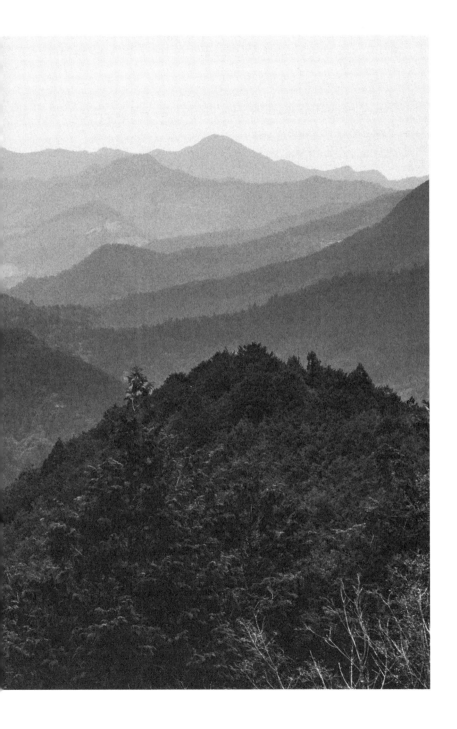

wants to dethrone, that the eleventh-century mid-Heian period female poet Izumi Shikibu wrote the following on pilgrimage:

> *Beneath unclear skies*
> *My body obscured by drifting clouds*
> *I am saddened that my monthly obstruction has begun*

In a dream that night, a god of Kumano came to her and said: *How could the god who mingles with the dust suffer because of your monthly obstruction? Even deities suffer from impurities so who am I to judge who can and cannot worship?*

This legend codified the female-inclusive nature of Hongū and the Kumano area. Even though some parts of the mountains, and Kōyasan's inner sanctum, remained off-limits to women, much of Kumano Kodō was open and welcoming.

Nearby, on the other side of the visible mountains, over Dainichi-goe Pass, is Yunomine Onsen, with "Tsuboyu," its World Heritage bath. A World Heritage bath you can actually

slip into, unlike the Roman baths in Bath (off-limits to bathers). Tsuboyu is impressively banal—a nook in a rock on the side of a river. The nook burbles with scorching milky blue-white hot-spring waters. You gotta stir the waters up good with a giant wooden spatula to lower the temperature a few degrees, lest your dunk turn the bath into soup. In fact, the water comes out of the ground so hot that the whole river steams. Locals cook eggs in it—the river. Only takes thirteen minutes. Above the nook they've built (and rebuilt as it gets washed away in storms) a wooden structure for privacy. In April, fathers enter the bath and dunk their two-year-old sons, carrying them then on their shoulders up over the pass, over to where I sit, these holy grounds, and then up to Hongū Grand itself. The "Book of John" tells me that once dipped, those sons are "imbued with the gods of Kumano." Can't let their feet touch the ground until they pass that giant gate, until they get to the safe space of the shrine.

How does this change a father? How does it make a son feel, to be whisked over a mountain on strong shoulders? I refuse to believe these aren't important acts, maybe the most important. Myth used well—myth translated into the joyful, the ridiculous, the meaningful.

I sit basking in the sunlight atop grass that is as much a god as anything I can see. Above, the crows circle and caw as they have for millennia.

IMMUTABLE STUFF

As I walk, Kumano deities manifest physically—the mighty Kumano River, Nachi Falls, the Gotobiki Iwa rock in Shingu, and more.

When I imagine the Peninsula as a god itself, I see a creature for whom it's as easy to summon a thing into being as it is for us to say a word. The Peninsula desires a shack and by that desire—of earth and rock and worm and leech—a shack manifests. The Peninsula desires an abandoned barn, and there it is, as it always has been, for as long as the Peninsula wants it to be.

When I was a kid, the whole world felt preordained, immutable. Everything about the old town simply was, always had been, and always would be. There was no old town without you, Bryan. Of course you were there. Of course we met. This was the way it was meant to happen. What agency did we have? Minute by minute, it felt like we had all the autonomy in the world. But over the long arc of our childhood? Almost none. Some god of airplane-engine factories consecrated it all, and thus from the tobacco fields we rose.

...

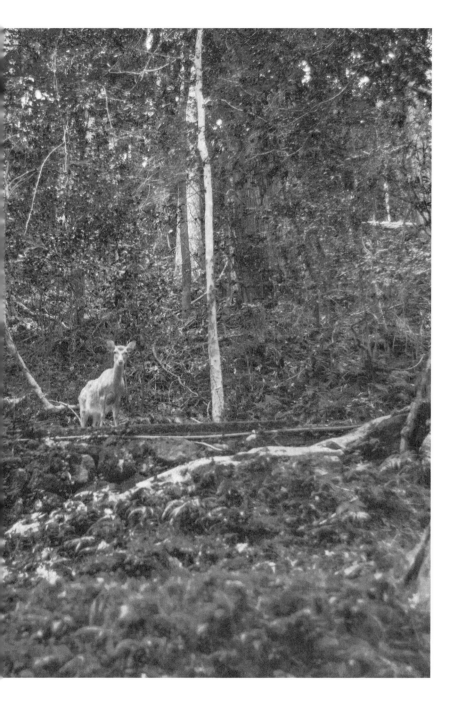

GYŪBA

Deep in the forest on Hashiori Pass sits a Meiji-era stone statue dubbed "Gyūba Dōji." I consult the "Book of John": It depicts the young Emperor Kazan straddling a horse and a cow, the first emperor to make the imperial pilgrimage to the Peninsula. *Gyūba*—"cow horse." *Dōji*—"young child." I have a theory, John writes:

> This was the first emperor to take this pilgrimage, way back in the late tenth century. The young emperor riding both animals becomes a Buddhist triad: Kazan as Amidha, flanked by two protective Bodhisattvas. Or maybe the idea is that one should approach the pilgrimage slowly, at the pace of a cow, and leave with brisk vitality, like that of a horse.

Slowly or quickly, on a June afternoon not so many years ago, someone noticed that the head of the statue—the emperor's noggin—had been sliced off. Newspaper accounts relay that some three hundred locals searched in vain. Searched the mountains and searched the shops—pawn and otherwise—as far off as Osaka and Kyoto and Kobe. Searched for second-hand hucksters. And then some other scoundrel, maybe even the same one, went and stole a patch of beloved moss over near Koguchi—just cut it from an ancient rock and lifted it like sod, thick as a couple sandwiches, a meter square—tried to barter it as World Heritage goods to various disreputable horticulturists. It was a bit of a wild time, all this small-stakes thievery in a place with almost no crime, small or large. Today,

I walk past that mossy rock. It's coming back, the moss. Not quite like it used to be, but leave a rock in a wet forest long enough, and it will do what it wants to do. I gently pet it, wonder how long it will take to return to its former splendor.

About that head of Gyūba—a replacement was fashioned and secured to the body using a stainless-steel bolt. And then two years and almost two months to the day: a head. The head. Found at the Ayukawa bus stop just a few kilometers away. They never reattached it. Sometimes, when the mood strikes, they like to show it off at the local museum.

I don't pass old Gyūba on this walk, but when I do, I get close, think about how almost certainly you and I would have done the stealing as kids, hacked it off for fun, thrown it down a ditch, fished it out and plopped it on a bus stop when the guilt had eaten away at our guts. I like to touch the scar on its neck, a scar I'm not responsible for, but feel as if I know the hearts of those who are.

SHALLOW ROOTS

Years ago, today's route was closed. It had been officially off-limits for ages, and replaced with a detour long and boring. The lack of progress annoyed me no end. In a burst of frustration, I walked up to Ishikura Pass—where DANGER was said to be—and took a peek. How bad could it be? What I saw: clean-pressed downage of *sugi*—Japanese cedars—snapped like toothpicks, thrown across the path by a typhoon. One of many yearly typhoons, typhoons getting worse and worse it seems. The Kii Peninsula already receives some four meters of rain each year. Increasingly the target of blunt-force climate trauma.

The first time I walked this peninsula I saw the muddy Kumano River, muddied they said because of a recent tremendous storm. The one that had killed this person's husband. The one that erased this mountain road. The one that all the diggers in the river were cleaning up, "fixing" the flow. The 1889 cataclysm on repeat.

But up on Ishikura Pass, in that jumble laid before me, I saw plain evidence of the post-war lumber industry. They over-planted sugi like crazy. Filling the forests with young sugi, industry sugi, *weak* sugi—shallow roots, roots all the same length, easily upturned by a stiff breeze. An *old* forest wouldn't be so easily bowed. You feel this monocultural forestry acutely in the nose and eyes in February and March. And you hear it in the silence, in the lack of birdsong along many of these paths.

I took a deep breath and decided to walk right through it all, right through the jumble. Dumb move. Halfway through,

as I clambered over and under the logs, they began to creak. If they had shifted just a few inches I'd have gotten crushed—legs, chest, skull. They were young trees, yes, but still trees. Idiot, I thought as I tried not to touch anything, as I wriggled my body between the trunks.

Perhaps the greatest mystery of our childhood was simply survival. We were protected only by the suppleness of our young bodies. Bryan, you and I nurtured reckless impulses as if they were ducklings. One summer afternoon: I dare you, let's bike as fast as possible and shove our sneakers between the front tire and the fork, see how far we can fly. We did it, flipped headlong and foolhardy forward, should have broken all our bones but broke none, bloodied our legs and elbows, scarred still, scuffed the hell out of our grips, rode with untrue wheels from that day forward until we gave up the bikes and childhood gave us up, moved us on.

Years pass. Today I walk the route and everything has been cleaned up. As I stand in the middle of what used to be chaos, surrounded by the clean lines of a lumber forest, I look at my forearms, my calves, wonder how close I was to losing a hand or foot. After having brushed risk so many times, long detours around danger seem silly. Pointless to a mind where—for so long—there were no detours, where little was done properly, where everything was a shortcut and without great luck, everything so easily cut short.

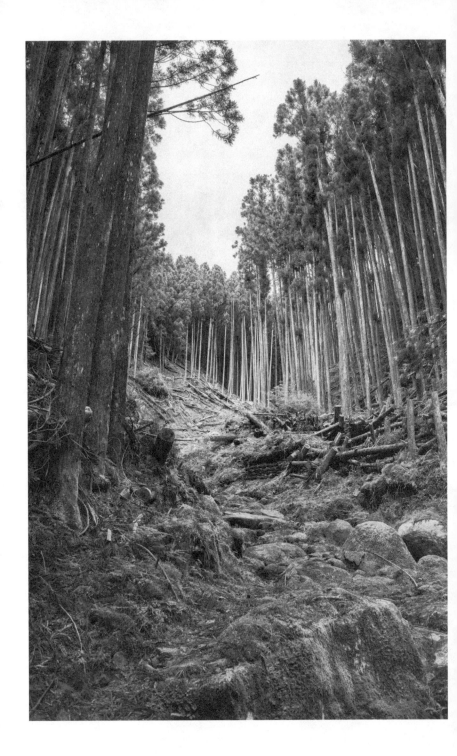

FARMER AND HIS CAT

Coming off a tiny mountain, a blip of a hill, a farmer moves aside to let me down the narrow route he was planning to walk. He has no hair or teeth. His skinny gray cat comes forward, locks eyes with me, stops, so confident. The cat's eyes are an electric orange. I reach down to let it sniff my hand and off it runs as though weightless. The farmer just nods and says, Good work. Not about scaring the cat, but about walking the path. I say, Thank you, sir (I like being extra-formal to farmers), and ask if the town is to the right or to the left at the fork. To the left, he says. The way the words come out of his mouth strikes me: They are said with a remarkable purity and kindness, contain no malice or judgment. It is almost as if he is speaking to a tree. I am happy to be a tree. Just head left, and you'll find it. And I believe I will.

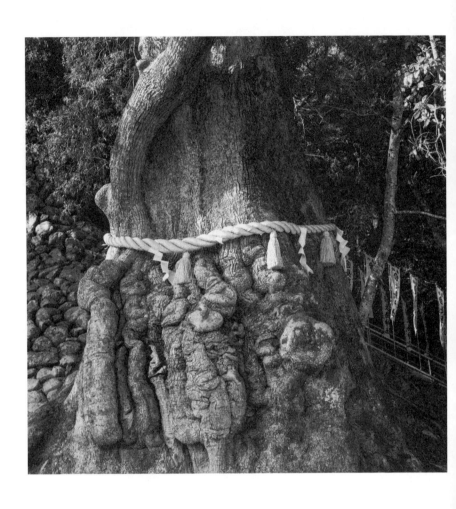

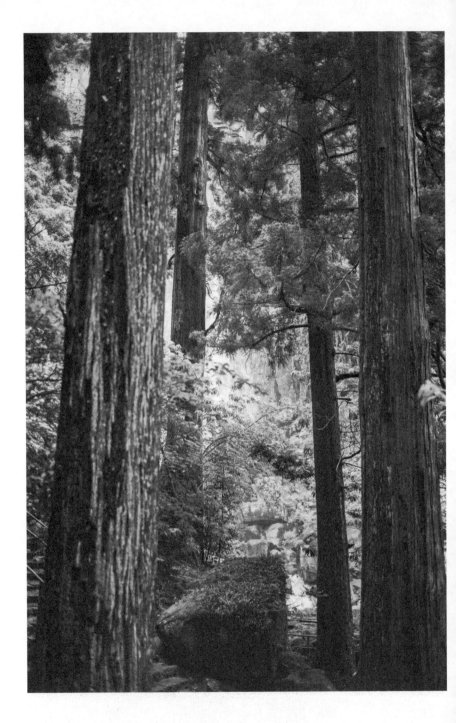

NACHI FALLS

Ferocious rain last night, clear skies this morning. Because of that, Nachi Falls are violent, pushing out a volume of water I've never seen. I'm here alone, have the spot to myself. (Thanks, virus.) I've stood before this falling water five or six times, and while pretty, sure, it's usually been demure, tall, but scrawny. Today, though, Lord—serious energy, serious power. I finally understand why it has been worshiped. The air vibrates with the fizz of the falls. The mist envelops me. I stand alone for fifteen minutes and trace the lines and clumps of particles from the top down along the rocky cliff into the pool below. Shape-shifting, swirling patterns, and within the swirls, febrile hallucinations: faces, horses, baseballs, seemingly anything else imaginable. It's nice to see these things. Bryan, that a holy waterfall can make me remember you, make me want to talk to you, is a testament to the pliability of our minds. Of all people, Rufus Wainwright appears. In the past I had once walked a stretch of terrible road for days listening to his baroque pop song "Poses" on repeat until his haunted voice felt like it was coming from the ground itself: "All these poses, oh, how can you blame me / Life is a game and true love is a trophy." There was a haunted echo of that song somewhere in the waterfall—the conducting, the chorus, an impossible trophy. A song of Wainwright's own youthful solitude in New York. A song of him doing his own kind of solo stroll, new black brand-name sunglasses in hand. Wainwright's middle name is McGarrigle. I remember you telling me your middle name, embarrassed, as if you had anything to do with it. It wasn't McGarrigle, that's for sure. But it was an old name

from an old place, much older than anything we knew, and I was jealous of its history. My middle name is nothing special, like an unsweetened Cheerio. I was probably staring too hard, too long at the falls. I was thinking of things that had no right to commingle so easily in a brain. But, it was the first time I had ever truly looked at a waterfall. As in, watched the water fall, doing so with an attentive gaze. I was glad to be mesmerized and glad to have traveled far.

There's a kissa up the road with a clear view of the falls. It has a second-floor window in the shape of an elongated octagon. The famous three-legged crow—the *yatagarasu*—adorns its sign. The same crow seen in illustrations and statues all over the Peninsula, adopted by the Japan Football Association on emblems and badges. The one said to have guided Emperor Jimmu, Japan's supposed first emperor, back in 660 B.C.; so says the "Book of John." The three legs represent Heaven, Earth, and Mankind. John goes on:

> The Foundation Myth of Japan states that Emperor Jimmu sailed from Kyushu to Osaka to battle indigenous tribes for control of the new country. The first battle at Yamato (the Nara region) was lost and he escaped, sailing down the coast to Kumano. It was here that he realized that he had lost the battle because he had traveled from the west, against the movement of the Sun Goddess Amaterasu. The yatagarasu guided him across the rugged Kii Mountains from the east to victory, thereby establishing the roots of Japan in Kumano.

And so, on this random kissa—that crow. Though I don't enter the shop, I always wave to the crow and press my face to

the glass to see what has changed. The shop is neat but odd, full of strange interior choices. Yes, like before, the shop's sink is still full of boxes of tissues. But huh, this time there are *even more* Tupperware containers filled with what looks like cooked spaghetti. The walls are covered in self-portraits (presumably of the owner). He perms his hair in tight curls, seems to bear an intense affection for his white minivan. There he is, standing in front of it—always alone, just him and the minivan—at

key points around the Peninsula. The café's always been there and I've never seen it open, never seen anyone helming it, but the door is never locked, a detail I make sure to confirm. Each visit I leave behind on the window a mark from the oils on my nose, take in the tableau, the whoosh of so much falling water in the distance.

ASCETIC PRACTICE

Because I was near Nachi Falls, the "Book of John" chimes in with a quote from a diary he found doing research, a mid-Nara-period diary from 749: "Faintly from the woods near Kumano, a sutra. The monotonous hum floated out, ambient and particulate. A party was sent to investigate and a decayed body was recovered. When we opened the jaws of the skull, the tongue of the corpse was found to be in perfect, fleshy condition."

John goes on:

> Nearly two hundred years later, in 915, Jozo, son of court Dainagon, Fujiwara no Kiyotsura [what a name], lives three years next to Nachi, beside those hundred-and-eleven-meter-tall falls. After conducting strict ascetic training, mastering the rites of fire, his prognostications come true and he performs miracles. Jozo writes: "Training in the Ōmine and Kumano areas provided me with these powers."

The Peninsula is filled with a history of men (mostly men) going deep into the mountains to perform a series of secret activities so painful and arduous that hazing doesn't begin to approximate their difficulty. These are the mountain ascetics. I've participated in three days of their training up in the mountains of Yamagata, and I can say with no hesitation: It is hard.

I wonder today what these men would have thought about the café with the three-legged crow, Tupperware, spaghetti.

How the general shape of the small village of Nachi was the same as it ever had been, but now with more gift shops, and pilgrims of an entirely different ilk. No retired emperors, just regular fellas. The big ascetic ask of a modern pilgrim was simply ascending a giant staircase.

Bryan, you and I were always in training. I can see this now. Training for what? Life itself. Growing up. Baseball. Whatever. We had no waterfalls. We trained in the ravine with a "river" fed by a sewer pipe. Our sutras took the form of increasingly profane words, our ascetic practices involved blowguns made from reeds, darts from sewing needles, and Scotch tape. Murder lurked. We always assumed a dead body was nearby. Just seemed like a certainty of youth, of our childhood, of the town. Something we anticipated with relish. We thought we found one—a body—in the woods near Dairy Mart, but it was just a drunk, passed out. Hissed like a snake when we kicked his thigh. Our power was biking as fast as we could, fire in the chest, away from things that might kill us.

SHOTGUN SHACKS

Shacks and shotgun shacks. Everyone a farmer. Hyper-territorial dogs. No one pays me any attention but the dogs—rough, neglected things. Bark bark bark. Yeah yeah I see ya boys, I see ya.

I walk on and also see a man who looks about two hundred years old, sitting in the kind of onesie pajamas I'd imagine a mountain person of yore wearing. Behind him: a pile of tin cans, stacked like a cairn. His house has four satellite dishes strewn around the yard, looking like relics of some lesser Cold War.

It's hours into the day's walk and a bizarre impulse fills my being: to get down on all fours and bark with the dogs, bark facing those satellite dishes, just to see what it feels like. I've felt untethered since leaving our town, since arriving in Japan. I am "here" but am I *here*? Perhaps this limbo makes sense to you now.

This impulse to transform myself comes over me at the most unexpected moments. What would it be like to be *this,* whatever or wherever "this" may be: A server at that diner with all the pickup trucks back across the ocean? The owner of a camera shop in Shinjuku run for sixty years? A crow circling Hongū? To be the one soaking in a tub in some house I pass during a night walk through Tokyo, classical music playing, the faint smell of a Hope cigarette in the air? To be adopted by an inn and make a life from that, to shed the past in some formal way, a way accepted as "valid" by society at large? This, my walking, what was this? A path of my own, unvali-

dated by anyone but myself? A dope drinking too much coffee—definitely that.

I see these sad dogs and can't stop myself from imagining living out my days on their chain, part of this landscape, the deafening shrill of insects rising from the woods.

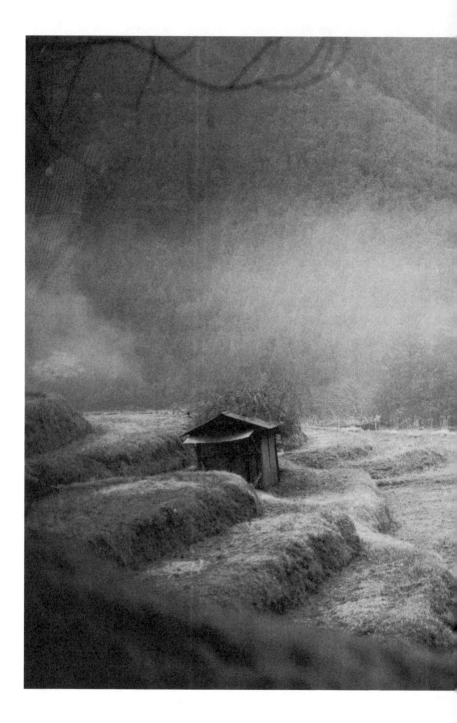

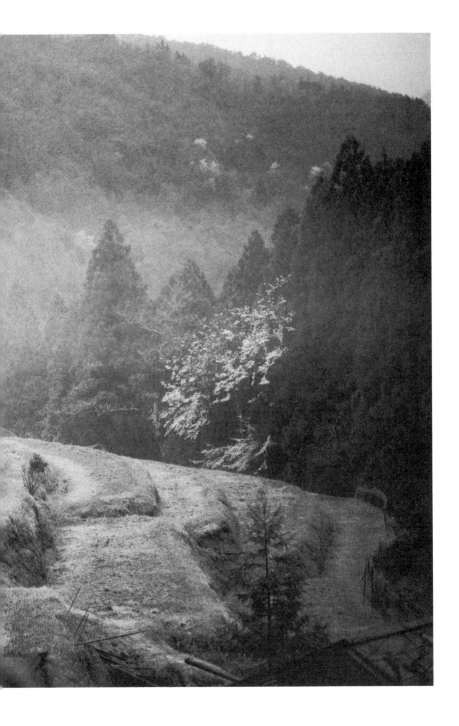

OKONOMIYAKI

Walking into Susami, I see a shirtless man clipping his finger-nails over the edge of his first-floor balcony, studying the bay.

I climb the concrete stairs embedded in the town's seawall—a huge pale fortification rising several stories out of the mouth of the bay, closing off the narrow entrance to the broader ocean. The top of the stairs is so high and feels so unsafe that a wave of nausea spreads across my chest. There are no guardrails. I imagine jumping off right there, that ever-present suicidal quirk of a living mind. Behind me is the Pacific. To my left, the little island of Inazumi with its Inazumi Benten Shrine. The sun is low. Its light spills over the small boats docked in the bay. One step forward and the fall would break my legs and more.

I stroll the golden sun-kissed village. Bupkis. I'm about ten years too late. A little *okonomiyaki* shop is the only thing open. Stick my head in, empty shop, owner—female, late sixties—watching TV. Got room for one? I ask. She looks at me like I'm vomiting the virus all over her floor. Wraps her mouth and head with her neck towel. I babble a little more, tell her how long and far I've walked, throw out a few compliments. She acquiesces, lowers the towel suspiciously, points me to the back seat. Says: You swizzle that thing and yourself good now with alcohol, yeah.

I ask her for grilled udon without pork, but *with* kimchi and she looks at me like I'm doing the viral vomit thing again. Okay, she says, if you want *that*.

She hobbles around the shop. Seasons the pile of vegetables

and noodles on the skillet with mighty shakes of salt and pepper tins. Mashes the mess with metal spatulas. Scrapes it onto a plate and hands it over and says, Don't know if it's any good 'cause I ain't never before tasted such a thing.

I chopstick a noodle, slurp it up, say, This'll do.

This'll do, she repeats back.

I tell her where I live and she says, Aww heck, I visited there last year. Took a plane. No. Took a train. No, took . . . a plane. Dangit. No, took a train. That's right. Took a bus. But first a train. Took the Shinkansen. First time ever on the Shinkansen. Can you believe it? Everyone laughed at me. First time?! And I says, I ain't got no reason to ride no Shinkansen.

I ask her how it was.

Wasn't nothing special, she says. Just a quick train, ain't it.

I ask if she's been abroad.

Taiwan and Korea, she says. Never been to no Hawai'i. Always gabbin' with my friend, let's go to Hawai'i, and we say it over and over and that's just where it stops. Ain't never getting there.

Her shop—her shack—is right next to the bay, and I ask if she ever thought about the ocean, waves, tsunamis.

I'm ready to die any good damn time, she says. No wall gonna keep that sea back. That's fine. Too much junk anyway, needs a good cleaning out.

Back in our town there'd have been something vaguely biblical about her prognostication, but here, no, it was just as plain a fact as any.

So you just walkin' all over, huh, what a thing.

I finish the noodles. Perfection. You should add this dish to your menu, I say, smiling. I had sensed a growing gaze of fondness upon my slurping. I want to stand up and walk over to her and squeeze. Her form is spherical. Her teeth are filled

with silver. Her fingers, doughy pads. Eventually I say, Thanks for putting up with me. I didn't mean to be a burden, just wanted a hot meal. And she laughs and shakes her head and says, Pay up, hon. Someone else might come in any minute now.

DISPATCH: THE HOTEL

About the hotel for the evening, I'll say this: The view is lovely. Waves lap in near-darkness. The bath is totally fine, but it's skirted by a huge, unfinished slab of concrete flooring, drains around the edges. Looks perfectly suited for hosing down a horse corpse. Or melting human bones. If murders haven't yet happened here, they will. The laundry room is unlike any I've seen. I refuse to believe it can render anything clean. The manager works without appropriate precautions, maskless, shifts uncomfortably under ordinary gaze, seems like a man concealing terrible things and doing so badly. I'll be leaving early tomorrow morning and skipping breakfast.

KISSA RON

I wanted eggs. Kissa Ron looked up to the task. Looked the apotheosis of *shibui,* which translates clumsily as an "impossible cool," or "aged cool," or maybe "rusty cool," or even "somber cool." Old men in well-proportioned vintage suits are unintentionally shibui. Turn-of-the-century buildings run by folks who don't know the architectural gem they got on their hands—shibui. Kissa Ron is like that. Lights off, golden morning light, Venetian blinds half-drawn. Ron is dark in a pleasing way. No-smoking signs line the walls. And yet, men with snow-white hair arrive alone and pick up ashtrays. It feels like a Raymond Chandler scene. Feels like I've crawled into a cigar.

The brown ceiling paper is stained and peeling, but the old globe lights look handsome just hanging there. "Tonight, I Celebrate My Love" plays on an overhead speaker. Peabo Bryson and Roberta Flack croon to each other. The romance is overwhelming. I eat one heck of an elaborate breakfast: coffee and toast with butter and jam, a fried egg, a Chinese-style salad involving seaweed, a scoop of cold spaghetti, a dollop of potato salad, and of course . . . pineapple? It would have come with bacon too, but I haven't eaten mammals in over a decade, so I had her leave it out. The "her" being the owner. She operates without discrimination, Welcome, welcome, sit wherever you like.

These kissas meld together, in the moment and in the mind. That's—in part—the point: a static variable within the dynamic churn of life. Something familiar, as if to say: Yes, you know this. A kissa here will mirror a kissa there. Kissas

across the country toe the kissa line and toe it well. Kissa Ron has its own unique qualities (like the latticed wooden barriers between seats providing something like privacy), but it shares remarkable swaths of DNA with a kissa in Hakodate, a kissa in Kagoshima. That blighted hotel was serving fish this morning. A man can eat only so much morning fish. I craved toast, eggs, burnt coffee. There was a near-100-percent certainty a kissa would deliver. This despite there being no kissa regulatory body, no secret parent company owning them all. Shibui is their default aesthetic, born of a certain moment in the mid-twentieth century, the Shōwa era, carried forward without affect or self-awareness.

Inside Ron, next to the entrance: an elegant, classic wooden telephone booth. It contains a vacuum cleaner. I ask when it last contained a phone and the owner explains that if you don't put at least 5,000 yen worth of calls through a public phone each month, they disconnect it. It was disconnected over two decades ago. Dethroned by cellphones, the neutered booth remains. A good prop and a useful closet in a dark room full of silent old men, rising smoke, tinkling silverware, porcelain placed against porcelain.

SPIRALS

You won't believe it, but I still remember it to this day. Your number. A number I'll never forget. A number I've dialed a billion times: 569-7441. That there, the most intimate thing I've ever committed to text. It almost hurts to write it down, like sharing a mantra, like sharing the true name of love. Not words, but primal, more pure, mathematic. Atomic. Like a helix on a standard pad. The singsong of those tones is one of the sweetest I've known. Same now as it's ever been. A melody of connection, of friendship, of annoyed older sisters, soon pregnant, slamming phones after yelling, Craig, stop calling *SO GODDAMNED MUCH.*

THE BLUE HOME

Fueled by the bounty of Ron, I walk the town of Kushimoto. The sun is directly overhead and the air is infused with the scent of the ocean, which is right there, just there, and if not always visible, always shifting the air pressure, however subtly, always pulsing nearby.

A hunched woman disappears into the shadows of a vegetable shop. A cemetery covers the face of a hill, graves just high enough to avoid a minor flood. Homemakers hang laundry and futons out along cinder-block walls. I stop and watch the *tonbi* kites circling above near their mountaintop nests. Hundred-year-old Taishō-era houses of a Western style remind me of the coastal homes back across the ocean—single-family, simple structures, agricultural, almost like barns. The paint of their wooden-plank siding weathered by a persistent ocean breeze. And in seeing that, I remember the coastal boardwalks where, I was told, my grandfather would sell whatever he could get in bulk as a kid—newspapers, clothespins, onions—and later go on to sell pens door to door, company to company, between shifts at the factory. Sort of like us two, you and me, Bryan, going around, collecting cans in black garbage bags, dragged on the road, a wake of clamor, hauling them to the supermarket to shove in those return machines. Hands and arms sticky with the drizzle of soda and beer, pockets full of wrinkled bucks and nickels, big dumb smiles on our faces as we walked home beside the fields.

· · ·

The sun is crushing. I'm comically drenched by my own juices. I duck down a narrow alley to find shade and come up

short. It's so hot that I sneak into someone's yard and crouch in a sliver of darkness below a well-manicured bush, pull out my water bottle, chug it with desperation. And when I finally open my eyes, there it is: a blue, wooden-shingled home plopped in front of a gravel lot and bone-dry vegetable patch. Peeling paint, windows framed in white. The roof is Japanese, tiled, but the aura of the whole thing—the well-used quality of it as an object, painted the color of midday sky—teleports me like falling on my back from antics in an oak tree, like having all the air knocked out of my chest: It is summer and you and I are running around your own blue wooden home, a place of absolute joy. I never told you how much I loved that place, how much it meant to be there with you, near that home. This was back before everyone replaced their shingles with vinyl. ("You never have to paint it!") The wood held our memories—a house worn and used, used up. We'd have used it up more if possible, if it didn't drive your parents insane. In the moment, as a child, I had no words for my emotions, but now I realize that I was filled with the desire to enter the walls of that home and seal myself in. Evidence of our play abounded: in the ruined lawn and holes in the yard, in the makeshift baseball diamond with a trash-lid home plate. But most permanently in those walls, the walls of the home itself, the blue walls chipped and dented by wayward rocks and high balls. You throw me one, a high ball. I back up, back against the rough shingles, pushing myself into your home and I'm too scared to catch it with the glove in front of my face. I hold it down low, like I'm scooping up cat litter. Come on, Craig, you say, you got this. Trust the glove.

Crouching under that bush in Kushimoto, five thousand miles from your house (is it still there? If it was torn down, would the town collapse into itself like a black hole?), drenched in sweat from the blazing summer sun, I realize: You truly

were as close to a brother as anyone I've ever known. Best friend, of course. But more. We didn't need our connection to be ordained from god or law or even from blood. Where was that line of family? We drew it in the dirt with a fallen branch and crossed it together, telling the world to screw itself. We'd get into trouble everywhere—inland, shorefront, made no difference. Had each other's backs. We pissed in the tank of a lawnmower for no good reason. We chopped down a stranger's baby maple. We sprinkled gasoline on lawns, lit them on fire with our secret lighters. We ghost-rode our bicycles down the street just to see how far they could go. Once, my bike hit a car and was convinced I was going to jail. Many around us did. You know this. Our idiocy was an idiocy born from too much idle time and no sense of guidance. Where *was* the authority? Drunk, often. Asleep in a car with a hose in the window, stressed out of their mind. Deviance was our way to bond, to share danger and risk in the name of a connection we so desperately craved. Inhaling together a freedom like heroin, in an era before the opium epidemics. While my grandparents and mother were placid, chill, hardworking tee-totalers who drank mainly tea, rarely coffee, the other homes were rife with alcoholism or worse. Early on, I intuited that I could use computer smarts as a way to escape, but even that path wasn't without traps. One neighbor—an old COBOL programmer—offered me a bump of cocaine as he drove me in his red Honda CRX to a computer fair to buy a modem. I was maybe twelve. Another friend's home was known for a wall of guns collected by his father, a Vietnam vet. Switch-blades were trinkets to covet and often carried in pocket. A kid down the street, a few years older, invited us over. Do you remember this bullshit? Locking us in the basement? Came down wearing a gas mask and carrying a machete saying, *Welcome to hell.* In his waistband was a handgun. We were eight or

nine. The kid let us go after I burst into tears. But you—you were ready to fight, always ready to fight, to stick up for me, for something bigger than the two of us.

Each of these moments could have ended differently. The fights, always taken to the edge of terrible. I remember an instant in the middle of some strange neighborhood brawl, I almost stomped a kid's head. I had thrown him on the ground after he had punched me in the face. Foot raised, ready to slam but shifted a few inches to the side at the last millisecond. I came home with a black eye that swelled up like a grapefruit. In that fraction of a moment before putting my foot down on his skull, I realized I had a choice. I could choose to not stomp. I could choose to not ruin both of us. I was so young but this feeling was there. Maybe it was in all of us. Recognizing it felt like big Jesus was whispering his magic into my ear—*there are better ways.* How would it have changed for me if I had let that violence deeper into my bones? It would have ended differently, I'm sure. You showed me that. Because for you, it did. In the end you did fight, many fights, finally the wrong fight. The violence found you, entered you. Though your murder some twenty-six years ago didn't make sense to me then—an event I didn't have the tools or time or space to comprehend—I can now see how tragedy waited for us both. Your death, another tragedy in a town beset with tragedy: a fight in some moldy kitchen, a butcher's knife to the chest, bled out on a dirt yard under the stars. What did you say in those last moments? What did you see?

When you're seventeen, childhood feels close enough as to be endless and the memories so dense as for their loss to be unthinkable. The idea of talking with you—of remembering it all—has only grown more valuable as time passes. A long walk through a distant land, so distant from where we both started, and where you ended; I somehow made it out. *Shit,*

do I carry a jinxed guilt, an unshakable guilt? Of course I do. One, two, three, I rap on the table with my knuckles whenever I think of your murder. One, two, three, a strange anxiety tic from childhood. Still there. I squeeze my eyes and feel the same relief I felt in elementary school. Blinky. Resetting the bootloader of the mind. Turning back the curse. One, two, three. I've been tapping that for twenty-six years. Because I wonder always if I could have done more. Was there a way to pull you into my secret orbit of computers and geekery? The older we got, the more you veered bad. Not by choice—there was so little opportunity for choice—but by the tides of systems, schools, tests. You never did as well as I did. What could I have done? I ask myself this with every step on the road. But then I remember, too, how living itself—just getting through the confusing days of those years, where we had no real autonomy—was enough to run kids into the ground. Insidious, scarcity-brain stuff. Many of our peers were enfeebled, reduced by circumstance. We saw what was around. Few guiding lights, faint and flickering. It was all I could do to keep my footing, to build up those arcane technical skills and get moving, to get as far away as possible, and walk walk walk, walk it all off. You got this, Craig, you'd have said. *Trust* yourself, *trust* your shit. You aren't no motherfucker like them. You would have said that and spat. Man, could we ever spit.

SEAMUS

Keep walking, keep walking. I haven't turned toward your murder in decades, yet it lives in a small box in a windowless room down a dark hallway in the back of my mind. Emits faint noises daily. A blue house in the wild, synapses kicked loose, a peek inside that box. The weather today mirrors my inner world. Gloomy to say the least. Clouds from early morning. The rains returned. I worry again about leeches, check my ankles incessantly. My head. My arms. All day, I spit in your honor. Spit on everything I see. Can still hit a target twenty feet away, no problem. We were friggin' spitting Olympians.

The route is at elevation, but mostly empty backroads, almost no forest walking. Were I to be chopped up on a walk, today is the day. Banjos loom. I sing "The Ballad of Paladin" and imagine the day ending with Kiefer Sutherland and a dead body. We loved *Stand by Me* because it was a movie and a fortune about us. We were *seen*. Death death death. I pass few homes and the homes I pass are done, nasty, falling apart and covered in garbage, committed to anomie. I say hello to an old woman and she just says, They done saw a bear o'er yonder, watch yerself. I pass a giant makeshift kennel, crammed with some twenty dogs, strewn with Styrofoam and plastic bags and old rags and the dogs bark and huff at me as if to say, We have never known friendship and will never know friendship and we don't believe in friendship and will never be your friend for we know only this filth within which we live and BEGONE BEGONE RUFF RUFF. The sadness of these dogs seems to infuse this whole damn sloppy world.

These days—the bright days and love-filled days and days of hope, of course, but even these lost days, rotten days, soiled days—I want to tell you about everything I see and feel: the dogs, the road, the broken shacks, the abandoned trucks, the hog farms squealing with terror and doom. Man, you'd have lost it listening to those poor pigs. Their smell, walking through the stench of those animals soon to be slaughtered. The stink hanging in the air, like being waterboarded with a tub of rotten syrup. The stark terribleness of it all reminds me of a mongrel we once knew from childhood: Spooger. What a name. (The words that stick with us through the years.) Tormented at the limit of his leash (by us, by others), bloodthirsty, always just beyond reach. The poor dumb beast was never let inside.

I walk. My pack feels filled with bricks. The landscape itself becomes your absence. The road endless, the dreariness crushing. A sense of burnout lingers. The walk will end. I don't want the walk to end. The walk ending means being thrust back into the "world." Back into the distractions of it all. COVID or not, busyness waits on the other side of the walk, and busyness means losing this thing I have with you right now, this connection, this thin line of communication. I yell your name to those weak cedars with their shallow roots:

BRYAN, YOU DICKFACE.

Just as I'm sure you'd have yelled to me.

Finally, I make it off the mountain and over the mighty Kumano River and to a bus stop I had staked out on a map. The skies had fully cracked, and down the rain came. I'm breaking my walking-only rule, taking a bus, that's how thoroughly exhausted I am. Can't handle the thought of hiking over one more pass, soaked, pathetic.

And then, he appears: Seamus the Irish priest, lumbering across the highway toward me as I check and double-check the schedule. *Konnichiwa,* he says. *Doko iku?* Suspicious (of

any large body coming at me through the rain), I squint and say, Hongū, and he says, Oh, just get in yous, we'll get you there. The bus is coming any minute but Seamus won't have it. Get in get in, that's just down the road.

He came to Japan in 1967, sent on assignment for the church. Lived in Tokyo then Kanagawa then Kyushu. Now lives around here. Was no trouble at all to drive me.

You're a great man, Craig, a great man. You're mad, mad! But a great man. I can see it all over your dripping self, this mad greatness. It's a wonderful thing now, madness, isn't it?

I tell him where the walk had started, hundreds of kilometers away, weeks back.

Aye, you're ab-so-*lutely* mad, but you're a powerful man, too. I was once a powerful man, he says, downshifting as we enter a tunnel, but I just turned eighty and those days are far behind me. I used to ride motorcycles, rode all across Europe, rode to India to those ashrams, aye. It's a miracle I'm still alive.

We grab lunch together. I buy Seamus a coffee as thanks for the lift and we cover almost everything two people can talk about in an hour. We cheers our coffees and he says, You know where that comes from, aye—the Brits, pewter mugs, and slammin' 'em together so a wee bit of my ale goes into yours and yours into mine and we know there's no poison in either one. We talk about small-scale trust and trust at large and the beauty of the world and wonder why it's so hard for people to see, to see the beauty. For too long, he says, the church made this world out to be the place of sin with the wonder stashed up above, when the wonder lay here before us all along.

Bryan, you and I were taught to trust no one, certainly no one beckoning with a car. I remember an older man with a comb-over who worked at the local video store. He spent ages trying to convince us that he was a director, a damn fine one, that he would make us—two little shits—famous, was

putting together a movie. Just come with him, get in his car, come to the shoot at his house. It was a movie that would have involved us taking off our shirts. Christ.

And now here, Seamus the Irish émigré seems to embody everything our old town wasn't. Palliative, an encounter like this. I learn more sitting in silence with Seamus for five minutes than I had from my father over a decade. Stack a thousand moments like this together and you might begin to heal a heart, domesticate the feral among us. But even believing in Seamus' goodness, I still feel—so many years later—our innate impulse to run, to trust no one. An impulse encoded on a cellular level, one felt more in the muscles than understood by the mind.

So I try to regard this man before me with an openness foreign to us. If I believed in some kind of higher logic, if I were so narcissistic as to think such a thing, I'd say my yelling into the forest somehow manifested Seamus as a message from you. As if to say: Hey, Craig, you fool, my brother, this too, this kindness and gentle honesty, this shit's *also* out there amid the cocksuckers and dickweeds. As if I had been walking within a thin strand of Kii's dark voodoo, and incanted in just the right way to produce a priest.

But I know that isn't true. Which makes Seamus all the more remarkable, the encounter all the more anagogical.

Seamus finishes his coffee and stands up. He puts on his jacket and comes around the table and before I know what's happening, he gives me a great bear hug, his jolly flesh pressing against my chest. It jolts me out of a daze months or years in the making. How long had it been since I had been properly hugged?

His stomach contains galaxies and I'm swimming between the stars where everything back on the Peninsula, on earth, is suddenly so small. Gorgeous, breathtaking, tragic, full of rav-

ishing, pulsing life, yes, but tiny, minuscule, almost nothing. Paper cuts fuse with holocausts. Nuclear physics merges with pizza toast melting into fried bologna. A swell of love—the precise amount of love a child needs to thrive—expands across the universe to Andromeda. A hug filled with DMT. I feel dizzy, elated, heartbroken, ebullient, crushed, favored by luck, and favored by misfortune. He pulls away and grasps my hands with both his giant paws and shakes them with vigor, pulling me back into my body and the now saying, You're a great man, Craig, turn toward it all. You are stronger than you think. It was an honor to meet you and I wish you continued peace.

Now the Peninsula voodoo was coming back to me. His simple blessing like an ice bath, coolness spreading throughout my body from the center, like the whole of the day, maybe the whole of the walk, was leading to this beacon of safety for us both, to this encounter in the rain on the side of the road, to this unexpected benediction.

ZELDA

Filled with the power of that hug, I walk. Ahead, a clustered burst of trees towers beyond the farmland—as sure a sign as any of a shrine. There aren't many spots to rest along these roads. Few benches, fewer covered benches for a guy as white as me. I am eternally grateful for these shrines and their shade. Shrines: primeval community centers, places of activity, where villagers bond during seasonal festivals. The grounds of the shrines filled with trees and rocks (those touchstones) for the gods, the many kami—natural temptations to draw them down to commune with and help out those villagers.

As I make my way into the shrine's inner grounds, the brightness of the open-sky farmland is replaced by the cool darkness of the canopy. Not only does the temperature drop, but the air itself seems to thicken. As I cross the torii gate's threshold, I feel an intense collision of realities. There is the reality of the shrine itself, but then there is also the reality of so many afternoons sitting before our old TV, playing *Zelda,* you by my side. Those chunky 2D graphics. We lived in them for months of our lives, a few hours each day. Projected our own colors and lights and textures into that small digital world, a world so large in our growing, hungry minds. And now, it's here, what we had envisioned long ago: the flitting dragon-flies, the glancing sunbeams, an ever-deepening green, the tiny ponds and once-old—now ancient, dilapidated—stone bridges. The shrine itself, enveloped by trees, rising within it all. I've seen scenes like this a thousand times during walks, but it isn't until the alchemy of today, this moment, this light,

this air, the residue of the hug, this particular hue of exhaustion and solitude, that the connection is so obvious.

I've been looking for this shrine for nearly three decades. We had secretly set some far-off marker beyond the horizon and suddenly I arrived, without ever knowing we had been searching for this very place.

Dazed, I rattle the bell, clang some coins into the *saisenbako*, clap clap, and say hello and thanks to the local kami, whoever they might be.

I sit in a notch of sun on the worn wooden steps and eat a rice ball. In the distance, the joyful screams of rare Peninsula children at recess fill the air. Around me the nightingales sing.

LUCK

Bryan, as you know—as we know—opportunity is not parceled out equally. And luck is nothing if not a direct product of abundant opportunity. I have not always been lucky on the Peninsula, and the Peninsula has not always been welcoming. For all the goodness I feel, sometimes this place can be a true asshole. High up on the Ōmine Okugake Michi route, years ago, I'll tell you what happened: I survived our town just to almost fall off a cliff. The bamboo grass hid the edge of the path. My foot slipped. The drop was substantial and straight onto rocks. Somehow, I caught a root, pulled myself back up, felt my heart slam itself against my ribcage.

John was there. He heard me slip and yelp, turning back just in time to see me haul myself up.

We had underestimated the path. Ropes led down from ledges. Chains came later. We contended with fifty-foot walls in a sleety typhoon. Man, it was bananas. Days scaling things like this, expansive valley views always steps away, soaring valley drops similarly close. An easy route to score a hangman's break. A wild route, a hard route, almost no "walking."

Also a route with a strange history. It's an old mountain-ascetic training path (still in use today), and as such, it has one of the last "no women" sections of any walk in Japan. A huge sign is posted above a torii gate just as you begin the incline up Mount Ōmine: NO WOMEN ALLOWED. It's often vandalized, which makes me smile. I tell women to ignore it, to go up the mountain. Is this even technically legal? Enforceable? This ban? I don't think it is.

The mountains are generally considered to be "female de-

ities" and as such are "jealous" of women traipsing over them. So it is said, foolishly.

It would be one thing if beyond that gate lay an austere gathering of serious men doing serious things with their cocks in hand, but I have been beyond that gate, and I can tell you: While some serious men are there (the priests, the true practitioners), there's a bunch of jabronies, too. It's the one section of the Ōmine you can go up and down in a day—stay in the lovely village of Dorogawa ("Dirty River") and hike up. So you get local yokels stopping for beer and cigarette breaks, being generally loud and unimpressive. Nothing ascetic about what they're up to.

But why the ban to begin with? As we walk, John explains that while in Buddhism there is no place for banning women from sacred sites, the issue is that the mountain ascetics— the *shugenjya*—were "lay priests." Priests when in the mountains, but "normal" guys back in town. As such they were still in contact with the everyday world. It's all a bit messy, the lines defining the edges of these words, these positions, these roles. Japanese mountain asceticism is a syncretic mix of old Shinto, Buddhism, Taoism, and Northern Shamanism. The men went into the mountains to receive supernatural powers. They gained great knowledge of the environment and the use of mountain plants for medicinal purposes and dietary supplements. So in a way, it *was* supernatural. The women stayed in the villages to attend to the ills of the villagers, to become attuned to their mental and physical challenges. The men returned with that plant knowledge, and the women applied it.

But the men also entered the mountains to escape life's temptations. Sex being one. A classic original case of trying to create a safe space. A mountain "man cave." As silly as we may find this, others have also found it dumb throughout history.

The famous thirteenth-century Zen priest Dogen openly criticized the banning of women from sacred sites like these.

Anyway, John and I crossed this threshold onto the manly part of the mountain, and I almost died.

Along the way we met a local man named Asamura. Asamura the Wise but also Asamura the Wild, a man cut from a rawness you would have instantly recognized, Bryan. A man who biked across a frozen continent in January on a budget of almost nothing. Who was picked up in parks by cops because they were convinced he would die in the elements, put in motels on a local police budget. A man who did jumping jacks all night to stay alive up north, once, when he miscalculated the cold in the mountains. A man who hides his heart in the way you and I hid ours, and in that way, a man I trust. A man with raw hands but a delicate face, gentle eyes. A Buddhist sculptor. He repairs statues around the Peninsula (wooden ones; not stone ones like the headless Gyūba Dōji), carries his huge, detailed works on his back across this unforgiving landscape, and John and I had been unwittingly admiring his craft for years. A secret pair of hands behind the scenes. A man who views this unyielding path with equanimity, walks backward, lithe like a snow leopard, never had a fall.

He wasn't officially a guide. Nor was he formally a practicing mountain ascetic, but he embodied their spirit, and perhaps in that way was more pure than even the official practitioners. Later John would write to me: "In addition to Pure Land Buddhism, Shugendō (mountain asceticism) had a strong influence on the Peninsula. Due to its isolated location, and the length of a return journey being over one month, a guide was necessary. The best of these guides were given the title of *sendatsu*. The original meaning of sendatsu was someone who had achieved a level of guiding mastery through ascetic practice, and was now showing the way for other followers."

Sendatsu, yes. Asamura was that if nothing else. We met him. John did his thing. The Effect was cast, and Asamura joined our walk on the spot.

A few days later, still up high, deep in man-only territory, a wail: *Andrew?* There is no Andrew. Just darkness of camp. Midnight silence, the temperature having dropped some twenty degrees to zero from midday and while we knew it was coming it still hit fast and hard. Asamura and John and I stood around the campfire for dinner—too cold to sit—shoveling beans into our mouths and drinking steaming soup and then, by eight, slipping into our individual tents and saying goodnight.

Andrew!? A sorrowful cry on the edge of dream. *No Andrew here!* I yell back, mainly annoyed. I had finally fallen asleep. So tired. So cold. Miserable, sorta. Miserable but delighted? Yes. The Ōmine Okugake Michi has limited water supplies and we had found the water spot. We didn't die the previous day. I didn't snap my neck on rocks. Yes, delighted enough. I zip the sleeping bag up around my face like a mummy, sink back to sleep.

Asamura and I wake before sunrise and John is gone. We check the nearby emergency hut. There he is, curled up in two sleeping bags. You were yelling for someone named Andrew, I tell him. Damn, he says, was going hypothermic, seeing things.

Laughing—as you do when you skirt danger—we take a photo together, in front of a small mountain shrine, looking battered and feral, farcically disheveled. I adore this photo. It shows John as human, fallible, when he is in so many ways the least fallible man I've ever met. Standing there next to him and Asamura I felt so many potentials. Asamura protected us on that walk, of this I'm certain. He showed us the safest route, handed over extra supplies. Not a brother but brotherly.

I wish I could carry his archetype back in time to us, to light that safer route. What I mean is: Somehow as an adult I've managed to attract and surround myself with these people, these beacons of good. People we never had. I love them so much that my bones ache—ache because I know I'll lose them someday. I will follow them anywhere. Together we walk in the near-frozen morning air and the sun rises. Light works its way across the rippling peaks of the Peninsula. Feeling returns to hands, to feet, to hearts. The mind moves once again. We carry our lives on our backs and traverse the spine of the world, no humans for miles, no routes down, just forward or back, the beast below always shifting, always ready to heave us off.

THE "BOOK OF JOHN"

I think of John, of our adventures, of our friendship, of the catalog of knowledge built up together over nearly fifteen years. In time, the "Book of John" has become stranger and stranger. It is not a book—certainly not one printed. Even so, the "Book of John" feels something like the Tao, or perhaps it is like the I Ching. It is not a divination manual, though it often manifests things you'd never find without it. And in that way, divines truthfully without affect. The "Book of John" is definitely a way of being in the world, and a way of communicating *with* the world. It is a talisman of curiosity and it chooses love. It is strange, and never not working. But working (smartly) is in good accord with the "Book of John." It is a vibe and an enigma and a fart-joke paradox in an ancient script. The "Book of John" applauds a well-timed potato chip. It compels a man to fly to Aomori in the rain to drive around for five hours to eat apple pie and do some "research." Could this research have been done on the internet? Absolutely. Would it have been in accord with the "Book of John"? Absolutely not. Because, according to foundational principles animating the "Book of John," something electric happens between theory and praxis, and being there—in the place, breathing the air of that place and stomping across the ground—brings that magic, that ineffable and wonderful electricity, to both the practitioner—the "researcher"—and those who may eventually get the information. You have to believe this. This is what the "Book of John" teaches in its outré ways. Its processes seem so simple, and yet are so effective, that they tremble in—as Peter Matthiessen aptly describes Macha-

puchare in *The Snow Leopard*—*mysterium tremendum*. The "Book of John" contains facts, but it is easy to be fooled. It is not about the facts. It's about pointing your compass toward a peculiar shrine, tucked behind a peculiar dirt road, on a peculiar peninsula, far off the beaten path, confident something worthwhile awaits.

LIGHTER

At my father's small home, so many years back—when I was cleaning it out before the funeral, when I was rising from a bed of towels and blankets on the living room carpet (I was too scared to sleep in his bed and the shag carpet was pretty nice, honestly, felt like a cheap futon), I went through it all. Shelf by shelf. Drawer by drawer. Camera in hand, photographing the details.

I walked the home in circles and shot. Ratios, light, textures. This was a job, another job, I told myself. I understood the brief at once: ethnographic study of a man who died alone. I didn't know this man, really, the man who died. Long ago maybe I thought I did, but in aggregate he was as much a stranger as anyone. His bedroom was bare—just the bed and a dresser he had owned his entire life. In the top drawer of that polished pinewood dresser: a hula lighter from a honeymoon trip to Hawai'i—next to three condoms that had expired decades ago and a stack of prayer cards—reminding me of a time and place I had never been.

Two drawers below, a surprise: an unframed collection of my face throughout the years. Loose photographs in an envelope. I remove the small pictures one by one and place them on the floor. I stand and look down. A childhood in broad strokes. And of course, you're there too, unseen, same crew cut, both of us having gone to the barber on the same day, that guy Bruce. Hefty, towering, clippers in hand. A man who cut our hair for nearly a decade before he was struck down by cancer. He survived, but for some reason we never returned. When I look at these faces I feel you somewhere close by, trying to make me laugh.

DISPATCH: CHILDREN

Even here, even on this peninsula where youth is vanishing, on weekday afternoons, toward the end of a long day of walking, the elementary-school kids are let out and roam about. Village or town or city, makes no difference, elementary-school kids walk as elementary-school kids walk. They have nowhere to be and nowhere they want to be but in the walk. Supple bodies bending and twisting as they shuffle forward, jumping, crouching low, pushing one another over, bouncing back up. They walk, and don't even know it as walking. In this way, they are ideal walkers, and have found the true walk. Their walk is a walk of peace, of a collective social decision to allow it to happen. Eyes are on them. Eyes peering out from behind hedges and eyes beside pushed-back curtains. Eyes attached to adults who care, who have the yoyū to care, who watch at a distance. Their freeness of walk is a product of a cascade of this support. The kids don't know this but they feel it, show it in every little yelp. They bump into one another and speed up and slow down. They run alongside rivers with their umbrellas held behind, like miniature fighter jets landing on aircraft carriers surrounded by dandelions.

• • •

The "Book of John" says that there's a literary turn of expression, of something being so amazing that even the old poet Saigyō "turned back." Its provenance is said to come from Atashika, where that post-office ranger I bumped into was living. There's a memorial in town next to a pine tree. It's said

that Saigyō was so impressed with the children of the village, so moved by their brilliance and spark, that he said he could no longer go on, turned back, went home.

...

I stop to chug an iced coffee from a vending machine. A group of thirty or so elementary-school kids are being herded like unruly geese onto a nearby bus. They all wear the same dorky yellow hats, hats that would have gotten us punched hard. WHAT ARE YOU DOING? they scream at me. Walking! I yell back. OH YEAH, WHERE'D YOU WALK FROM? And I tell them. I tell them where I walked from and they just say, HOLY SHIT.

...

The elementary-school children run from me giggling. They hide behind their umbrellas. As I pass them I say (to the umbrellas), Mighty fine little town you got here (as I say to most kids I pass; "Nice town!" is a kind thing probably not enough people say, certainly not to kids, and I mean it too—these little towns are pretty nice), and one of the boys yells back, THIS CRAPHOLE? AND JUST WHAT THE HECK ARE YOU ANYWAY?

...

I stroll picturesque stream-flanked ippon-uras and watch kids walk before me in zigzaggy lines and think about how adults are so point-to-point specific, but these children try their hardest to stretch out their walks home, ducking into little nooks in the entryways of houses and behind stone walls, poking one another, tugging on tree branches, howling and squawking with those little leather Dutch backpacks bopping

behind, trusted to get home and trusted not to be messed with by anyone along the way. The heart swells in witness to many things on a walk like this, but it swells perhaps most in response to these kids, their walk, their grace, elevated by the unspoken virtue of everything and everyone around them.

FOLSOM

The last day of the walk. Bryan, man, I wish I could say that it's glorious and perfect and full of sparkling joy, but I can't. Bullshit. Total bullshit. The entire morning I've been walking uphill, all logging roads, no cute kids, no villages, blazing sun, breezeless. The rains are truly done. Summer, terrible summer, is here. When there *is* "trail" it's unmaintained and mostly rubbed off the mountain by land slippage. I have to shimmy alongside steep unmarked ridges—sliding down, crawling back up—to get to a bridge to cross a river. Almost give up and swim it. Bad shape, all of it, not fun to walk. And the flies. Do you like flies? I've got no fewer than twenty flies circling my head right now. Tiny flies flying into my eyeballs, behind my sunglasses. Big bastards flying into my ears, my nostrils. If I open my mouth they'll make a run at it, persistent, suicidal. They're crawling all over my arms and neck and shoulders, and I don't mean every few minutes a fly lands on me—I mean I'm swarmed. When I stop, even more descend.

In this frazzled state, my mind goes to the police report. You at the house party. A house you didn't know, owned by someone you had never met. But this was common, this was part and parcel of the town. Get wind of an address, show up with a crew. Break-dancing, arm-wrestling, booze, weed. Stupid stupid. The report is so detailed. Twenty, twenty-five other people, a party of teenagers from town. Saturday night, Fourth of July. Firework percussion in the distance. I was already far away and you'd never get any farther. You could have left that house at any time—just leave, leave, it's so easy, so simple, to take one step and then another out that door, walk

anywhere else, do whatever you have to do to remove yourself from the hexed equation—but you stayed. Three in the morning and the older guy (though not much older) looking after the place comes back (he doesn't even own it, the poor schmuck was just watching it for a friend), there wasn't supposed to be a party, doesn't like what he sees, starts cursing you and the few remaining kids. Because you were kids. Strong bodies but kids in mind, just hours away from being able to vote, to join the military. (Which many would go on to do.) When I read the police report I read: exhaustion, fear, stupidity, impulsiveness, petulance. Curses turn to punches turn to knives. A stupid, stupid chain of events.

I yell at the flies. Call them every name we know. Oh, they are great flies, aye, powerful flies. I want to kick them in their fly faces. I wish I had the patience of Seamus. Or the silver tongue of John, to convince the flies that they should fly somewhere else. Just one day spent with men like these and you would have learned how to walk away from that house. But we didn't learn. We were alone. The whole town was alone, abandoned by the greater whole. Now, I'm truly alone. Left it all behind. Walked so far from where we began. My strategy: the walk. The simplest strategy. Thirty years later and I'm still operating on scarcity, still trying to put in the distance between then and now. As if there would never be enough steps. As if that town could reach out and grab me and pull me back at any moment. And so I default to our talents—what we taught ourselves to do because it's all we could figure out—and curse loudly without witness. Hell yes, it's cathartic. The fucks and fuck yous. With each curse I feel my body lift off the ground, but I also feel the remaining klicks and can't believe how much more of this I've got. Hours. Sweat in the eyes, I trudge on, head down. I put on Johnny Cash's "Folsom Prison Blues" just to lighten the mood and it only makes me

more confused, leaves me marveling at how this incredible recording had been made inside a penitentiary, how this beautiful music could also be so cursed, how all the men whoop and holler when he says he shot a man in Reno just to watch him die. Stupid stupid, this impulse, this laziness, scarcity breeding scarcity, and then celebrated, this endemic scarcity lodged within.

Eventually, I emerge from the logging roads and the ruined forest covered in dirt and sweat and leaves and mud and fly corpses. I depleted my water hours earlier like a true doofus, was parched, would gladly place my mouth on any liquid-bearing faucet. I spy a kissa. Stick my head in, and the looks on the faces of the three patrons and the owner let me know with no uncertainty: not this place.

I remember that vending machine in the field. Then, barefoot, frozen, drunk. Now, hot, soaked, nearly a decade sober, wearing hiking boots, having come down from the mountain path like a Sasquatch. My feet burn in a different way. Finally, I find a vending machine next to an elementary school. A few kids are running around outside in the playground. I sit in the middle of the road. Half-hope a truck will take me out. Chug two bottles of that same sports drink. Pure elixir. Hug my pack like a teddy bear. Moan. I could sleep away a lifetime right here.

And yet, still so much walk in the day. Fat, meaty kilometers. Electrolyte-infused, I stand. The kids had gathered nearby as if witnessing a man shot in Reno, resurrected. They cautiously initiate first contact and I issue a gregarious *Helllooooo tiny humans* in a low, wacky voice and dance a little jig as I shoulder my pack and—sensing my playful fellowship—they topple into one another and run circles around my legs and poke me, shrieking, asking WHERE YA GOIN' HUH WHERE YA GOIN' and I keep making up names of coun-

tries and planets and they keep saying THAT AIN'T NO REAL PLACE.

Let's be generous:

Hearts without violence. Children of simple abundance.

The road leaves town and cuts through more rice fields stretching to the mountains. An old man sitting in front of a shrine, smoking, asks me where I'm from and I tell him and he says, No, not that—which prefecture?

My cursing of the world ceases. My heart feels annoyingly fragile—a heart of deficit now filled with unwitting abundance. Made all the more fragile because the end of the walk is in sight. And yeah, however frustrating a day might be, however many flies might crawl over your sweat-glistening face, a day walking is still something to be cherished. At the beginning of a big walk the end seems implausible, a million years away, like imagining the last day of an elementary-school summer. In those first hours of the break—hopping onto the bus, the last bus of the year, sitting side by side—the possibilities felt limitless. Together, you and I'd map out our days of idle nothingness, a string of trouble, bike rides, fights, stolen cigarettes, and even though the days would tick by, we never quite believed they'd finish, that the end would arrive. And yet it would, of course.

Slowly, then quickly: a bunch of crap would creep in. Sadness, mainly. And that tightening knot in the gut of the looming rote responsibilities of school. As the years passed I tested higher and higher and you tested lower. So it came to be, the system cleaved us apart, placed you on a path to that doomed house, established some hierarchy between us that had previously never existed. My classrooms had computers. Yours barely had pencils. Same town, different, unjust universe. I spent my teenage summers playing music with privileged kids who came from true abundance in far-off towns. You worked

the tobacco fields. Neither of us understood what was happening until it was too late and awkward. The last time I saw you we were seniors in high school, walking opposite directions down the street. A street we had walked together countless times. We said hello, but it was obvious that we were both embarrassed. We lacked the emotional intelligence to bridge the fissure. But back in those childhood summers we drew out our days like taffy, and no matter how much trouble we might get into with our parents, we stayed out, lying on our backs in piles of leaves in the woods, chewing reeds, watching the gentler stars appear, talking about all the lives we were sure we'd forever live.

ASSO

I make it to Asso Station. Barely an open-air waiting room next to the tracks. Maybe thirty meters square. Inside sit twenty middle-school-aged girls shoulder-to-shoulder in their pleated-skirt uniforms all head-down in phones. They take up every seat. Oh, Bryan, this scene. Miraculous. I could pour gasoline on myself and light myself on fire and none of them would look in my direction. The inconsequentiality of my existence to these girls is beautiful. I eavesdrop as I wait for the train and hear them speak like us, like little truck drivers using the gruffest of pronouns like *omae* and *temē* and saying things like: *Bitch, what the fuck you gonna do about those eyebrows?*

I want to high-five each and every one of the little pottymouths. But you better believe I hold still. Not a single twitch. Hold my breath. Would hold my heart if I could, if I knew how. Hell—I want to know exactly what the fuck she's gonna do.

. . .

I had walked thirty-four kilometers to that station and I listened to those girls and asked my body how it was doing and my legs said they could walk all day and all night. My feet said, Well, we can do a few more hours. And so I snuck out of that waiting room, skipped the train, decided to keep going, to push out another nine kilometers or so and finish the goddamned walk as a kind of rebuttal against, or refutation of, those earlier curse-filled garbage kilometers.

A FINISH

Off I set, energized and free. Firecrackers bursting in my brain—little pops on the edge of my vision: the thirty-five-kilometer high. A high you get over and over again on a long walk like this. It feels wonderful. Above, a sky bruised by dusk. I feel you nearby. Your murder had happened just weeks after we graduated from high school. I found out in the evening in a place warm and far from home. Someone told me the news. I wandered outside and lay in a hammock between two palm trees and cried. Above, a dark sky I didn't know, stars you'd never see. Everything cut short. Through pure luck I was on my way out, wouldn't look back for decades, until now, until this landscape knocked it out of me with its anthropological decay, its natural lushness, a lushness our ravine always aspired to but never quite achieved. The farms I see here, like farms we knew on the edge of town. So distant and yet the parallels are unmistakable. The few children on these paths make me think again and again about how it could have been. Economically, the people of this peninsula don't have much more than we had, and yet the differences jolt: the violence, it's gone.

I have been walking for you. Every walk has been a walk in your name to get us both to this place. A place like our home and yet not. A place with abundance. Spiritual, cultural, historical, social abundance. I can walk as far as I want. The rules have changed. The limitations are gone. I can walk to Osaka or Kyoto, heck I can walk to Almaty or Istanbul. A world collapsed. Seamus' belly. Distances rendered meaningless. I feel capable and alive and glad to be in the walk, swad-

dled by the walk and the cool night air. Explosions behind my eyes. The abandoned tennis courts and shops scintillate. Were it possible, I'd call you right now—wake you up and ask you what you remembered of our childhood because I know so much is locked away in your mind.

I think about my angry days—so many—of youth and recent years, of how I never thought I'd make it this far, of how—so long ago—I built up the toolkit alongside you for cursing the road and life so thoroughly and skillfully. Anger: a survival instinct. It's all we knew. No reconciliation, just anger. Broken, on the side of a mountain, that surge of anger and frustration was everything. A quake, a rising sea shaking loose all the decomposing shit inside the mind. I had to spit it all out—execrate the road and the trees and the flies—just purge my brain and guts and spine of garbage onto that wretched path on that wretched mountain.

I've been thinking about the okonomiyaki woman. Her silver teeth flashing. Can't get her words out of my mind. She spoke of Methuselah purifications. Come and wash it all away, she said. Once cleansed, the mind soars and the body becomes light, keeps moving no matter how disgusting it feels, how used-up it may be. Because, good lord am I used up— my stink could wilt an oak tree, would send a dog running. The ultimate mark of a summer's day well lived.

That night back in Susami, after the okonomiyaki woman told me of her willingness to die, I said to her: Oh, well, if the big quake comes right now, you know I'm throwing you on my back and we'll be at the top of that mountain right there in no time, yeah?

And she just laughed and laughed.

I feel certain in these final kilometers that I can carry her, can carry you, carry some thousand-pound burlap sack of our sorrows and commensurate retributions. I am strong. I see this

now. Seamus was right. Stronger than I've ever been. A strength pulled from these people around me, from a love we never knew. There is yoyū out there and it is now in my bones, powers the "Book of John," powers this walk. No wall gonna keep that sea back but I could haul everything important in this world up any mountain in sight, away from a thousand tsunamis and storms that would cover the earth a thousand times over. That water would flow up and up and wash away so much junk, once again wipe clean the towering shrine torii, take the homes, the kissas, the sleeping barbers, take away the old watch shops and horrible hotels and beautiful old inns with adopted owners, and scrub away even the ashen ghosts of fire and war, sure, but it'll never touch us. It'll never touch these fucking feet.

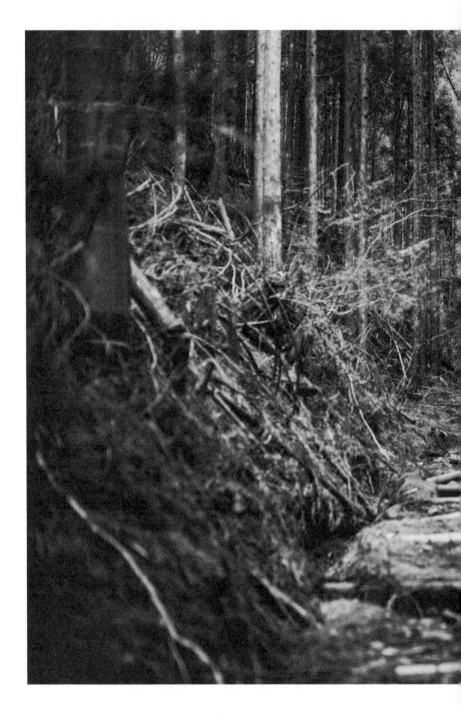

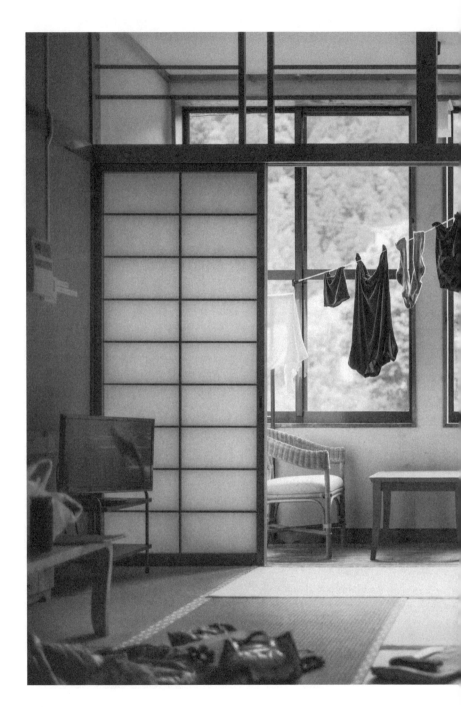

EPILOGUE

When the waters recede—quicker than you might imagine—and the curtain of destruction is pulled back, homes are atop homes, flipped sideways, others vanished. Walls are toppled and roofs bent. Boats float down alleys. As the waters pull back, the mountains of the bay, made weak, begin to crumble. Whole trees fall into the ocean. The vacuum of the force of this phenomenon does something strange: It sucks the waters away with such energy that the ocean floor is revealed. For a brief moment the town is more than it has ever been, doubled in size, the land carrying with it a strange promise, possibility extending to the very mouth of the bay. Time has temporarily been reversed. But do not go low. It is a trick. You need to go higher still.

ACKNOWLEDGMENTS

I began this book on a walk around Kii in May 2021, and planned on finishing it in a twenty-one-day burst in September of the same year. Ha ha ha! That deadline whooshed past. And then the next, and the next. The cast of characters grew. Then shrank. Then grew again. Now it's in your hands. No small miracle.

First off: *TBOT* itself is dedicated to Mizuki. Although we aren't bound together legally, she lives forever in my mind as a daughter. I hope my actions have reflected my feelings. Being a father figure in her life—particularly when she was around the ages of eight to twelve—reconfigured my brain in ways that will resonate indefinitely. Without her I would be so much less. Many, many years ago I would tell her bedtime stories about "my friend Bryan." Her life force cracked open my heart in a way that allowed me to go back to him, to revisit what we had and didn't have as kids.

This book would also not exist without the friendship and support and shrewd editorial eye of Oli Chance, longtime pal. He's one of the first people I met after stepping off the plane at Narita in August 2000. It's only fitting he was so involved, so early on.

On the "business" side of things: A huge thanks to Andy Ward and Ben Greenberg at Random House for being so enthusiastic (and contractually flexible!) and willing to take a chance on this book. To my editor at Random House, Molly Turpin, for asking roughly nine million critical, generous questions, all of which I tried to answer in prose, and all of which made this book stronger. And to David McCormick

for his agently advice and helping me navigate the dark waters of publishing's legal clauses.

Without John McBride I wouldn't have started any of this walking. I've spent months of my life walking side by side with him. So—thank you, John, for opening up this world to me. Also, it was John who facilitated permission to reproduce the ancient "passport." The image is from the collection of Laura Moretti at the University of Cambridge. The translation is by students at the university's Graduate Summer School in Japanese Early-Modern Palaeography (of which John was one, of course). Someday we need to make the "Book of John" a real book, printed, out in the world. Everyone'd be all richer for it.

Extra-big thank-you to David Cady for his copyediting eye and two decades of friendship and hosannas. To Wesley Verhoeve, for helping me sift through thousands of my photographs to find the ones for this book. To Matt Blackstone, Carina Fushimi, Kusaka Hikaru, Sophie Knight, and Tyler Walker for their support and eyes on early (and late) drafts of the manuscript.

Collective thanks and cosmic bear hug to the members of SPECIAL PROJECTS, my indie membership program, which has enabled—financially and spiritually—all the walking I've done since 2019. This book wouldn't exist without those members. I am still in awe of how many of you are out there, and the weird-ass adventures we've gone on together.

Thanks, too, to MacDowell. Even though you've rejected me every single time since my residency in Winter 2011–2012 (so many rejections!!), that one stint you *did* offer me changed my life. What a place. What amazing people. What cute little lunch baskets. Drafts of a few (small) sections of this book were actually written there (Dad scenes: MacDowell cabin, fire burning, piano occasionally plinked), if you can

believe it or not. Anyway, I'm glad lots of other people are getting a chance to experience residency there. If I had a billion dollars, I'd do everything in my power to sustainably multiply your presence. (Oh, and sorry for throwing up in my cabin.)

And finally, thanks in no particular order to the following humans for their continued guidance and support: Sam Anderson, Frank Chimero, Lynne Tillman, Rob Giampietro, Kuripuru, George, Derek Baines, Mina & Joe, Serena & Aziz, Giamin & Kevin, Robin & Kathryn, Sayuri Ikeda, John Gruber, Dan Frommer, Bin Sugawara, Hikari Ohta, Chris Palmieri, Matt Romaine, Saul Griffith, Dan Greenspun, Adam Savage, Peter Collingridge, Ethan Glasserman, David Marx, Jon Gray, and that okonomiyaki woman who made me smile a little during that final truly shit day of walking.

Oh, heck—and finally finally *finally* a special thanks to my mom, who in a bout of surrealist invention—while working at the airplane-engine factory—began saving for college when she was barely twenty. Not for her college education—for mine. For a kid she didn't yet have or know, but imagined. Whatever drove that specific impulse is a mystery. But for a kid in a country that doesn't subsidize higher education, knowing that we had a little bundle of cash earmarked for Life Beyond—well, that's precisely the sort of thing that allows a child's mind to soar. (Although I'm sure she wishes I had soared a little closer to home.)

CRAIG MOD is a writer, photographer, and walker living in Tokyo, Japan. He is the author of *Things Become Other Things* and *Kissa by Kissa*. He also writes the newsletters Roden and Ridgeline and has contributed to *The New York Times, The Atlantic, Wired,* and more. In 2023 he wrote an impassioned recommendation of Morioka, Japan, to *The New York Times*. To the bafflement of everyone, the paper ranked the city number two (behind London) for "Places to Visit in 2023." This fluke turned Mod into a minor celebrity. He sat for interviews with some forty or fifty newspapers and TV shows, trying to explain the goodness of a city like Morioka to people for whom the goodness is so self-evident that it has become invisible. This whole media dance culminated in his going on a two-day walk around Morioka with one of Japan's biggest TV stars: the seventy-nine-year-old sunglasses-wearing Tamori-san, who was lovely (and very tiny!). The response— a total heartfelt reverence for the avuncular Tamori—from people on the street ("Good morning! Tamori-san!!" yelled construction workers from atop their scaffolding) made Mod feel like he was walking with John Lennon. Mod's moment of celebrity was mercifully short-lived. Nobody recognizes him anymore when he walks around town.

ABOUT THE TYPE

This book was set in Bembo, a typeface based on an old-style Roman face that was used for Cardinal Pietro Bembo's tract *De Aetna* in 1495. Bembo was cut by Francesco Griffo (1450–1518) in the early sixteenth century for Italian Renaissance printer and publisher Aldus Manutius (1449–1515). The Lanston Monotype Company of Philadelphia brought the well-proportioned letter-forms of Bembo to the United States in the 1930s.